Dorothea
Lange
and the
Documentary
Tradition

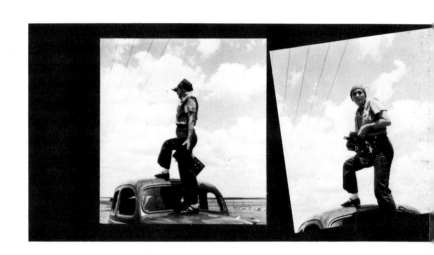

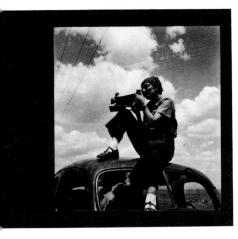

Dorothea Lange
and the
Documentary
Tradition

Karin Becker Ohrn

Louisiana State University Press
Baton Rouge and London

Designer: Patricia Douglas Crowder
Typeface: VIP Trump
Typesetter: G & S Typesetters, Inc.

Grateful acknowledgment is made to the following: KQED Public Television, San Francisco, for permission to print quotations from the films *The Closer for Me* and *Dorothea Lange: Under the Trees*; The Bancroft Library, University of California, Berkeley, for permission to reprint quotations from the interviews by Suzanne Reiss, *The Making of a Documentary Photographer*, with Dorothea Lange, and *Paul Schuster Taylor: California Social Scientist*, with Paul S. Taylor; Women in Communications, Inc., for permission to print portions of Chapter XI, which appeared in slightly different form in "A Life in Photography" by Karin Ohrn, in *Matrix*, LXII (Winter, 1976–77); and California State University Northridge Foundation and Department of Journalism for permission to print portions of Chapter VII, which appeared in slightly different form in "What You See Is What You Get: Dorothea Lange and Ansel Adams at Manzanar" by Karin Ohrn, in *Journalism History*, IV (1977).

LIBRARY OF CONGRESS CATALOGING IN PUBLICATION DATA

Ohrn, Karin Becker, 1946–
 Dorothea Lange and the documentary tradition.

 Bibliography: p.
 Includes index.
 1. Lange, Dorothea. 2. Photography, Documentary.
3. Women photographers—United States—Biography.
I. Title.
TR140.L3037 770'.92'4 [B] 79-20841
ISBN 0-8071-0551-1

To the memory of
Georgia Ann Nordeen Becker

Contents

Illustrations

Preface and
Acknowledgments

In 1923 a young portrait photographer in San Francisco found a quotation by Francis Bacon and put it up on her darkroom door. Forty-two years and thousands of photographs later, the quotation, which regarded "the contemplation of things as they are" as "a nobler thing," had retained its place on a long succession of her darkroom doors. It guided her through the Depression, as she photographed in the migrant camps of California and across rural America; through World War II, as she documented the American version of concentration camps for its Japanese American Citizens; and during the 1950s, in her photojournalistic work for the picture magazines. The essence of this quotation continued to influence her as she took her cameras to South America, Asia, and Egypt, around the world and back into her own family environment, where she photographed her grandchildren playing at the seashore. And, as death approached, "the contemplation of things as they are" became her hope and challenge for future photographers and all those enthralled with the beauty and passion of the visual world.

Dorothea Lange was recognized as a great photographer during her lifetime—a reputation based primarily on the photographs she made while working for the Farm Security Administration (FSA) in the 1930s. She continues to be recog-

nized as one of the best to work on that outstanding team of photographers and has been included among the masters in books on the history of photography.[1] Even people who know little about photography or would not recognize Lange's name have seen her photographs in books and articles on the Depression years.[2] Her most famous photograph, "Migrant Mother," of a woman and her children in a California migrant camp, is probably the most frequently published photograph in the history of the medium.[3]

Since her death in 1965, Lange has gained added recognition, evidence that her audience was not confined to her contemporaries. On the thirtieth anniversary of the relocation of Japanese Americans, for example, her photographs of that phase of American history appeared in books and newspapers and on television.[4] Most of Lange's work from that period had never been seen before, and for the first time Americans were able to look at the evidence of the crimes they had committed against fellow citizens.[5] The photographs Lange made in the 1930s are now seen more widely, revealing to people who were not yet born when they were made—or perhaps warning them—what life can be like during times of severe economic hardship.[6]

Lange also indicated some new directions that she felt photographers should pursue. She suggested, for example, that a team of photographers be formed to document contemporary America, as the FSA photographers had done in the thirties. To the extent that these paths are now being explored, they are clear extensions of some of Lange's most admired work.[7]

It is time to look at her life and work and examine their scope in order to place her well-known photographs within the context of her life in photography, to see what other contributions she may have made to the development of the documentary approach, and to see what her life and work have to offer toward understanding and extending the power of photography. This study examines the factors that formed Lange's photographs—her attitudes toward photography, her intentions for her work, her personal orientation toward her choice of subjects, the constraints imposed by organizations that employed her, and the historical periods bridged by her work. This is not possible without also examining, to a certain extent, the changes in the milieux in which Lange lived and the work of other photographers in situations parallel to hers. The making of documentary photographs is a socially and culturally patterned activity that has been variously interpreted by photographers working in the documentary tradition. I have examined how one photographer applied and influenced the patterns

that have guided all photographers who continue to choose a documentary approach. Comparing Lange with selected photographers in each period of her life clarifies the patterns they shared in their work and enables us to see what was unique about Lange and the contribution she made to the documentary tradition.

I do not pretend to be reconstructing Lange's life and work as she saw it. Were she alive, her present interpretations of her work undoubtedly would be different from those she had when making a particular photograph or editing a selection of her work for a particular audience, just as her orientation toward these activities changed during her life. My reconstruction is based on my interpretations of her words and photographs—a finite, concrete body of material composed of slices from a complex life and work.

The primary sources for this task of reconstruction were two interviews conducted with Lange toward the end of her life;[8] Lange's correspondence with Roy Stryker, director of the FSA photographic project;[9] the photographs Lange made and the captions she wrote to accompany them while working for the FSA, the Bureau of Agricultural Economics, and the War Relocation Authority;[10] and the volumes of photographs and a few notes spanning her life in photography, which Lange and her assistant, Richard Conrat, assembled during the last two years of her life.[11] In addition, I used several articles by Lange, articles based on interviews with her, and two films about her that were made shortly before she died.[12]

Many of the people who knew Lange and worked with her are still living. I interviewed some of them and found that, although their memories of Lange are as widely various as their individual relationships with her and are necessarily colored by the passage of time, these conversations provided a wealth of information on how she worked. Even more important, the people who knew her provided a basis for understanding Lange as one whose day-to-day life was an intense expression of the same concerns that permeated her photography. I wish to express special thanks in this regard to Ansel Adams, John Collier, Jr., Richard Conrat, Phillip Greene, Therese Heyman, Russell Lee, Margaretta Mitchell, Beaumont Newhall, Ron Partridge, Suzanne Riess, Dyanna Taylor, Paul S. Taylor, and Paul Vanderbilt. In addition, at the archives where Lange's work is located, I found people who were encouraging and genuinely interested in expanding the information available on her life and work. Especially helpful were Leroy Bellamy, of the Prints and Photographs Division, Library of Congress;

James Anderson, of the University of Louisville Photographic Archives; and Charles Lokey and Therese Heyman, of the Oakland Museum. I also wish to thank John G. Morris, personal representative of the estate of W. Eugene Smith, for granting permission, in conjunction with Life Picture Service, to reproduce pages from two *Life* essays by W. Eugene Smith.

It is unlikely that I would have undertaken an examination of Lange, were it not for the initial exposure to her photographs; which I received while working as Will Counts's teaching assistant. He, Richard Gray, Trevor Brown, and Henry Glassie each provided guidance, criticism, and the challenge that the significance of this study merited my best efforts. Conversations with Henry Holmes Smith provided further encouragement.

The research was carried out with financial support from Indiana University in the form of a dissertation grant-in-aid, from Women in Communications, Inc., through the award of the Jo Caldwell Meyer Research Grant for 1975, and from the University of Iowa, through a Summer Fellowship, 1976.

Finally, a circle of friends and family sustained me through the many stages of bringing this work to fruition. Each one helped me in various and indescribable ways, enriching both the work and its author. Jeffrey Hartenfeld's special contributions began with the inception of the idea and carried through the final selection of the photographs, and Steven Ohrn's hard questions, good ideas, and loving support can be felt on every page.

The contemplation of things as they are
Without error or confusion
Without substitution or imposture
Is in itself a nobler thing
Than a whole harvest of invention.

FRANCIS BACON

Chapter I

Becoming
a Photographer

In the sixth decade of her life, Dorothea Lange began searching for the origins of her life in photography, exploring memories of herself as a child. She wanted to fill in around the facts—her birth in 1895, in Hoboken, New Jersey, into a German immigrant family of lithographers and her formal education at Public School 62 in New York City and at the Wadleigh High School for Girls—to recall how she learned that photography would be her medium. She thought of the search as painful and was reluctant to begin. Her husband, Paul Taylor, said that she rarely spoke of her childhood or early family experiences. Then, in 1960, the Regional Oral History Office at the University of California asked her for an interview. With Taylor's encouragement she agreed, warning interviewer Suzanne Riess that she "would probably go deep," for she was interested in exploring personal aspects of her past experience.[1]

Lange's reluctance is understandable. Her father, Henry Nutzhorn, abandoned the family when she and her younger brother, Martin, were in elementary school. Their mother, Joanna Lange, moved in with their grandmother to have help raising the children, while she went to work at the New York Public Library

on the Lower East Side. At an age when most children are dependent on their mothers, young Dorothea found her mother leaning on her.

Joanna Lange was a good-natured, compassionate and unselfish woman, but she had a concern for appearances, which Dorothea disliked. She described her mother as "slightly obsequious to anyone in authority." Her grandmother, on the other hand, was quarrelsome and disorderly and drank too much, but she was more sensitive than her only daughter. She was a talented dressmaker, and the many legends that surrounded her appealed to Dorothea, who often found herself caught between the sensitivity she shared with her grandmother and her devotion and concern for her mother. Her grandmother said of her, "That girl has a line in her head," referring to Dorothea's early sense "of what was fine and what was mongrel, what was pure and what was corrupted in *things.*"[2]

Polio had left Dorothea with a crippled right leg, and her sense of shame over the deformity was heightened by her mother's requests that she attempt to conceal her limp. Yet, she also gained an understanding of the effect misfortune has on others as she learned to accept her own. She later said, "I think it perhaps was the most important thing that happened to me and formed me, guided me, instructed me, helped me, and humiliated me. All those things at once. I've never gotten over it and I am aware of the force and power of it. . . . Cripples know that about each other, perfectly well. When I'm with someone that has a disability, we know."[3]

Her sense of being an outsider grew during her years as a lone gentile student "in the sweatshop, pushcart, solid Jewish, honeycomb tenement district." She had taken for granted that she was bright and picked up on things easily, but found she could not keep up with her classmates. "They were too smart for me. . . . Aggressively smart. And they were hungry after knowledge and achievement . . . fighting their way up. . . . To an outsider, it was a savage group because of this overwhelming ambition."[4] She felt anonymous and left out, not a part of the life of the school or the neighborhood. Every morning she went into New York City with her mother and walked from the library to school. After school she walked back to the library, where she sat and read in the staff room, its high windows looking out on the tenements, until it was time to go home.

On the nights her mother worked late, Dorothea walked home alone through the Bowery, stepping over an occasional drunk passed out on the sidewalk. She learned to adopt an expression that would draw no attention to herself, that would make her invisible to the people around her and enable her to walk

through the worst parts of the city without fear. In later years, her "cloak of invisibility" made it easier for her to photograph under the most difficult situations, and she was seldom afraid to work alone in any city.

As Dorothea lost interest in school and began a pattern of frequent truancy, she spent whole days walking, looking at the city and its people. Using her ability to move freely and easily through all manner of situations, she explored and observed the strange life around her, which was so unlike her home environment, learning what it meant to make "all parts of the world your natural element." She did not consider this activity to be morally objectionable or unproductive: "I remember spending as much time as I could neglecting what I thought I should be doing—I didn't study well—looking at pictures. I looked and looked and looked at pictures, that I used to adore. . . . I love visual representation of all kinds, in all media, for all purposes. I find beautiful things in advertisements." But her vision was not confined to representations. Through the windows in the library staff room, she saw the lives of her schoolmates and watched families celebrating the Jewish holidays, "all of a tradition . . . alien to myself, completely alien, but I watched." Observing the young Leopold Stokowski conducting an oratorio, she recalled seeing only the beauty of his hands. She watched the people who rode the horse-drawn crosstown cars with her, in the darkness under the elevated train, and on spring days she walked in Central Park, watching the new leaves coming out. She saw the beauty of the sun setting over the wash lines in the Hackensack Meadows and became aware that she had an ability to see things in ways that others could not.[5]

Dorothea hated Wadleigh, the uptown girl's high school, and though she was no longer in a minority, she could not recall having many close friends. Those she remembered most vividly were older people with qualities that impressed her. There was a nurse, for example, from whom she learned about self-denial and the serenity that can accompany it. There was the man who took her to hear Marlowe read Shakespeare and who wrote her three letters a day. From him she learned what it meant to be totally devoted. "The whole point of remembering these people," she said in the Riess interview, "is to try to find out what it is that forms you. It isn't, I think, so much things that happened to you, episodes, as it is persons that affect you. . . . They introduce you to different worlds, different kinds of existence with predominant qualities. . . . Those are the things, the combination of them are what forms you."[6]

Lange felt that she had, on some unconscious level, drawn on these early ex-

periences in her decision to become a photographer. Looking back, she was never sure that she had *not* been a photographer, even before she had made a single photograph. "I was a photographer, getting to be a photographer, wanting to be a photographer, or beginning—but some phase of photographer I've always been."[7]

After her high school graduation, Lange announced her decision. "I had no camera and I'd never made a picture," she said. Her mother tried to discourage her, saying that she should "have something to fall back on," an attitude Lange considered dangerous.[8] Despite her resolve, her mother and grandmother insisted that she become a teacher. Her family provided the money for her to go to the New York Training School for Teachers, which she attended briefly.

Her college education held little interest for her. "In those years," she said, "I got a camera and I spent every spare moment that I could, working in photographers' studios in New York." She was willing to learn from any photographer who would take the time to teach her the skills she needed; most of them were typical photographers of the period, earning a living turning out conventional portraits of wealthy families and people of the stage. Many of them Lange later described as "lovable old hacks . . . unimportant people from anyone else's point of view."[9] Nevertheless, she felt indebted to them for the opportunities they had given her.

One of these teachers was an itinerant photographer who came to the door of her mother's house with a load of samples under his arm. When Lange learned that he had no place to work, she helped him convert their abandoned chicken coop and learned how to build a darkroom in the process. The man had traveled around Europe, peddling his range of portraits, from glossy postcard-size with deckled edges to large tinted portraits. He taught her many techniques that were old-fashioned even then.

She worked for about six months for a man named Aram Kazanjian, an Armenian who had a large studio where she learned some of the practical aspects of running a portrait business. Kazanjian had a profitable operation that gained customers largely through telephone solicitation. Lange was hired as "one of a battery of telephone girls." She said a typical phone call would begin, "Good morning, Mrs. DuPont, this is the Kazanjian Studios calling. Mr. Kazanjian is *so* interested in making a portrait of you and your son together, and we will be in Baltimore Saturday morning, and is there any possibility if you have time over the . . ."[10]

Lange also did printing and retouching for Kazanjian and remembered retouching a photograph of a wealthy woman surrounded by her grandchildren. On her lap the matriarch held an open telephone book which Lange retouched, turning it into the family Bible. At Kazanjian's, she said, she "learned the trade."

The portrait photographer had to know how to pose the model. Lange learned this from Clarence H. Davis, who had a studio above a saloon and specialized in portraits of opera singers and people of fashion. He posed them seated in front of an elaborate background, surrounded by grandiose carved furniture, and wearing tulle and heavy drapes. The process could take as long as two hours. "The head is placed and then you hold it, and then each finger is positioned. The fingers were very important to him, and he said, 'the knees are the eyes of the body,' so your knees and your fingers and your head, were all posed and then he would induce the atmosphere, and then he'd photograph. . . . He used to love to put on the gramophone, records from the opera." [11]

Not all portrait studios were owned by photographers. Some owners hired different people to do each part of the work—printing, retouching, and even operating the cameras. It was while working in the Fifth Avenue studio of a Mrs. A. Spencer-Beatty that Lange learned to be an "operator." Spencer-Beatty's camera operator had quit, her business was in critical financial straits, and she had a three-hundred- or four-hundred-dollar commission to fulfill. Out of sheer desperation, she sent Lange with "a great big 8x10 camera" to take photographs of the Irving Brokaw family. Lange was "scared to death . . . not of the people, but that I wouldn't be able to do the pictures that would be acceptable to them—hardboiled pictures, really formal, conventional portrait groups." She found, however, that she had learned more than how to operate a camera. "I had enough insight, you see, by that time, to know how professionals behaved on these jobs and what people wanted and didn't want, what was acceptable, what was the commercial product." [12] She succeeded and was sent out on other assignments. She did most of the work on weekends and was paid about twelve dollars a week.

During this four-year period, Lange was also learning about photographers who were struggling to have their work recognized as an art form and were shunning the conventions that had confined photography to formulaic composition with interchangeable subjects. Edward Steichen, Gertrude Käsebier, and Clarence H. White were among the fifty photographers who eventually joined the group that called itself the Photo-Secession, dedicated to a style of photography that went beyond mechanical record. [13] Alfred Stieglitz established the

group and, while organizing its first show in 1902, coined the name from the practice in Europe of calling artists who split off from an established tradition "secessionists."[14] Robert Doty, of the George Eastman House, describes their work: "Technique, once mastered, became unimportant, and the result had to be more than just an image on paper. Composition, massing of light and shade, correct rendition of tonal qualities, arrangement of lines, development of curves, were the means. With them they sought values, texture, character, any aspect which would appeal to the emotions of the viewer. Gradually there emerged a style which depended upon the relation of light and color, the softening of sharp lines, and particularly the suppression of details to obtain an impression. This was called 'pictorial effect.'"[15]

Stieglitz published the journal *Camera Work* and opened the Photo-Secession Gallery on Fifth Avenue in New York, which exhibited contemporary art done in various media. In 1910 the secessionists held a major photography exhibition at the Albright Gallery in Buffalo, a modern museum well suited to such a revolutionary exhibition. The photographs, which were widely acclaimed, revealed a developing schism within the Photo-Secession. Sadakichi Hartmann, a noted critic who published frequent articles in *Camera Work*, described the pictorial photographers as being divided into two camps: those who favored "painter-like subjects and treatment" and those who favored "the standards of true *photographic themes and textures*."[16] The word *pictorial* gradually came to be associated only with the type of work done by the former group, which used and reused trite allegorical themes and techniques mimicking a style of painting that had slipped into decadence decades earlier. Thus the word soon acquired its present connotation of vapid, stilted, and worn-out.[17]

Meanwhile, the new realism evident in the Buffalo exhibition was growing. The New York *Times* commented on this trend in a review of a 1912 exhibition that included the work of Alvin Langdon Coburn, Käsebier, and White: "The advocates of pure or 'straight' photography feel that by manipulating the print you lose the purity of tone which belongs especially to the photographic medium in trying to get effects that can be more satisfactorily obtained with the painter's brush."[18] Once photography began to be accepted as an art form in its own right, more photographers felt free to explore the unique ability of their medium to combine aesthetic considerations with a true-to-life record of the world around them. It was this combination, if not the Photo-Secession move-

ment per se, that created a seedbed for the development of what was to be known two decades later as documentary photography.

The last issue of *Camera Work*, in June, 1917, was devoted to the work of Paul Strand, a young photographer who later made a deep impression on Lange. Strand's portfolio included stark photographs of New York City street life as well as photographs revealing the beauty in abstract patterns of contrasting forms. In an accompanying statement, he wrote: "Objectivity is the very essence of photography, its contribution and at the same time its limitation. . . . The photographer's problem is to see clearly the limitations and at the same time the potential qualities of his medium, for it is here that honesty, no less than intensity of vision, is the prerequisite of living expression."[19] These words foreshadow an approach to photography that Lange came to admire and, to a great extent, adopt in her own work.

As a college student she had not considered whether photography was art. "I knew that some people made pretenses at this," she said, "and I knew that there were some photographs which were in that classification, but I just looked for ways of doing it very well indeed. . . . But to be an Artist was something that to me was unimportant and I really didn't know what it meant." She attended Clarence White's classes at Columbia during the year that *Camera Work* drew to a close. By that time she had seen his photographs, and his name was well known to her. "Here was a kind of a young-old man who had a very separate quality and the importance of him to me is that I discovered a very extraordinary teacher. Why he was extraordinary has puzzled me ever since, because he didn't do anything. He was an inarticulate man, almost dumb. . . . [But] the man was a good teacher, a great teacher, and I can still occasionally think, 'I wish he were around. I'd like to show him this.'" She could barely remember what he taught her about the camera: "I don't think he mentioned technique once, how it's done, or shortcuts, or photographic manipulations. It was to him a natural instrument and I suppose he approached it something like a musical instrument which you do the best you can with when it's in your hands."[20]

Some of White's students became well-known photographers, yet, Lange said, "I don't know people whose work looks like Clarence White's which, of course, is a great recommendation to him as a teacher, validates what I said, that a student's work didn't look like his. But . . . he had an uncanny gift of touching people's lives, and they didn't forget it."[21]

Arnold Genthe was in many ways on the opposite end of the spectrum from the Photo-Secession. He had made photographs in Chinatown at the turn of the century and took his camera into the San Francisco streets after the 1906 earthquake, documenting the destruction and confusion. Although his documentary photographs are his best-known work, he was primarily a studio portrait photographer, famous for his portraits of women.

Genthe had moved his studio to New York when Lange went to work for him as a receptionist. She also made some of his proofs, spotted and mounted pictures, and learned retouching. She remembered him vividly:

Arnold Genthe was an unconscionable old goat in that he seduced everyone who came in the place. Yes, he was a real roué, a real roué. But what I found out when I worked for him was that this man was very properly a photographer of women because he really loved them. I found out something there: that you can photograph what you are really involved with. Now this seduction of women was only part. He wasn't at all a vulgar man; he loved women. He understood them. He could make the plainest woman an illuminated woman. I watched him do it. . . . He was in love with the kind of life he lived, he was in love with himself as a human, and his effect on other people. He was a creative person. He did the first color photography I ever saw and he loved color as he loved women, the same kind of color. Nothing hard, analytical, nothing disciplined in that man.[22]

When he hired Lange, probably in late 1913 or 1914, Genthe had already done his best and most famous work, and he was using a very limited technique developed years before. "He worked under a certain battery of lights, certain very controlled conditions. . . . He was there working within a good commercial formula and making a lot of money."[23] Nevertheless, he was able to awaken in Lange a sensitivity to beauty that did not conflict harshly with the attitudes she picked up in White's seminar.

Four years after announcing her decision to become a photographer, Lange thought she had the skills she needed to support herself. She had gained some knowledge of how to operate a studio, solicit customers, manage the finances, and relate to her subjects in a professional manner. And she understood that a genuine appreciation for her subjects would be reflected in her photographs. She began to make "modest photographs of people," mostly family and friends. Just before leaving New York, she spent the winter of 1917–1918 photographing children. "I didn't have a place of business," she said. "I got myself a big camera; I got myself two lenses. And I worked day and night. Day and night. I have had periods when I have worked, really worked. That was one of them."[24]

By 1918, Lange was ready to leave home: "I wanted to go away as far as I could go. Not that I was bitterly unhappy at home, or where I was, or doing what I was doing. But it was really a matter of testing yourself out." She wanted to go around the world traveling with Florence Ahlstrom, a close friend from her high school days. Fronsie, as Lange called her friend, worked as a Western Union clerk, and the two young women were convinced they could make their way around the world working at their respective trades, Lange photographing people along the way. They set out that January.

Leaving New York, Lange felt as if she were drawing a curtain on her past; indeed, no record survives of her earliest photographic efforts. Her family moved several times, and when she returned to New York after an eight-year absence, she found that her mother had destroyed the boxes of photographs she had left behind.[25]

Lange remembered the quality of her early work as being very uneven. Yet, she said, "I did have, by that time, a camera, an assurance that wherever I wanted to go, I could probably earn my living. . . . I had an uncertain technique, but an outlook. I knew that I would never develop a commercial product like Clarence H. Davis, that I had my own to make, and I was pretty sure that I was working in a direction. I don't know just what that direction was; I don't know to this day, quite. I had launched myself in a scrappy, choppy, unorthodox way, but I don't know a better way, if you could go through it than that."[26]

Chapter II

From the Studio
to the Street

The first part of their trip around the world brought Dorothea Lange and Florence Ahlstrom to San Francisco. They had traveled by boat to New Orleans and then taken trains to California, stopping off to visit friends and people they met along the way. Lange remembered this as a time when everything seemed to work out all right, when friends were made rapidly, and when personal attachments quickly multiplied.[1]

They had planned to stop and work in San Francisco before continuing the trip, but all their money was stolen the morning after they arrived, and the need to find work became immediate. Lange went through the telephone book, looking up places that did photofinishing. "I didn't want to get a studio job," she said. "I wanted to sense the life of the city. So I got a job in a store in San Francisco, at 712 Market Street." At the store, Marsh Photo-Supply House, her job was taking in the developing and printing, selling as many enlargements as she could, and, when time permitted, framing.[2] Over the counter she met many of the people whose lives were to be closest to hers, among them the photographer Imogen Cunningham and her husband, printmaker Roi Partridge. Lange also joined a camera club, not because it held promise for her career, but because she wanted use of a darkroom. Through the club, she made many lifelong friends.[3]

Several months later, through the help of a friend, Lange borrowed three thousand dollars to open a portrait studio. She chose an old Sutter Street building, which she shared with a small gallery that sold prints and etchings. Her business flourished and the studio became the center of her life. By five o'clock every afternoon the place was full of people, sitting on the black velvet couch and gathered around the fireplace. Lange was in and out because she usually had work to do in the darkroom downstairs.[4]

One evening she noticed "some very peculiar sharp clicking footsteps" overhead. She later learned they belonged to Maynard Dixon, who was fond of wearing finely tooled cowboy boots.[5] Dixon, well known for his paintings of western landscapes and Indians, was a popular figure on the San Francisco art scene. His Bohemian life and sense of humor were reflected in many of the sketches and caricatures he made for friends.[6] When Lange met him, he was forty-five, twenty years her senior, and working as one of a group of artists designing billboards for the large advertising firm, Foster and Kleiser. They were married six months later, in the spring of 1920. The Sunday evening ceremony was held in Lange's studio, with Florence Ahlstrom serving as maid of honor and Roi Partridge as best man.[7] Their marriage did not significantly alter the patterns of their lives. Dixon continued to make extended trips to the Southwest, where he made sketches for his paintings and kept up his friendships with cowhands and Indians, and the studio remained the center of Lange's work and the place where their friends gathered. In particular, Cunningham and Partridge visited frequently and became close family friends.

Lange characterized her clients as "the San Francisco merchant princes." "People who came into that building and bought original etchings and original prints were the kind of people who, if your work had any quality, would notice it." She described them as from "large families who knew each other, and had a very strong community sense and that warm, responsive love for many things —children and education and buildings and pictures, music, philanthropy."[8]

Few of Lange's clients were famous in the conventional sense. She was not interested in making the kind of publicity portrait or official portrait for businessmen, politicians, and entertainers that has become the basis of many photographers' work and reputations. Her photographs commemorated some occasion in people's lives. "They were intimate things, for family."[9] Occasionally, Lange took commissions to photograph people in their own homes, not an unusual practice in those days. An example is the portrait of Adele Raas, which

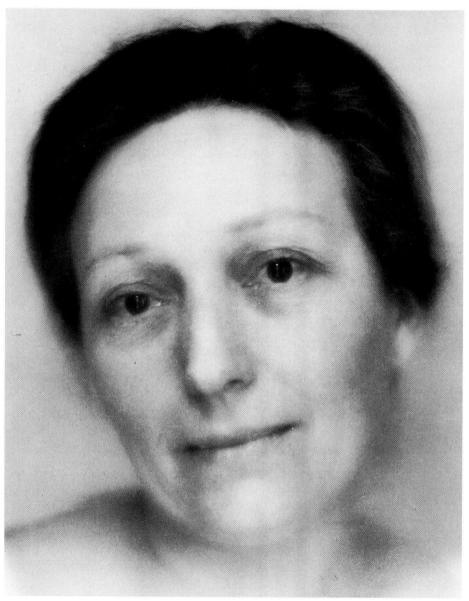

1. Adele Raas, San Francisco, ca. 1920, by Dorothea Lange.
Oakland Museum

Lange made in about 1920. In the mid-twenties, Lange moved her studio to Montgomery Street. She worked out of two buildings along that street at different times, but her clientele did not change significantly.

In making photographs, Lange saw herself as providing a service for her subjects rather than expressing her personal notion of the sitter's character. She described her work modestly: "I didn't do anything phenomenal. I wasn't trying to. I wasn't trying to be a great photographer. I never have: I was a photographer and I did everything that I could to make it as good as I could. And good meant to me being useful, filling a need, really pleasing the people for whom I was working. By that I don't mean pandering to their vanity, but sincerely trying to give them what they wanted. . . . [M]y personal interpretation was second to the need of the other fellow." [10] Lange saw this approach as different from that of many other photographers, including portrait photographers.

Imogen Cunningham provides a comparison. Like Lange, she had decided as a girl that she wanted to pursue a career in photography. She had been strongly influenced by the work of Gertrude Käsebier, a member of the Photo-Secession and a contemporary of Clarence White. Before marrying and moving to San Francisco, Cunningham had run a successful portrait studio in Seattle. The photograph of Elizabeth Champney, author of *Vassar Girls Abroad*, is representative of the commercial portraiture Cunningham did in that studio. The direct and thoughtful elegance of this portrait contrasts with the intimacy expressed in Lange's photograph of Adele Raas.

In addition to her portraiture, Cunningham had worked with allegorical themes—"September Morn stuff," as she called it. [11] This more romantic approach gradually infused her portraits. After her move to San Francisco, Cunningham, unlike Lange, sought out artist friends as her subjects and did less commercial portraiture. The series Cunningham made of photographers Edward Weston and Margrethe Mather in 1923 illustrates her attempt to reveal her subjects' inner qualities. She did not dwell on the value that photographs had for her subjects, but instead placed more emphasis on her interpretation of their character. "I'm very inclined to like people when they go into themselves, but they seldom like that themselves as an expression of themselves. 'Oh, you've got me looking too gloomy,' they say, or 'too pensive.' Well, I like it." [12] Lange, on the other hand, tried to show the character of her subjects in ways acceptable to them, hoping they would cherish the portraits as family mementos.

Despite these different intentions, both photographers worked in ways that

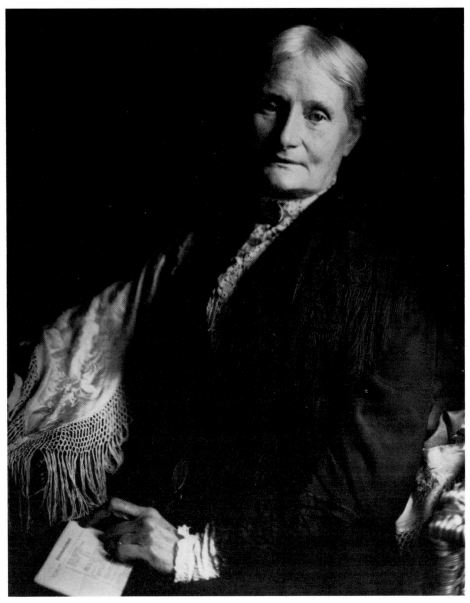

2. Mrs. Elizabeth Champney, Writer, 1910, by Imogen Cunningham.
The Imogen Cunningham Trust, San Francisco

put their subjects at ease. Both were dynamic conversationalists who used their quick wit to cultivate the personal association necessary to all good portraiture. They wanted their subjects to look natural and thus refused to use the conventional props and theatrical lighting employed by many photographers of the day. Lange even tried to convince her subjects to be photographed in their old, simple clothes. Not concerned with fashion, she strove for a timeless quality and excluded all background cues from her portraits. As she later said, "I really and sincerely tried with every person I photographed, to reveal them as closely as I could." [13]

Lange and Cunningham put less emphasis on the equipment they used than did many other photographers. Each considered a large format camera with a good lens to be sufficient for giving them the technical quality they desired. They both preferred long exposures, believing that a brief shutter opening could distort their subjects by catching them in uncharacteristic poses.

The similarities between Lange's and Cunningham's training and ways of working with subjects were not so influential on their work as were their photographic goals; hence, their photographs from the 1920s look quite different. Cunningham's portraits, of which many more are available, usually include a context, some evidence of the person's occupation or environment. When she photographed subjects together, as in the case of Weston and Mather, the context of the relationship was present. Although quite willing to crop her photographs, Cunningham seldom cut out all cues of time or place. Her subjects look introspective, as though they have forgotten the presence of the camera. They were engaged with themselves at the moment of the portrait, and the viewer senses that he or she is being exposed to a private moment in their lives.

Lange's photographs are more confined than Cunningham's. Often excluding all but the head and shoulders of her subjects, Lange concentrated on the face, especially the eyes, as in her portrait of Adele Raas. The photographs she made of family groups tend to be less formal than was customary during the 1920s. They are characterized by the soft natural light that she loved to use, and family members are often tenderly touching each other. A tinge of shyness and the near-smiles on the faces of many of the children Lange photographed suggest a quality of cooperation with the photographer, quite unlike the introspection Cunningham liked to cultivate in her subjects. The Clayburgh children's self-conscious awareness of being photographed is typical of the intimacy created in many of Lange's portraits, an intimacy that explicitly includes the viewer and is

3. Edward Weston and Margrethe Mather 2, 1923, by Imogen Cunningham. The Imogen Cunningham Trust, San Francisco

4. Clayburgh Children, San Francisco, 1924, by Dorothea Lange. Oakland Museum

thus appropriate to a photograph made for a family circle. Unlike Cunningham, she did not think of her work as appropriate for museum walls or gallery exhibition. She considered herself a vehicle for her subjects.

Although marriage to Maynard Dixon did not immediately alter Lange's professional career, her life and work began to change as the years passed. The couple had two sons—Daniel Rhodes Dixon was born in 1925, and John Eaglefeather Dixon was born three years later.[14] In addition, they took major responsibility for raising Constance, Dixon's daughter by a previous marriage.

Increasingly, Lange saw her portrait business as being important to the financial security of her family. She said Dixon always thought the family was on the brink of poverty. They both believed the studio income freed him to pursue his painting. Lange said, "I was never quite sure enough of what our livelihood would be, and I wanted to—this sounds as though I'm putting a very good light on my own motives, but as I look back it's true—I wanted to help him. See, I helped him the wrong way; I helped by protecting him from economic difficulties, where I should have helped him in other ways."[15]

Occasionally Lange accompanied Dixon on his sketching trips to the Southwest, and she spent six months with him in Taos, New Mexico, during the winter of 1930–1931. She recalled seeing in Taos "this very sober, serious man driving with a purpose down the road." She wondered who he was, thinking he must be an artist, and learned that he was Paul Strand, a photographer whose work she had seen. "It was the first time I had observed a person in my own trade who took his work that way," she said. "He had private purposes that he was pursuing, and he was so methodical and so intent on it that he looked neither to the right nor left. He went down that road and he came back at night. . . . I didn't until then *really know* about photographers who went off for themselves. All the photographers I'd known always were with a lot of other people, but somehow this was a lone man, a solitary."[16]

That winter her time was mostly occupied with caring for the children and helping her husband: "I have to hesitate before I say that I was too busy. Maybe I kept myself too busy. But that thing that Paul Strand was able to do, I wasn't able to do. Women rarely can, unless they're not living a woman's life. I don't know whether I was temperamentally sufficiently mature at that time to have done it. At any rate, I didn't have the chance. I photographed once in a while when I could, but just a little."[17]

After the birth of her sons, she photographed them and made two albums of

5. My Sons in the Mountains, 1924, by Imogen Cunningham.
The Imogen Cunningham Trust, San Francisco

6. Soquel Creek, 1930, by Dorothea Lange.
Oakland Museum

family photographs for her mother.[18] These photographs are similar to those Cunningham made of her family at that time. Both women were combining soft romantic technique that appeared in the early work of the Photo-Secession with the mood of family snapshots. For example, Cunningham's 1924 photograph "My Sons in the Mountains" is remarkably like a series Lange did of her family vacationing with their friends the Lovetts. Louise Lovett had hired Lange to make a portrait of her around 1919, and the two women became good friends. Joanne Lovett Lathrop recalled Lange photographing the two families: "Our families were together just part of that summer at Soquel, California, near Santa Cruz in 1930. The Dixons, Maynard, Dorothea, Danny, and baby John, camped in a grove of cottonwood trees near a lovely stream on the farm of Louise's parents. . . . As I remember the pictures—they weren't consigned or planned as an album—they perhaps happened much as you or I would take snapshots today."[19] Some of them were mounted in an album similar to those Lange had made for her mother.[20] In making these albums, Lange was carrying out the same service she provided for her clients. She valued these intimate documents for their significance to herself and her family.

Despite the importance of her studio business and the rewards of rearing a family, by the late 1920s Lange felt a need to broaden her work. Possibly influenced by Cunningham, she tried photographing plants, in some ways a good alternative to portraiture, since she loved their forms and they were easily available to her. Cunningham had become interested in plants as photographic subjects when her children were small, and she had exhibited some of this work in Stuttgart in 1929 as part of an exhibition of trends in realistic photography. Lange's plant photographs were not so successful. During the summer of 1932, she spent some time on a friend's mountain estate. "I tried to photograph the young pine trees there and I tried to photograph some stumps, and I tried to photograph in the late afternoon the way the sunlight comes through some big-leaved plants with a horrible name, skunk cabbage, with big pale leaves and the afternoon sun showing all the veins. I tried to photograph those things because I like them. But I just couldn't do it."[21] She thought the photographs were terrible and apparently destroyed them.

Lange's growing dissatisfaction with commercial portraiture led her to do a great deal of thinking about her work, particularly during the occasional vacations the family took. Late in the summer of 1929, while attempting some landscape photography in the mountains, she went off by herself one afternoon and

was caught in a violent thunderstorm. As she later explained to her son Dan, "When it broke, there I was sitting on a big rock—and right in the middle of it, with the thunder bursting and the wind whistling, it came to me that what I had to do was take pictures and concentrate upon people, only people, all kinds of people, people who paid me and people who didn't."[22] She decided that when she returned to San Francisco, "I would only photograph the people that my life touched. I discovered that that was my area. Difficult as it was, I could freely move in that area, whereas I was not free when I was trying to photograph those things which were not mine."[23] Following that experience, the modest folders she had printed each year to publicize her Montgomery Street studio announced PICTURES OF PEOPLE—DOROTHEA LANGE PHOTOGRAPHER.

It is clear that by the time of the stock market crash, Lange's attitudes toward her photographs were undergoing substantial changes, and she felt a need to do work of a more serious nature. Having sensed in Strand a stronger dedication to work than she had, she wanted to go on to a kind of photography that would demand a greater personal commitment. Of her portrait business, she said: "I could have gone on with it, and enlarged it, and had a fairly secure living, a small personal business, had I not realized that it wasn't really what I wanted, not *really*. I had proven to myself I could do it, and I enjoyed every portrait that I made in an individual way. . . . I wanted to work on a broader basis. . . . I was still sort of aware that there was a very large world out there that I had entered not too well."[24]

Meanwhile, the Depression deepened, Lange's and Dixon's financial situation became less secure, and to make ends meet, they had to change their life-style. They closed down their house and moved into their studios, half a block apart on Montgomery Street. The boys, who were then four and seven, were enrolled in a boarding school. This arrangement was less expensive than running a house and two studios, and Lange and Dixon thought their work should take priority over home life. However, the decision was extremely difficult for Lange. She had worked hard to provide a secure life for her husband and children, and this separation recalled the pain of her own childhood, when her father had abandoned the family.

But the strain had its positive side; it drove Lange's work into new areas. She felt the world outside her studio offered a "bigger canvas," and she turned to it, in part to ease the pain of separation from her sons. "I worked then as I would not have done, I am sure, if I had gone back to my habitual life. There in my studio on

Montgomery Street, I was surrounded by evidences of the Depression."[25] The abrupt change in her life enabled her to accept the challenge she saw outside her studio. "If the boys hadn't been taken from me by circumstances, I might have said to myself, 'I *would* do this, but I can't because . . .' as many women say to themselves over and over again, which is one reason why men have the advantage. I was driven by the fact that I was under personal turmoil to do something."[26]

Her studio was at a crossroads where she could see growing numbers of unemployed men going by. One morning, as she stood at her south window watching a solio proof image come up on the paper, a person in the street caught her eye. "I watched an unemployed young workman coming up the street. He came to the corner, stopped, and stood there a little while. Behind him were the waterfront and the wholesale districts; to his left was the financial district; ahead was Chinatown and the Halls of Justice; to his right were the flophouses and the Barbary Coast. What was he to do? Which way was he to go?"[27] The contrast between that scene outside her window and the image on her solio proof helped her resolve her own dilemma. "I knew that if my interests in people were valid I would not only be doing what was in those printing frames." She had to begin to try to capture on film what she had seen happening outside.[28]

Lange could not simply close her studio and begin photographing people in the streets. Because these new subjects broke existing conventions of photography, she could not count on their being accepted. To support the new work, commissioned portraits would have to continue, though she knew that simultaneously pursuing two such different types of photography would put a strain on her.[29]

An alternative would have been to join with friends who were working to gain recognition for what is now known as straight photography. A group of photographers, including Cunningham, Weston, Ansel Adams, Willard Van Dyke, and a few others, had been meeting to discuss their ideas about unmanipulated, detailed images. Group f.64, as they called themselves, has been hailed as "the most progressive photographic society in the country" of that period, and in later years some people remembered Lange as having been a member.[30] Although she discussed her work with the group, she did not exhibit her work with theirs and was apparently unwilling to accept the technical constraints they placed on their work.

In addition, she believed that her new work would have to fill a social need, as she felt her portraits did. As she later explained, "All my life, I have never been

able to resist . . . seeing the other fellow's needs before my own. If that sounds as if I am giving myself a compliment, I intend it opposite. I tried very hard all my life to make a place where I would be, where what I did would count, aside from just pleasing myself, a place for it, where it would stay."[31] The problem of finding a direction for her work had consumed Lange for months. Finally, early in 1933, she made the first steps toward creating a new career for herself.

Near Lange's studio a woman who was called the White Angel had set up a breadline. "I looked down [at the line] as long as I could," Lange said, "and then one day I said to myself, 'I'd better make this happen.'"[32] She borrowed some film magazines from a friend, loaded her 3¼ x 4¼ Graflex and went down to photograph the breadline.[33] She approached a man in worn clothes who was leaning against a wooden barrier. He was looking down at his folded hands, holding a tin cup between his arms. Behind him, with their backs to him, stood a line of better dressed men, the crisp, stylish lines of their hats marking them as newly unemployed. Lange felt curious about the crowd, not because she was in any personal danger, but because she thought someone might try to grab her camera. For that reason she took her brother, Martin, along for protection.[34] Thirty years later, when asked what she had felt about the scene before her, Lange replied: "I can only say I knew I was looking at something. You know there are moments such as these when time stands still and all you do is hold your breath and hope it will wait for you. And you just hope you will have enough time to get it organized in a fraction of a second on that tiny piece of sensitive film. Sometimes you have an inner sense that you have encompassed the thing generally. You know then that you are not taking anything away from anyone, their privacy, their dignity, their wholeness."[35]

She made two photographs of the man, from different angles and distances. He didn't look up. She made several other photographs of the breadline and the men eating their lunch, then went back to her studio and developed the film. She returned the film magazines to her friend, not noticing one of the shots was still inside. The next day her friend discovered the shot, developed it, and brought it to her. It was a photograph of the man with the tin cup.[36] She made a print of it, and studied it. "I had struggled along for months and months with this material," she later said, "but I saw something, and I encompassed it, and I had it." She put it on the wall of her studio, curious to see what her customers' reactions would be. Most of them just glanced at it or asked, "What are you going to do with this sort of thing?" Not knowing that "this sort of thing" was to occupy the next twenty years of her life, she could not answer the question.[37]

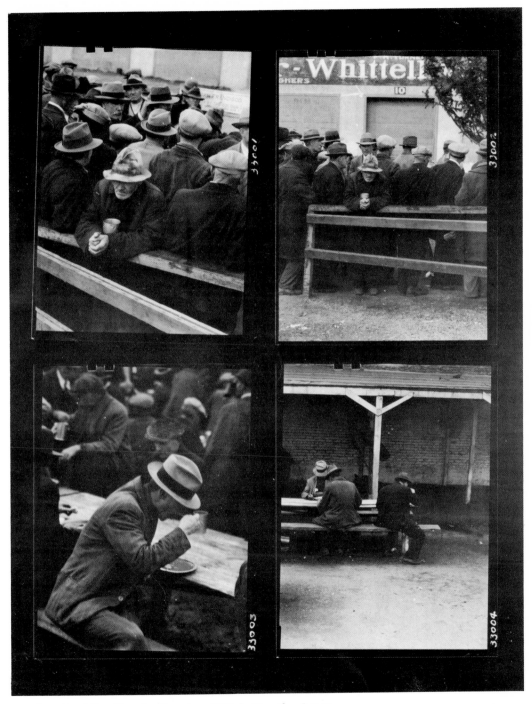

7. White Angel Breadline, San Francisco, 1933, by Dorothea Lange.
Oakland Museum

Chapter III

Documentary Expression in the Thirties

The awareness that the nation was deep in an economic depression was slow in coming. As farm prices fell, government officials continued to make optimistic predictions about the brevity of the "slump."[1] By 1932, farmers' gross incomes were less than half what they had been a decade earlier, with wheat down to $.30 a bushel, from $2.94 in 1920. Beef was selling for $5.78 per hundredweight, compared with $14.95 the previous decade, and cotton was selling for $.07 a pound. The parity index—the ratio of farmers' incomes to their costs—was at an all-time low of forty-nine before stories began appearing in the national press calling attention to the severity of the problems.[2]

Lange, drawn from her studio by scenes of unemployed men in the streets, was not alone in her efforts to document the effects of the Depression. Unknown to her, a widespread movement had begun among artists, authors, social scientists, and journalists, to reveal the impact of the vast economic and social changes in the lives of the American people. New forms of documentary expression emerged, cutting across traditional divisions between different media. Painters were hired by the government to design huge murals for the walls of banks and public buildings; the Federal Theatre Project produced plays called *The Living*

Newspapers; authors collected folk narratives and life histories as part of the Federal Writers' Project; movie houses that showed only newsreels and short documentary subjects attracted large audiences; ballets were choreographed to incorporate traditional folk dances and readings from historical documents; a whole new genre of news magazines arose, devoted to photojournalism; social scientists moved from survey research to community studies based on participant observation; and within universities the study of national life and culture became formalized, as American studies programs began.[3] The rise of the "documentary imagination" drew attention to American people, values, and cultural currents previously overlooked or undervalued in the nation as a whole.

The federal government was undoubtedly the largest patron of the arts. Although there were fluctuations in the administration's support of artists, the amount of money poured into painting and sculpture by Works Progress Administration, $46 million in 1936–1937 alone, was unprecedented.[4] Influenced in part by the mural art of Mexican revolutionary painters, American artists painted murals on the walls of public buildings across the country, depicting both the positive and oppressive impact of industrial progress on the population. In 1932, the Museum of Modern Art exhibited examples of mural art showing aspects of the postwar world; a selection of photomurals was part of the exhibition.[5] The Photographic Division of the Federal Arts Project sponsored, among others, Berenice Abbott, who had returned from France to document a "changing New York."[6] Painters, graphic artists, and photographers were also hired by the Federal Arts Project to collect and catalog examples of American folk art.[7]

Independent filmmakers in the United States broke away from the pattern of Hollywood productions and, following the lead of British and Russian documentary film, presented real situations in which the participants themselves were the actors. Within the Resettlement Administration, a documentary film unit was formed. Pare Lorentz, its chief member, made several films about the transformation of the American land. *The Plow That Broke the Plains* (1936) was filmed in part by Paul Strand, who had been influential in the Photo-Secession's movement toward realistic photography; and *The River* (1937) included scenes shot by Willard Van Dyke, founding member of Group f.64. Members of the Resettlement Administration also contributed to documentary films made by other government agencies. Influenced by the documentary example, John Ford came out with a film version of John Steinbeck's *The Grapes of Wrath*.[8]

During the early years of the Depression, the press had ignored the problems

the country was facing. Public opinion polls in the late 1930s indicated that almost one out of three adults doubted the honesty of the press. "In no other decade," according to William Stott, "was the American press so out of step with its audience." The strongest evidence for this is the anti-Roosevelt editorial stance of the press in the 1936 election campaign, when Franklin Roosevelt was overwhelmingly reelected.[9] This was the period of radio's flowering, a fact that may account for part of the gap between the press and the public. Radio had become the more credible medium, breaking down what Archibald MacLeish called "the superstition of distance" through its ability to convince an audience that events occurring far away were real and related to their everyday lives.[10]

Radio soap operas began in the thirties and brought the audience in touch with people who, although imaginary, were portrayed as ordinary citizens like themselves, making them seem true to life. Other kinds of radio dramas also gained immediate popularity; the Federal Writer's Project financed the production of many plays presenting themes drawn from the social chaos of the times.

Some portions of the press also picked up on these social themes; radical journals like the *New Masses* proliferated and gained a large constituency. The *New Masses* occasionally included artists' work, depicting both workers and unemployed people on relief. Other journals, including the *New Yorker*, began to imitate the layout style and the social satire of *New Masses*.[11] More significant than the visual impact of these journals, however, were the new literary forms contained in their pages. Journalists and commentators like Edmund Wilson, who wrote for the *New Republic*, and John Spivak, who for a time had the reputation of being America's greatest reporter, used various techniques of three-dimensional reporting to vividly describe events.[12] Often called "reportage," a term adopted from Europe and the Soviet Union, their writing relied on description and concrete evidence from the lives of ordinary people to portray the severity of the times.

Nonfiction literature flourished in the thirties and took many forms in the press, in the popularized writing of social scientists and social workers, and in books that often combined photographs with documentary text. Personal narratives appeared in virtually all the general magazines of the day and in a range of books. Some of these narratives, or "life histories" of average citizens, were gathered by authors working for the Federal Writers' Project and published as collections.[13] Social workers and sociologists rewrote their case histories for the general public.[14] Journalists also adopted these forms, incorporating long

conversations with their sources into their writing and sometimes publishing "worker narratives" verbatim, as *New Masses*, *Harper's*, *Atlantic Monthly*, and *New Republic* often did.[15] More and more authors wrote in the first person, describing their personal reactions to events so that readers could experience them as if through their own eyes.[16]

Through the influence of British sociologists like Beatrice and Sydney Webb, field methods that relied less on survey research were developed within the social sciences. Participant observation began with the work of Robert Park and William Thomas and their students at the University of Chicago in the 1920s. These sociologists sought to discover natural social groupings; locating, understanding, and analyzing these groups required a certain amount of participation in the activities of the people they were studying.[17] During the 1930s, many of the classic community studies were done: the first of the "Yankee City" series, Robert and Helen Lynd's study of a New England mill town, John Dollard's study of the color bar in a southern town, and William Whyte's research on an Italian American gang in Boston. These are examples of research based on "pitching a tent among the dwellings of the natives," as early ethnographers had done.[18] Participant observation studies sometimes necessitated masking one's identity as a social scientist; Thomas Minehan, for example, lived as a tramp for two years, doing research for his dissertation, *Boy and Girl Tramps of America*.[19] Even research that relied on traditional methods of interviews and surveys often incorporated the subjects' accounts verbatim in the findings.[20] The audience for many of these studies included the general public as well as other social scientists. This broader interest in social science received further encouragement from journals like *Survey Graphic*, whose editor, Paul Kellogg, printed many articles and photographs dealing with contemporary social issues.

Much of the writing of the thirties represented, as Alfred Kazin has noted, "the reflex patriotism and hungry traditionalism of a culture fighting for its life," especially as the war in Europe grew closer. The expression of the 1930s was more deeply marked by a search for the roots of the nation's failure and by attempts to bring to light the heroic aspects of those confronting that failure. Within documentary expression, "stocked away like a reserve against bad times, is the raw stuff of the contemporary mass record." It was a record of "grim awareness rather than of great comprehension" of the forces that gripped the nation. "In this respect," Kazin argues, "none of the devices the documentary and travel reporters used is so significant as their reliance on the camera." The

camera functioned for many writers as a symbol of their attempt to avoid illu-
sion. The act of reporting unfolding events was generally viewed as noninterpre-
tive, in the sense that it was believed possible to record in words, as with the
camera, the objective reality of what had taken place. And because the search
for "objective realism" was so prevalent, a fascination "with the camera *as an
idea*" emerged.[21]

The reverence for the camera as an instrument for recording "things as they are"
went back to the time of its invention, when it was feared that photography
would mean the end of representational painting. Photography did nearly
supplant painting in the area of portraiture, as studios sprouted up in the mid-
nineteenth century to provide people with personal documents of the way they
wanted to appear to their family and friends. However, the idea of using the
camera to photograph social conditions did not come into its own until the
1930s.

During the Civil War, Mathew Brady, believing that "the camera is the eye of
history," had put aside his efforts to assemble a photographic "Gallery of Illus-
trious Americans" and organized a team of photographers to document army life
and the destruction the war brought to the South.[22] In England, there had been
several examples of photographic documentation of poor people living in the
streets of London; a social science survey in 1851 had been illustrated by wood
engravings from daguerreotypes, and twenty-five years later a collaboration be-
tween a photographer and a journalist resulted in *Street Life of London*.[23] How-
ever, these British documents appear to have remained unknown to American
photographers until after the Depression. More influential was the work of
Eugène Atget, a Parisian who photographed the people and places of his beloved
city as the vestiges of the nineteenth century were rapidly disappearing. Atget's
work was rescued from obscurity and brought to the United States by Berenice
Abbott during the 1930s.[24]

One of the earliest photographers to document social conditions in this coun-
try was Jacob Riis, a journalist who photographed in the slums of New York
beginning in the 1880s. A Danish immigrant, Riis knew the conditions he pho-
tographed from firsthand experience. Reproduction techniques had not yet been
developed for printing photographs in newspapers, but line drawings of Riis's
photographs appeared in the New York *Sun*. Riis's book, *How the Other Half
Lives*, included poor reproductions and drawings from his photographs.[25] His

work played a part in alleviating slum conditions but then faded into obscurity until 1947, when his negatives were recovered and reprinted.[26]

Arnold Genthe's photographs of San Francisco's Chinatown and of the earthquake and fire which devastated that city in 1906 are another example of early social documentation with a camera. However, as mentioned above, Genthe was primarily a portrait photographer; his documentary photography was a minor part of his career and appears to have had little influence either on his young apprentice Lange or on other photographers in the decades that followed.

A photographer who appears to have had a greater influence on the documentary photography of the 1930s was Lewis Hine, who recorded the flow of European immigrants through Ellis Island.[27] Hine was a sociologist who had worked for the National Child Labor Committee, photographing young children working in cotton mills and in the streets. His photographs, used as illustrations in the pamphlets he wrote, are considered instrumental in the passage of laws limiting child labor. Following World War I, Hine was hired by the Red Cross to photograph their relief activities in Europe. From 1908 on, his work had appeared in *McClure's* and *Everybody's* and in the liberal-reformist social work journal *Charities and Commons*. This journal became *Survey*, and its supplement, *Survey Graphic*, appeared in the 1930s. A few of Hine's photographs were published in *Survey Graphic* during that decade. He photographed the construction of the Empire State Building in 1931 but in general had difficulty finding outlets for his work. He tried to get a job working on the photography team of the Farm Security Administration. Roy Stryker, who directed that project, respected Hine's work and had used his photographs to illustrate an economics textbook he had written; but apparently he thought Hine's best work was behind him. He gave Hine leads on other positions but was not willing to hire him.[28]

The work of Group f.64 and of some members of the Photo-Secession deserves mention here. Although this work lacked the social commitment that marked documentary photography during the 1930s, it paved the way for a new respect for photographs of "reality," quite distinct from those which imitated painting styles and subjects.

There were few precedents for the kind of photography Lange had begun and, with the possible exception of Lewis Hine, none from whom she could have learned the method she was to develop—weaving words and photographs to create documents that would encourage social change. Initially, the potential of using the camera as an instrument for interpreting social conditions and

encouraging social change had little impact on the way photography was regarded by intellectuals and the general public during the Depression. People were getting used to the fact that cameras could show them things from different points of view, revealing relationships that the human eye alone would not ordinarily see.[29] Yet these different points of view were generally thought to be the result of mechanical manipulations, not of the photographer's interpretations of what took place in front of the camera.

Eventually, the dual phenomenon of the public's growing sophistication about possibilities within the photographic medium and the general and persistent belief in photography's objectivity paved the way for the use of photography as a medium for news. At the beginning of the decade, few newspapers had photographers on their staffs, and photographs appeared infrequently in the press. The exception was the sensational "jazz" press, which used photographs, often highly manipulated, for emotional impact. Prime examples can be seen in the excesses of the New York tabloid newspapers, especially the *Illustrated Daily News*, first published in 1919, and the *Daily Mirror* and the *Daily Graphic*, both of which began publishing in 1924. The fear that photography would lower press standards by sensationalizing the events—a common attitude among editors in the 1920s and early 1930s—gave rise to a heated discussion at the 1935 Associated Press Managing Editors convention, where it was suggested that the next convention be devoted largely to a discussion of proposals for a wirephoto service for AP member newspapers. The suggestion was accepted, and the next convention aroused "a new consciousness of the value and necessity of pictures in American newspapers."[30] By the end of the Depression, photographs had become an essential part of presenting the news. The wire services carried photographs to their subscribers; most newspapers had hired photographers; and in a large number of general circulation magazines that had emerged, news was shaped entirely around photographs.

Picture pages had not been uncommon in newspapers and had appeared with varying frequency from the early 1900s. The first issue of *McClure's*, in 1893, included a feature entitled "Human Document," consisting of photographs from the lives of famous men. In 1914, the New York *Times* issued the *Midweek Pictorial*, a war extra that was continued after the war as a rotogravure weekly with thirty-two pages of regular news photographs.[31] For the most part, these and other early attempts at news photography were not integrated with verbal

reports. The photographs were given brief captions and grouped together on a separate page within the publication. They were neither edited nor combined to present a visual narrative. Instead, they were placed on the page according to size, convenience, and sheer visual impact of content. Thus, a frivolous, cute photograph was often placed quite boldly alongside a smaller photograph of a significant political event.

During the Depression these patterns changed, as new styles of photography and photo-editing emerged. The trend away from isolated sensational or trivial images in some segments of the press was influenced by the German example.[32] Picture magazines, including *Berliner Illustrierte Zeitung* and *Münchner Illustrierte Presse*, gained popularity in the 1920s, and by the early thirties a large number of German magazines were devoted to picture essays of current events. The small hand-held cameras used by German photographers were eminently suitable for candid photographs of rapidly changing scenes in which available light was used, and photographers like Felix Man and Erich Salomon were using the new cameras to create coherent chronicles of important events of the day. Under the guidance of these photographers and picture editors such as Stefan Lorant, the photo essay emerged as a new form, a series of images photographed and laid out to tell a continuous story about a person or event.[33] In the 1930s, some of these people emigrated from Germany to England, where they had a role in establishing similar publications. Lorant moved to London in 1934 and became editor of the *Weekly Illustrated*, with Felix Man as one of his chief collaborators. Several of the European photojournalists served as consultants during the prepublication plans for *Life*, and many, including Alfred Eisenstaedt and Martin Munkacsi, moved to the United States and joined the staffs of newly formed picture magazines.[34]

Other publications also had an impact on the American mass-circulation picture magazines. *Fortune* and *Vanity Fair*, catering to a select audience who could afford expensive publications, used photographs extensively. In addition to articles on Hollywood movie stars and Hawaiian vacations, their pages included photo essays on business and transportation, foreign politics, and other topics of varying relevance to the American social and economic scene. Newspapers had begun to publish Sunday supplements devoted largely to news photography. Even *Time* magazine had been experimenting with photojournalism, using photographs to complement some of its articles.

Publishers were aware of the growing popularity of photography. A 1925 Gal-

lup survey had revealed high readership interest in photographs per se and an even greater interest in related photographs that told a story.[35] However, the necessary capital for starting new magazines was not available, and the technology had not yet been developed for printing large runs on high quality paper. The invention of faster-drying inks, machine-coated paper that was lightweight and cheap, and heat-set printing processes that prevented the ink from smearing— all occurred in the mid-thirties, as each publisher vied to be the first to come out with a popularly priced picture magazine.[36]

Life was the first to succeed, hitting the newsstands in November, 1936, with a front-page story on Montana boom towns, photographed by Margaret Bourke-White. It began with a circulation of 380,000, and by the following August it had acquired a readership of ten million and a circulation of 1,200,000.[37] *Look* magazine followed in January, 1937, as a direct outgrowth of the Des Moines *Register and Tribune's* Sunday syndicated picture magazine. By August, *Look* cleared a circulation of over 1,300,000.[38] *Life* and *Look* were followed by a range of imitators—*Foto, Click, Peek, Pic, Scoop*—which never enjoyed the circulation of the larger magazines and died out quickly.[39] The popularity of *Life* and *Look* was paralleled by a growth in newspaper photojournalism, and pages of picture essays were regularly featured in newspapers by the end of the decade.

The history of photography in the press had shown that scenes of war, crime, and other morbid or gruesome events brought increased circulation. In 1937, Henry Luce, the publisher of *Time* and *Life* stated:

> The photograph . . . is the most important instrument of journalism which has been developed since the printing press. It is also the least understood. Even today, the photograph is associated almost entirely with sensational journalism. There is a modicum of obvious truth in that conception but in my opinion, there is far more error than truth. And thus the photograph, far from being the degradation of journalism as a conventional literary high-brow or as an unexperimental theorist would naturally think, turns out to be an extraordinary instrument for correcting that really inherent evil in journalism which is its unbalance between the good news and the bad.[40]

The most significant feature of photojournalism in the thirties was its emphasis on the lives of average people. Parallel to the trend in virtually all other forms of expression, the picture press had recognized that photo essays showing where ordinary people worked, how they lived, how their lives were affected by problems of unemployment, and how they were coping with success and failure could attract a general audience.

This trend did not bring an end to the use of "superficial, tawdry, salacious, morbid or silly" photographs "in such numbers and in such confusion as to form a totally indigestible mental meal." As Robert Taft pointed out in 1938: "Many times the publisher's only principle of selection appears to be, '*Any* photograph is better than no photograph.' . . . So extensive have these abuses been in the past that the mention of the term 'photograph' in journalism has come to mean *sensational* journalism."[41] Even today, leading editors and publishers have, in many cases, continued to exploit the emotions of their readers, apparently with no greater goal in mind than high readership. Nevertheless, by 1936, good examples of photojournalism were being published, and some channels had been established for the documentary photographer who wanted to reach a wider audience with his or her visual story of "things as they are."

The forces, both internal and external, that turned Lange toward social documentation were to place her in the center of the trends in documentary expression during the thirties. Between 1935 and 1940, her work was to reflect the widespread movement to integrate art, literature, journalism, and social science into documentary forms having social significance as their primary purpose. Photography was to be singled out by government agencies and the press as a medium eminently suitable for drawing attention to social problems and creating an atmosphere for social change, and Lange was to become a central figure in this major endeavor.

Lange never liked the term *documentary* to describe her work; *document* seemed too cold for the kind of empathetic record she tried to create. For years, she and her friend Beaumont Newhall searched for a more suitable term. They rejected *historical photography* because of its connotation with the remote past; *factual* was inappropriate, for it did not suggest "that magical power in a fine photograph that makes people look at it again and again and find new truths with each looking." They never found a term that satisfied them, and the kind of photography they respected and encouraged throughout their lives has continued to be called documentary.[42]

The characteristics by which documentary photography came to be recognized as a particular style by Lange, Newhall, Stryker, and others, are not all exclusive to the photographers whose work is called documentary; nor did all these photographers steadfastly adhere to a clearly defined style. The cluster of characteristics defining the documentary style incorporates all aspects of the

making and use of photographs. Although not rigid, these characteristics serve as referents for comparing photographers working within and on the fringes of the evolving documentary tradition—a tradition that includes aspects of journalism, art, education, sociology, and history.

Primarily, documentary photography was thought of as having a goal beyond the production of a fine print. The photographer's goal was to bring the attention of an audience to the subject of his or her work and, in many cases, to pave the way for social change. George Elliott has said that "documentary photography, like realism in fiction, is a servant art: it aims to create in the viewer the naive illusion, 'that's what things are really like.'"[43] Lange and other documentary photographers of the thirties wanted to reveal their subjects in ways that would convince their audience that they were being shown reality. The purpose of documentary photographers' work tended to take precedence over the technical constraints. No single procedure, type of camera, or film was used, and technical excellence was a subsidiary goal. Most documentary photographers, however, were also technical purists. Since their photographs were to present their subjects realistically, technical intervention and manipulation were kept to an absolute minimum. They usually printed on glossy paper, to heighten the direct quality of their photographs.

The technical contraints Lange and others placed on their work were not as crucial as their own relationships with the people or scene they were photographing. Actively interpreting the world necessarily required an active involvement with it. Like the new social scientists, they were participant observers who did not consider their participation to be in conflict with their deep respect for a factual record. The photographers' knowledge of the subject was usually based partly on research done prior to making the photograph.

Documentary photographs were seldom presented without text; photographers and editors recognized that words could add force and concreteness to the images. Sometimes captions that contrasted with the photographs' content were added, creating dialectical relationships between the verbal and visual messages. Extended captions were also used and often included facts and figures relevant to the subject of the photograph, direct quotations from the people in the photograph, and quotations from others who were familiar with the subject.

Another device was to present more than one photograph at a time, as in the German photo essay form. Showing different aspects of the same scene could enhance the audience's understanding of the subject. Conversely, photographs

taken in different times and places were often shown together as a series, to illustrate relationships among diverse people, places, or events. Constructing an effective series or picture story often required planning in advance and careful editing once the photographs were in hand.

Like the authors and reporters who were gathering personal narratives and life histories, Lange and other documentary photographers thought of themselves as creating a record, complete as they could make it, of the world as it was. From this record the citizens of the future could learn, not only what the nation had been like, but also how to avoid making the same mistakes in their own time. Because documentary photographers believed their work to have historical significance, they felt a deep sense of moral responsibility to their subjects and to future generations, as well as to their contemporary audience.

In 1940, Lange wrote a clear synthesis of her views of the scope of documentary photography and the contributions she felt it could make to understanding ourselves and our culture:

Documentary photography records the social scene of our time. It mirrors the present and documents for the future. Its focus is man in his relation to mankind. It records his customs at work, at war, at play, or his round of activities through twenty-four hours of the day, the cycle of the seasons, or the span of a life. It portrays his institutions—family, church, government, political organizations, social clubs, labor unions. It shows not merely their facades, but seeks to reveal the manner in which they function, absorb the life, hold the loyalty, and influence the behavior of human beings. It is concerned with methods of work and the dependence of workmen on each other and on their employers. It is pre-eminently suited to build a record of change. Advancing technology raises standards of living, creates unemployment, changes the face of cities and of the agricultural landscape. The evidence of these trends—the simultaneous existence of past, present, and portent of the future—is conspicuous in old and new forms, old and new customs, on every hand. Documentary photography stands on its own merits and has validity by itself. A single photographic print may be "news," a "portrait," "art," or "documentary"— any of these, all of them, or none. Among the tools of social science—graphs, statistics, maps, and text—documentation by photograph now is assuming place. Documentary photography invites and needs participation by amateurs as well as by professionals. Only through the interested work of amateurs who choose themes and follow them can documentation by the camera of our age and our complex society be intimate, pervasive, and adequate.[44]

Chapter IV

Toward the
Farm Security
Administration

During 1934, Lange began to take more time from her portrait business to photograph breadlines, men sleeping outside unemployment offices and in city parks, May Day demonstrations, and longshoremen striking for higher wages. Using her ability to go unnoticed, she did not attempt to hide her camera as she moved among these people.[1] She had no idea how she would use the photographs. They cost her time and loss of business, and she believed that she was simply getting something "out of her system."[2] These initial efforts, however, were leading up to a project that would clearly establish her as a major figure in the documentation of the Depression.

Van Dyke was impressed with the new photographs Lange was making, and he wrote an article about her work in which he accurately described her as "not preoccupied with the philosophy behind the present conflict, she is making a record of it through the faces of the individuals most sensitive to it or most concerned in it." However, when he states that she approached events with "no attempt at personal interpretation of the individual or situation" and without any particular political viewpoint—"her mind like an unexposed film"—he ignores the influence of Lange's previous experience.[3] The people along New York's Bowery, where she had walked as a little girl, had made a strong impres-

8. General Strike, San Francisco, 1934, by Dorothea Lange.
Oakland Museum

sion on her; and the men walking the San Francisco streets in search of work may have recalled her early memories of how people look when they are down and out, often through no fault of their own. Lange's political sympathies lay with the people who were demonstrating for higher wages and government subsidies, and she later said, had it not been for Maynard Dixon's cautious attitudes toward left-wing politics, she would have become more actively involved in the demonstrations.[4] Nevertheless, Van Dyke's description of her approach and method is accurate; she went out, uncertain of what she would find, as an observer exploring the rising tension with her camera.

Van Dyke arranged for an exhibit of Lange's photographs at his Oakland studio, the first opportunity people outside her own circle of acquaintances had to see her new work. Paul Taylor, an associate professor of economics at the University of California at Berkeley, saw the exhibit. In 1927, when he was studying Mexican labor, he had taken a postcard-size Kodak camera to the field and became convinced that photography could play an important role in social science investigation: "No amount or quality of words could alone convey the situation that I was studying."[5] He saw photography as "another language," increasingly important to his work.[6] Taylor had just completed an article on the 1934 San Francisco general strike when he saw Lange's exhibit, and he selected one of her photographs, of a Communist orator, as the frontispiece for the article.[7]

In January, 1935, Taylor began working as field director of the Rural Rehabilitation Division of the newly formed State Emergency Relief Administration. A national census had revealed that about 12 percent of the population was dependent to some extent on public relief funds, and the Federal Emergency Relief Administration had been established to distribute funds to the states for "rehabilitation" of these persons by providing them with the means to sustain themselves through their own efforts.[8] Taylor was studying a group of unemployed people who, as part of the Unemployed Exchange Association, had formed a self-help cooperative. They operated an old sawmill in Oroville, California, trading lumber for needed goods and services.[9] Van Dyke was interested in social applications of documentary photography, and at his request, Taylor asked the members of the cooperative if he could bring in a group of photographers to document the project. The people agreed, and Van Dyke arranged for several photographers to accompany Taylor to the project. The group included the anthropologist Preston Holder and three photographers: Imogen

9. "Workers Unite," San Francisco, 1934, by Dorothea Lange.
Oakland Museum

Cunningham, Mary Jeanette Edwards, and Dorothea Lange. This was the first time Taylor and Lange met.[10]

Lange remembered the community as being "very sad and dreary and doomed." There was little to eat besides "old carrots and turnips," she said, and "not enough oil to run the engine, not enough shingles for the roof, not enough of anything excepting courage on the part of a few."[11] The dream that the sawmill could ever support them she described as heartbreaking, more painful because the members did not see how small their chances for success were.

Taylor arranged for an exhibit on the Berkeley campus that included work the photographers had done at the cooperative, and Lange signed the fourteen prints of hers that were exhibited there.[12] In retrospect, however, she was dissatisfied with the photographs she made at the sawmill. She had wanted to help the members by making photographs that would arouse others' interest in the cooperative, but her attempt at an optimistic portrayal had gotten in the way of making "a real document, a real record."

However, photographing the cooperative had given her an insight that was to affect the rest of her work. It was the first time she had seen how a social scientist worked in the field:

I remember Paul sitting there in their community house—an abandoned sawmill, so it had that atmosphere—interviewing and speaking to these people. I had never heard a social scientist conduct an interview. I knew about people going and asking questions and filling in questionnaires, but an interview I had never heard. And I was very interested in the way in which he got the broad answers to questions without people really realizing how much they were telling him. Everybody else went to bed while he was still sitting there in that cold miserable place talking with these people.[13]

In the next few months she was to have an opportunity to learn much more about how he performed field work.

Taylor began investigating the living conditions of the thousands of migrants who flooded into California from the Midwest and Southwest following the dust storms of April, 1934. His job was to recommend a program suitable for helping the migrants, and he wanted Lange to photograph the conditions. There was no job category for a photographer, and Taylor could not convince those who controlled his budget of the necessity of including photographs in his report. Lange was put on the payroll on a one-month trial basis because the office manager, Lawrence Hewes, Jr. agreed to hire her officially as a "typist," and allowed her to procure photographic materials by calling them "office supplies."[14]

10. Unemployed Exchange Association, Oroville, California, 1934, by Dorothea Lange.
Oakland Museum

With this dubious approval, Lange accompanied Taylor and his team of assistants on two field trips. The first was to Nipomo, California, in February, 1935, to investigate the migrants who were harvesting the pea crop, and the second was into the Imperial Valley. The group found families living in tattered tents or in shelters they had constructed out of brush, without access to water or sanitary facilities. Many of them were ill or undernourished, and most of them were without work or were employed irregularly in the fields, earning less than a dollar a day. Lange remembered being shocked at the attitudes of the other field assistants, who called the people in the camps "informants" and ordered $1.75 meals in a hotel. One exception was a Mexican woman who went off by herself to interview other Mexican women in the camps. "She didn't speak of 'informants,'" Lange said. "I think what she came out with was life histories."[15]

Taylor remembered being solicitous toward Lange on the first trip, telling her not to intrude her camera too quickly: "If you don't take a single picture the first day, that's all right with me." He recalled how effectively she established relationships with the members of the cooperative, talking with them and photographing them almost immediately.[16] The people she had previously photographed in the city had been silent, Lange said later, "and we never spoke to each other. But in the migrant camps there were always talkers. This was very helpful to me, and I think it was helpful to them. It gave us a chance to meet on common ground—something a photographer like myself must find if he's going to do good work."[17] Their conversations, in addition to establishing rapport, provided the migrants' interpretations of their situation, which were at least as expressive as the facts, figures, and photographs that went into the official reports. Taylor appreciated this and included many of the conversational fragments in articles he wrote about the camps. A man leaning against his car had told Lange, "This life is simplicity, boiled down." A pregnant young mother, poring over a map, had asked, "Where is Tranquility, California?" People described the life they had left behind: "We got blowed out in Oklahoma," and, "It seems like God has forsaken us back there in Arkansas."[18]

Lange learned on these trips what it meant to be a social observer. She had moved from masking people's environments in the earlier studio portraits and photographing people within the world of the San Francisco streets to realizing that a photograph alone was not capable of revealing the fabric of a person's life. Her subjects' words and the statistics and verbal information provided by others could weave additional meaning into her photographs. Other photographers had

11. "Where is Tranquility, California?" by Dorothea Lange, April 17, 1935.
Library of Congress

already combined words and photographs to create social documents. Lewis Hine's studies for the National Child Labor Committee in the early 1900s and Jacob Riis's photographs of people in the New York slums were two examples. Lange, however, was not aware of their work at the time and felt she had discovered a new photographic method. "The impulse I had didn't stem from anyone else," she said.[19]

Lange also developed a goal for her work. She and Taylor gathered information and made photographs in order to effect change. They were not seeking a general audience, however; their reports were designed to convince officials in the State Emergency Relief Administration to appropriate funds for the establishment of camps for the migrants.[20] Taylor has said that Lange took the initiative in assembling these reports—laying out and captioning the photographs, and binding. Dixon helped with the lettering and drew a map of California for each one.[21]

Their work was successful; the reports resulted in the first twenty thousand dollars needed to establish the camps. They also succeeded in attracting attention from the press. During the summer of 1935 and the following spring, the San Francisco *News* carried articles and editorials on the pea pickers, illustrated with photographs by Lange.[22] When the first camp was dedicated in October, 1935, at Marysville, California, the Sacramento *Bee* carried photographs and an article on the front page. The article stated that among the people who attended the dedication were "Dr. Paul S. Taylor, who has spent several months in camp surveys . . . and Miss Dorothea Lange, official photographer."[23]

By that time, Lange had closed her studio and was devoting most of her energies to this new work. Some photographs Taylor made of her show that her appearance had adapted to the rigors of fieldwork. Her hair was shorter and her body more angular. Foregoing a fashionable appearance that would have increased her social distance from the people she photographed, she preferred to wear pants or other clothing that would give her freedom of movement.

That winter, Lange and Taylor were married. "It was not altogether easy," he said, for family situations involving children from both marriages had to be faced. "There were two divorces, mine and hers," Taylor said. "There was cooperation in both respects. Both Maynard and my first wife went through the processes in Nevada. When Dorothea and I went to Albuquerque in early December, we were married there. On the afternoon of that same day she went out and photographed. And our work went on from there, together."[24] Both of them had been hired by the newly formed Resettlement Administration to continue and

12. Dorothea Lange, 1934, by Paul S. Taylor.
Oakland Museum

expand their work on migrant labor in California. They moved into a house near the Berkeley campus, where Lange's two boys and Taylor's son joined them.

The Resettlement Administration, established in 1935 by executive order, drew together several government agencies, including the Rural Rehabilitation Division of the Federal Emergency Relief Administration, which had previously employed Lange and Taylor. President Roosevelt appointed Rexford Tugwell, undersecretary of agriculture and formerly a Columbia University economics professor, to administer the agency. Tugwell was a close adviser to the president, a member of Roosevelt's brain trust, and one of the more radical members of the administration. In his new and powerful position, Tugwell was responsible for administering a nationwide rural land-use program, overseeing the resettlement of low-income families and the construction of model communities for them to live in, and developing a program of rehabilitation grants and loans for small farmers. Some of these programs were radical social experiments, unlike anything the federal government had undertaken before. Yet they also drew on several philosophical currents that were important aspects of the American cultural tradition: the deep-rooted agrarian reverence for the land, particularly the nineteenth-century back-to-the-land movement, and the pattern of communist and celibate communities that played a significant role in American development.[25]

The Resettlement Administration's philosophy and programs, often socialistic and based on government support of the poor, antagonized the expanding agricultural corporations. Anticipating considerable hostility toward the new agency from many powerful sources, Tugwell quickly established a program of public information. The Information Division was designed to convince the public of the necessity for taking unusual steps to relieve problems of rural poverty and to demonstrate how the agency was carrying out its programs. Various sections within the Information Division were responsible for writing news releases and bulletins; providing special information and articles to syndicates and periodicals; making films and radio programs, often of a dramatic nature; and developing a file of photographs to document thoroughly the agency's areas of concern.[26]

Despite numerous criticisms that the Information Division served primarily as Tugwell's personal press agency, it remained a dynamic part of the Resettlement Administration throughout the brief and somewhat chaotic history of that

organization.[27] In 1937, Resettlement was moved into the Department of Agriculture and renamed the Farm Security Administration (FSA). Despite Tugwell's subsequent resignation and other changes in the FSA, its Information Division adapted and continued to inform the country about agricultural problems and government efforts toward solutions.[28]

The Historical Section, created to photograph the agency's programs and the changing patterns of rural America, was the most influential arm of the Information Division. Its visual reports reached virtually every corner of the country and continue to define our perceptions of life during the Depression.[29] Roy Stryker, hired as director of the Historical Section in the summer of 1935, was a former teaching colleague of Tugwell's from Columbia University. He had been using photographs in his economics classes for years, and he and Tugwell had coauthored an economics text, richly illustrated with photographs, including many by Lewis Hine.[30] Stryker made no pretense to being a photographer. In fact, he considered his lack of photographic expertise an asset, because subscribing to a "particular school of photographic thought," as he put it, would have conditioned his perspective on his new job.[31] Although he respected cameras as powerful tools of record for social science and history, he had few preconceived notions about the making of photographs that could be valuable contributions to such a record.[32]

For several weeks after arriving in Washington, Stryker was unsure of what direction the Historical Section should take. He hired his former student, Arthur Rothstein, as the first staff photographer and assigned him to photograph everything that might prove to have historical value, from the scraps of paper that crossed Stryker's desk to the improvements being made in the Resettlement Administration staff offices. Neither Rothstein nor Stryker made any attempt in those first weeks to distinguish between the significant and the trivial.[33]

Among the items that came across Stryker's desk were the reports Lange and Taylor had done on the migrant workers' situations in California. He was impressed by their work and regarded it as a prototype for what the Historical Section could do. Because he liked the quality of Lange's photographs, he hired her in August, 1935. Her work set a standard and a style for the photographic file.[34]

The Resettlement Administration was not the only or even the first federal agency to use photography. In his study of government publicity, James

McCamy found that the Resettlement Administration followed the same pattern as other agencies: "Sometimes the publicity agent visited rotogravure editors or news service managers with a portfolio of pictures on share-croppers, drought refugees, migrant workers, or Resettlement communities."[35] What made the Historical Section unusual were the kinds of photographs it distributed, the sheer number of photographs made, and the variety of channels used to get them before the public. By 1942, Stryker and his staff had amassed over 270,000 photographs made in all regions of the country. Hundreds of these were published in newspapers, magazines, government pamphlets, and books; they were exhibited at schools and libraries, department stores, museums, and professional conventions; they were presented as evidence on the floor of the Senate.[36]

McCamy found that most government publicity offices offered unimaginative straight news photographs that conformed to the "standard practices of a press that shows a paucity of originality." The photographs showed "equipment, projects and persons in connection with some event that makes news, as the editors judge news." In contrast, the Resettlement Administration photographs not only showed commonplace scenes of land and people in ways that were often dramatic, yet accurate, but also showed aesthetic as well as personal consideration for the subjects. Moreover, Stryker used the new form of the photo essay. He encouraged the photographers to take part in editing their work into the photo essay form, and he distributed the photographs in series.[37]

The Resettlement photographers developed special talents. They became journalists who knew how to use their cameras to communicate with a large audience; nevertheless, they operated outside the usual definition of news photography. Stryker thought it significant that the FSA file contained only one photograph of Roosevelt, "the most newsworthy man of the era—this, mind you, in a collection that's sometimes said to have reported the feel and smell and taste of the thirties more vividly than the news media."[38] The photographers did not think of their work as the creation of art objects; according to Stryker, they used "the intuitive, spontaneous approach, not the studied artistic approach."[39] Their work, however, often appeared on the walls of art museums and galleries. They were thoroughly informed about the topics they photographed, and they went to the field with sufficient background knowledge to enable them to distinguish what was relevant. In this sense they were social scientists, documenting the character of people and their relationship to a changing environment. In

the broadest sense Stryker expected the photographers to be "historians of the present," gathering evidence for a record of human experience.[40]

Eleven photographers served on Stryker's staff and left their individual marks on the FSA file. Many worked with the agency for only a few months. Sometimes there were only two photographers on the staff and never more than four or five working at one time. Their pay scale ranged from $2,300 to $3,200 per year, plus travel costs and supplies, certainly sufficient income during the Depression years, but their positions were less than secure. Occasionally photographers were paid for selected negatives only; in 1937, Lange received three dollars per selected negative plus the cost of her travel and supplies. Many, including Walker Evans, left the agency because of budget cuts or personal disagreements with Stryker. Others went to higher paying jobs in the news media, where they tried to apply their methods and attitudes to the picture magazines. Carl Mydans left in 1936 to join the *Life* staff, and Arthur Rothstein became a staff photographer for *Look* in 1940.

In addition to the lack of continuity on the staff, there were periodic financial setbacks, criticism from Congress and from other government agencies, and attacks from the press, which were often aimed directly at Stryker's team, the most visible segment of a controversial organization. Also, Stryker did not fit the image of an efficient administrator overseeing a tightly run cohesive group of photographers. In later years he referred to the accumulation of over a quarter of a million negatives at a cost of nearly one million dollars as a "bureaucratic miracle."[41] And, as he reminded an old friend: "This was *not* a preconceived, well-planned project. The FSA photo project was like Topsy—it grew. We were a group learning and maturing, and I had my share of learning and maturing to do too. . . . *Never, never* forget it was a group project. First, we were the favored children, allowed to have our fun in the background while our elders (the FSA administrators) fought the battles of Congress and the budgets. We arrived in the right spot at the right time. Some people call it luck. Sure we worked—sure we delivered. But above all *we grew into our project.*"[42]

The reputation FSA has gained as a landmark in the development of documentary photography often misleads people into believing that the members of the project had an unwavering sense of purpose from the beginning and worked closely together in planning and carrying out this vast photographic documentation. Lange later described her impressions as she walked into Stryker's office for the first time, during the summer after she began working for the FSA: "You

speak of organization; I didn't find any. You speak of work plans; I didn't find any. I didn't find any economics professor. I didn't find any of those things. I found a little office, tucked away, in a hot muggy summer, where nobody especially knew exactly what he was going to do or how he was going to do it. And this is no criticism, because you walked into an atmosphere of a very special kind of freedom."[43] It was this quality of freedom and the sense of responsibility shared by the staff—a responsibility to themselves as photographers, to the people they photographed, and to all those who would ever see their work—that enabled them to make photographs of lasting power.

Chapter V

Farm Security Administration Fieldwork

Despite Lange's formative role in the Resettlement Administration Historical Section she was, in many ways, marginal to the group. Unlike the other photographers, she was not based in Washington, D.C. "The center of my life was in California," she explained.[1] She and Taylor were establishing their newly formed family; and, as he described it: "In one sense it was peaceful, in another it was a very intense life that we were both living, trying to create a healthful situation involving children from two families. . . . We were building, in a human relations sense."[2]

Although Taylor usually did not accompany Lange on trips around California, during the summers they arranged to work together in the field. When he was hired by the Social Security Board to investigate farm labor conditions, they spent the summer of 1936 traveling through the South and West. Taylor's knowledge of economics and rural sociology influenced Lange's choice of subject matter. Her partnership in this team allowed Stryker to give her more autonomy than the other photographers in selecting general topics and deciding how she would photograph them. At Stryker's request, she was designated as a photographer-investigator. The other FSA photographers' titles were variously photographer, principal photographer, or photo-reporter.[3] Two of them, Arthur

Rothstein and Russell Lee, have been selected for comparison with Lange, in order to highlight the specific ways in which she was an unusual FSA photographer and to clarify the constraints of that job.

While he was at Columbia, Rothstein had majored in chemistry, worked on the college newspaper and yearbook, and organized a camera club. His photographs had done well in several New York salon exhibits. He was young and the world outside his native New York City was new to him when he was hired as the FSA's first photographer. However, his technical skill allowed him to renovate an old darkroom and hire a skilled staff, all within a few months and on a limited budget.[4]

Russell Lee worked on the FSA staff longer than any other photographer, and his photographs are often said to resemble Lange's.[5] He had been a successful chemical engineer before turning to painting. After several years of art school, he was still dissatisfied with his skill and bought a used 35mm. camera to aid his painting. He began to photograph auctions near his home in Woodstock, New York, and he also photographed seasonal floods and bootleg miners in Pennsylvania. After seeing an exhibit of Resettlement Administration photographs in 1936, Lee took a portfolio of his work to Washington to see if Stryker would hire him. Stryker liked the photographs and tried him out on an assignment photographing textile workers in a Resettlement project in Hightstown, New Jersey.[6] A few weeks later, when Carl Mydans left the Resettlement Administration to work for *Life*, Stryker called Lee and offered him the job.

Lee's and Rothstein's work often overlapped with Lange's; they photographed similar subjects, often in the same areas of the country. Although each of them has been recognized as a "good" FSA photographer, contrasts in their work can be accounted for by examining their preparations for field work, their methods of photography in the field, their treatment of their photographs, and their interpretations of each step in this process.[7]

As head of the Historical Section, Stryker coordinated the photographers' assignments, deciding what subjects should be covered and the photographers best able to handle each one. The photographers were not expected to follow his instructions exactly—he wanted them to develop themes and ideas as they went along—but he did insist that they have a solid background before entering the field.

When Lange was preparing for a trip, Stryker would write to her about specific

photographs he wanted her to take, would suggest reading and send her books, and occasionally would make a "shooting script" for the region where she would be working. In April, 1937, when Lange was planning a trip through the South to document farm tenancy problems, Stryker sent her Arthur Raper's book, *Preface to Peasantry*, and a list of things he wanted her to look for. The list ranged from the general, including "rural churches and schools, especially those which bring out the fact that the South has inadequate educational and religious facilities," to the specific, including the structural details of traditional housing and newspapers used as wallpaper.[8] Lee and Rothstein received similar instructions.

In the summer of 1937, while preparing for a trip through the South to document tenant problems, Lange wrote to Stryker: "My work on migratory labor has taught me the importance of adequate background when working on a large theme. It is not enough to photograph the obviously picturesque. The same is true of tenancy." She often requested additional information; for example, she asked Stryker to send her copies of speeches by Henry Wallace, the secretary of agriculture, to give her insight on his point of view concerning the problems of farm tenancy.[9]

Stryker sometimes requested specific photographs to complete or round out a set of photographs already in the file. In one instance, Stryker sent Lange a "script" for her California work, suggesting photographs of disease prevention measures and construction details of the government camps. At another time, he wrote her, "I still hope you will try for our railroad track stretching across the land into nowhere, if possible a lone roadside water tank; it might help the picture if the highway also followed along the track."[10] Similar requests, often for the same photograph, appeared in Stryker's letters to the other photographers. Although he spoke of the photographers as investigators exploring the American landscape, Stryker also had very definite ideas about what that panorama looked like.

Lange and Stryker carried on a constant dialogue through the mail about things she would look for on her trips and ways she could learn more about them; she made nearly as many suggestions as he did. Although Lee and Rothstein may have had a similar dialogue with Stryker in person, the tone of Lange's and Stryker's letters suggests a quality of mutual exchange not found in his correspondence with the other photographers.

Field work was physically difficult for Lange, and she often took another per-

son along to drive and help her with the equipment. Sometimes it was Taylor; other times it was Rondal Partridge, Imogen Cunningham's teenage son, or someone who knew the area, such as a county supervisor from the regional FSA office or a member of the local sharecroppers union. The other photographers took assistants along, too, usually someone familiar with the area. They were allotted four dollars a day for food and lodging—not much for two people, even during the Depression.[11]

Typically, Lange and her assistant drove down a road until she saw something she wanted to photograph. She would get out of the car and casually look around. Then she would quietly take out her camera. If she saw that people objected, she would put it away until they got used to her. Stryker said that of all the photographers who worked for the FSA, Lange "had the most sensitivity and the most rapport with people."[12] Even before meeting her, he saw in her photographs "the great feeling for human beings she had which was so valuable. She could go into a field and a man working there would look up, and he must have had some feeling that there was a wonderful woman, that she was going to be sympathetic, and this never failed to show in her work."[13] Lange's camera was of secondary importance in her relationships with her subjects. "One is a photographer second," she said.[14] "Now if they asked who you were, and they heard you were a representative of the government who was interested in their difficulties, it's a very different thing from going in and saying, 'I'm working for *Look* magazine, who wants to take pictures of you.' . . . The key in which it's written, like a musical sheet, is different."[15] She also said her lameness worked to her advantage in these situations: "People are kinder to you. It gets you off on a different level than if you go into a situation whole and secure. . . . My lameness as a child and my acceptance, finally, of my lameness, truly opened gates for me."[16]

Lange was never obsequious or apologetic. Partridge remembers her saying, "When you photograph, all you're doing is a job, and you're in control of your job and you have every right—*must* have every right in your mind—to make that photograph, and every reason." This belief was not inconsistent with her unobtrusive approach. "If you have every right and every reason behind you, the people will never notice you." She never forced herself on people but went around making photographs as if she belonged; and always she found people accepting and respecting what she was doing, for they saw her as a person who took her work seriously.[17] Her cloak of invisibility that she had adopted as a child also helped her work with people. Taylor said, "It made her feel that she could go up

and do things which otherwise seemed to be intruding on their privacy. It gave her a feeling of confidence in working with the camera."[18]

Often the person accompanying her would make her less obtrusive by talking with the people she wanted to photograph. Taylor said he would go up to people and begin a conversation, "and out of the corner of my eye, I would see that she had got out her camera, so I would just keep the talk going. I had their attention. . . . Keeping out of range [of the camera] generally wasn't a problem. She worked pretty close to them for the most part. If I thought I was interfering I would just sidle out of her way as inconspicuously as possible, talking to them all the time. My purpose was to make it a natural relationship, and take as much of their attention as I conveniently could, leaving her the maximum freedom to do what she wanted."[19] For example, in making a series of photographs in the home of an ex-slave living in the Texas brush country, Lange photographed while the man told Taylor about his childhood as a slave and about driving cattle over the old Chisholm Trail.[20] This approach is evident in a photograph Lange made of a plantation overseer and a group of field hands in Mississippi. On the left side of the frame, usually cropped out when the photograph is reproduced, Taylor can be seen talking to the men.

Rothstein used a similar technique when photographing in rural Arkansas. He said that a friend who knew the area well went up to the people Rothstein had chosen to photograph, while "with my Leica, I stood quietly and unobtrusively in the background. Gradually, my friend asked questions that probed deeply into the problems of these people. When they answered with anxiety or concern, completely unaware of the camera, I stepped forward and snapped pictures. . . . With the aid of my friend's skillfully directed conversations, I had controlled the action, expressions, and attitudes of my subjects. At the same time, a factual and true scene was presented"[21] In contrast, Lange did not necessarily wait for expressions of anxiety or concern. A comparison of her work with Rothstein's shows that she was more likely to photograph the naturally changing facial expressions of her subjects or the thoughtful pauses in their speech.

In encouraging her subjects to cooperate, Lange often treated the making of a photograph as a ritual event. If a person made an expressive statement about his or her life, Lange might have said, "I'm sure many other people have felt that very same thing. How wonderful it is that you have said it to me. We must have a photograph to remember this by."[22] Or while she was setting up her 4 x 5 Graflex, a group of fascinated children often gathered around to watch, and she

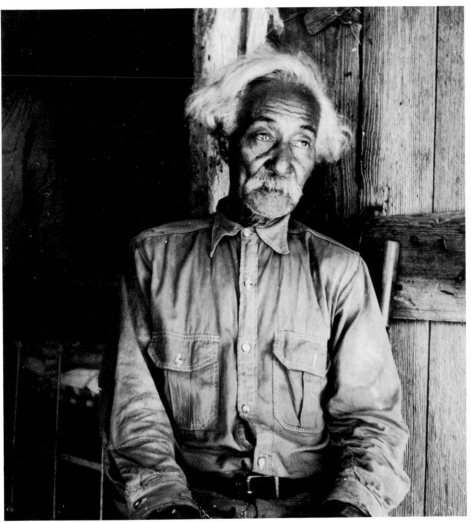

13–14. Bob Lemmon, Carrizo Springs, Texas, 1938, by Dorothea Lange. When asked what it was like to be a slave, he replied, "When it's midnight and it's raining and he say 'go'—you go." (13) Oakland Museum (14) Library of Congress, FSA Collection

15. Plantation Overseer and Field Hands, Mississippi Delta, 1936, by Dorothea Lange. Library of Congress, FSA Collection

would involve them in the event by photographing them with her Rolleiflex. She did not ask people to hold a pose or repeat an action, instead she might ask a question: "How much does that bag of cotton weigh?" And the man, wanting to give her a precise answer, would lift it onto the scales and Lange would make her photograph. She was always in complete control of the photographic situation, and her subjects cooperated.[23]

Rothstein was not averse to posing people. He suggested that controlling a situation—for example, by asking subjects to place more emphasis on particular actions—could, in some cases, heighten the impact of the photograph without sacrificing a "truthful and accurate representation." In a 1942 article, Rothstein described how he might have accomplished this, using his most famous FSA photograph, of an Oklahoma dust storm, as an example.[24] In fact, Rothstein has said that he did *not* pose the action in this particular photograph, despite editorial changes in the article which made it appear that he did.[25] His dedication to "honesty and truthfulness in photography" nevertheless appears to allow for the possibility of a more explicit posing of people than Lange at least admitted to in her work.

Lee was often interested in documenting each step of an activity, a practice that required the active cooperation of his subjects.[26] On his first assignment for the Historical Section, he made a series of photographs clearly showing, step-by-step, the work of men in a cooperative clothing factory in a Resettlement Administration community at Hightstown, New Jersey. Lee's concern for complete documentation may be related to his training in science; Stryker called him "the taxonomist with a camera."[27] On one occasion, Lee wrote to Stryker from Taos, New Mexico, that he had found an old woman "who went through all the motions of baking bread in an outdoor oven." "I got step-by-step procedures," he said, "and it is really fascinating."[28]

Stryker did not discourage the photographers from posing their subjects, especially when it meant getting a needed photograph. He wrote to Rothstein in Lincoln, Nebraska, that "the news people are running us ragged for such things as . . . Debt Adjustment Committee at work (even if staged)."[29] And he later wrote that the resulting photograph by Rothstein "was the best we have had." But, he added: "One criticism which was made by the 'experts' is that it looks a little bit too posed. However, I am not worrying very much about it. If you should be taking pictures of this sort of thing again, watch the detail of the people as they are posed. All four men have fountain pens in their hands poised

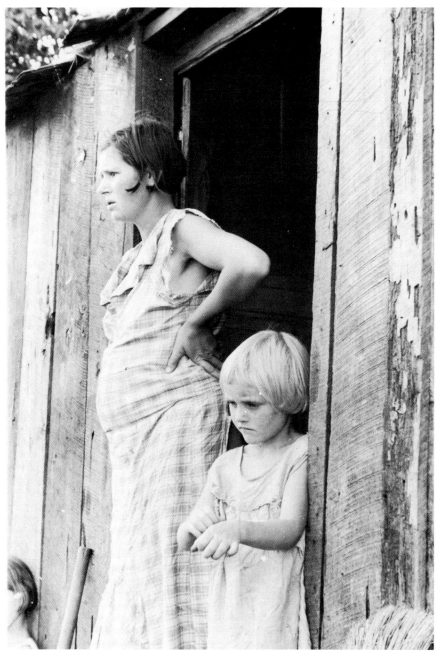

16. Sharecropper's Wife and Child, Arkansas, 1938, by Arthur Rothstein.
Library of Congress, FSA Collection

17. Dorothea Lange at Work, 1937, by Rondal Partridge.
Courtesy of Rondal Partridge

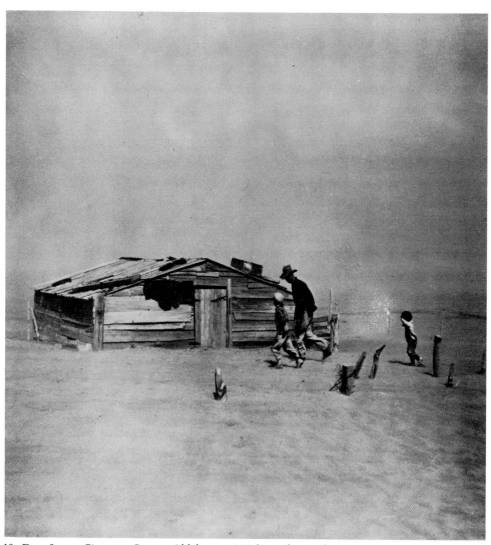

18. Dust Storm, Cimarron County, Oklahoma, 1936, by Arthur Rothstein.
Library of Congress, FSA Collection

for writing which would be unlikely in an actual situation."[30] Stryker found a series of Lee's photographs of Iowa families standing in front of their houses "a bit stiff."[31] But he liked Rothstein's series of twenty-three members of the local Grange, a national farmers' organization working to unionize agricultural labor. He told Lee, "Rothstein just seated them and took one after another" and asked Lee to try a similar approach.[32] Rothstein used the technique at the Tulare Camp for Migratory Workers near Visalia, California, where he made a series of head-and-shoulder shots of about thirty men, women, and children, each against the same background. On other occasions, Lee and Lange photographed the Mineral King Cooperative Farm, an old ranch near Visalia where the FSA had established ten families. Lee and Lange were less methodical than Rothstein, but both made direct photographs of people looking right into the camera. Lange's close-up of one of the camp directors is more spontaneous than Rothstein's portraits. She made other photographs of people in the same formal posture of Rothstein's subjects, but because she chose a longer view, those photographs, despite the sensitivity to light and shape they reveal, have some of the qualities of posed snapshots. Several of Lee's photographs of groups of people are much like Lange's. But when he photographed indoors with a flash, the snapshot effect was further increased.

Stryker encouraged Lee and Rothstein to make photographs that would appeal to the picture magazines and suggested at one point that Lee's photographs of a forest products laboratory were "a bit too factual" for *Life*. He said, "You ought to take a few additional pictures of the *Fortune-Life* type which presents [sic] accurately the operation in question and overdramatizes the men and/or microscopes by lights, by cockeyed angles, or any other devices."[33] Lange's photographs were used in some of these magazines, and she had a major role in assembling picture stories for some of them; but Stryker never suggested that she use a shooting technique appropriate to their format. Either he found her photographs suitable for these publications already, or, more likely, he knew that she would be offended by the suggestion that she alter her field method to suit a particular publication.

The technique of talking with the people she photographed continued to be an important part of her work. She "had a sense of words as acute as her sense of the picture," according to Newhall.[34] Stopping by the side of the road, she would get out of the car to ask for directions or a drink of water, which she would take a long time to drink, as she drew people into conversation. "If people are talking

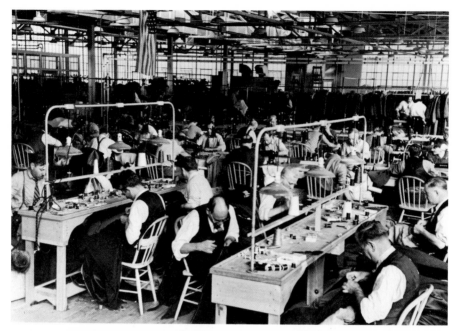

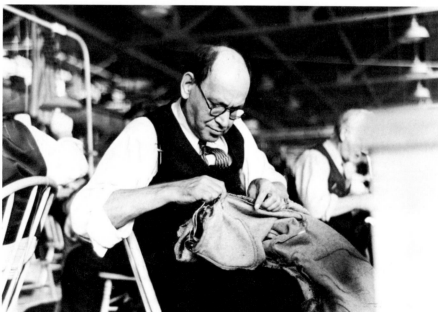

19–20. Cooperative Clothing Factory, Hightstown, New Jersey, 1936, by Russell Lee. Library of Congress, FSA Collection

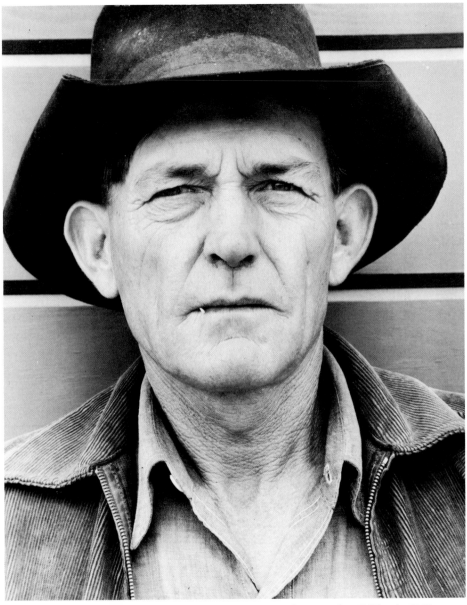

21. Migrant Field Worker at Tulare Camp for Migratory Workers, Visalia, California, 1940, by Arthur Rothstein.
Library of Congress, FSA Collection

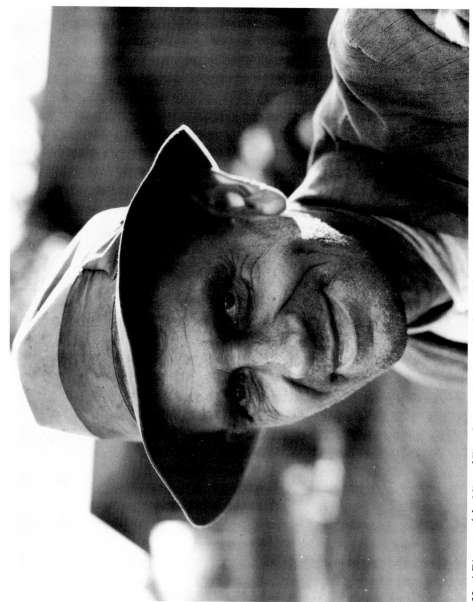

22. A Director of the Mineral King Cooperative Farm, Visalia, California, 1938, by Dorothea Lange. Library of Congress, FSA Collection

about themselves and their own experience and their own involvement, they are eager to talk," she said.[35] Taylor agreed that the people they met welcomed the opportunity to speak out about their situation.[36]

Lange talked, listened, and photographed until her head was full of these conversations. When Partridge worked with her, each of them picked one person and concentrated on what that individual said. She could remember about thirty minutes of conversation after which she would suddenly stop photographing and head for the car with Partridge to write it all down. Each of them wrote the portions they remembered and then read it to each other to trigger their memories. It often took a couple of hours to transcribe what they had heard during a half hour of photographing. Sometimes they wrote down only the "more tense parts" of the conversation, but, Partridge said, "There were days when we wrote down everything we heard."[37] When Lange worked with Taylor, he did most of the talking, but she listened as she photographed, then wrote it down.[38] Each of the FSA photographers was responsible for taking notes in the field, but none of the others put the emphasis on extensive verbatim transcriptions that Lange did.

Lange identified herself as a government photographer only when people questioned who she was and what she was doing. She would explain that people back in Washington wanted to know what their problems were so that steps could be taken toward solving them. Occasionally Lange was asked for proof that she was a government representative, usually by a local official who regarded that information as his business. Her attitude toward her work apparently engendered trust on the part of her subjects; according to Taylor, they seldom challenged her.[39]

People who worked with Lee have been impressed by his ability "to take photographs of the intimate areas of people's lives when most photographers would not have gotten in the door." Stryker remembered working with Lee in a small town in the upper Midwest. When a woman asked Lee why he wanted to take her picture, his response was, "Lady, you're having a hard time and a lot of people don't think you're having such a hard time. We want to show them that you're a human being, a nice human being, but you're having troubles."[40] The woman introduced them to several friends and invited them all to lunch so that Lee could photograph them, too. FSA photographers' work required that people trust them with intimate details of their lives—how much money they made, what their homes looked like inside, what they ate for dinner. The ability to establish this trust quickly and easily made Lange and Lee unusual field workers.

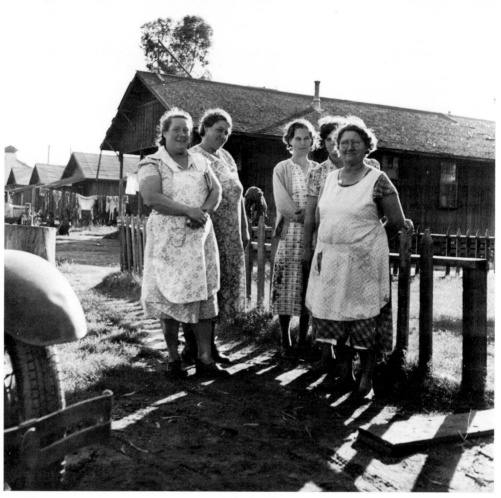

23. Women of the Mineral King Cooperative Farm, Visalia, California, 1940, by Dorothea Lange. Library of Congress, FSA Collection

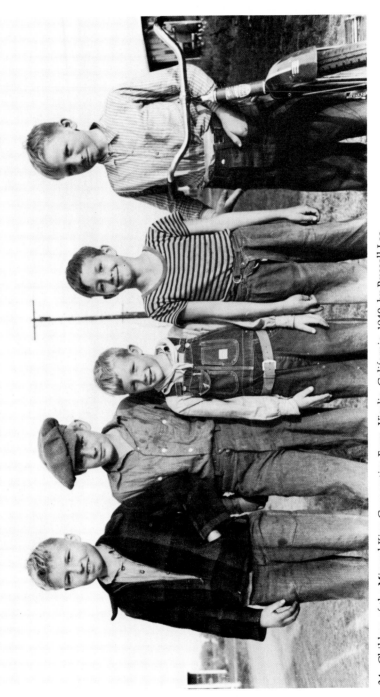

24. Children of the Mineral King Cooperative Farm, Visalia, California, 1940, by Russell Lee. Library of Congress, FSA Collection

Each of the photographers used equipment that reflected his or her ideas about field work. Lange used a Rolleiflex camera and a 4 x 5 Graflex, which she mounted on a tripod. She preferred these larger format cameras because she felt her technique was not compatible with the continuous shooting pattern employed by photographers who used the newly introduced 35mm. cameras. The 2¼ inch Rolleiflex could be operated quickly when necessary, and it made the larger format negatives Lange preferred. She wanted to use one of the Historical Section's view cameras but finally bought a Zeiss Jewel, which she used with a wide-angle lens. The large format and wide angle were necessary for getting the detail she wanted when working indoors in small spaces.

Lee's first camera was a Contax, one of the earliest 35mm. cameras made. He was a master at obtaining sharp, clear negatives at a time when the large grain on the film prevented most photographers from using the 35mm. format successfully. His concern for detail in his images and the analytical and technical skills he had developed as an engineer enabled him to adapt quickly to larger-format cameras. In the field he often used two 35mm. cameras fitted with different lenses, and one or more larger cameras, ranging from a 3¼ x 4¼ Speed Graphic to an 8 x 10 Linhof view camera for architectural shots and landscapes.

Like Lee, Rothstein used a wider range of cameras than Lange, and he enjoyed experimenting with them for different effects. He also liked to try out new equipment as it came on the market. In 1939, for example, he used a Polaroid stereoscope color camera to photograph the San Francisco World's Fair. His primary cameras were 35mm., but he always took at least one other large format camera to the field with him.[41]

Rothstein and Lee used artificial light far more than Lange did. She preferred available light and found flash guns to be heavy and cumbersome. She often used reflectors to throw more light on her subject, to avoid harsh shadows, and to retain the quality of the existing light. Although she carried a flash with her to the field, she seldom used it, simply not photographing in settings that required additional light. When Stryker suggested that she use flash to get photographs needed for the file, she complied with reluctance.[42]

Most of Rothstein's and Lee's indoor work was done with flash. Lee used on-the-camera flash, despite its harsh shadows, to keep his technique as simple as possible and to maximize the detail in his photographs.[43] He later used two or more flash guns wired together, eliminating some of the harsh shadows but occasionally producing bizarre effects. Styker's reaction to photographs Lee had

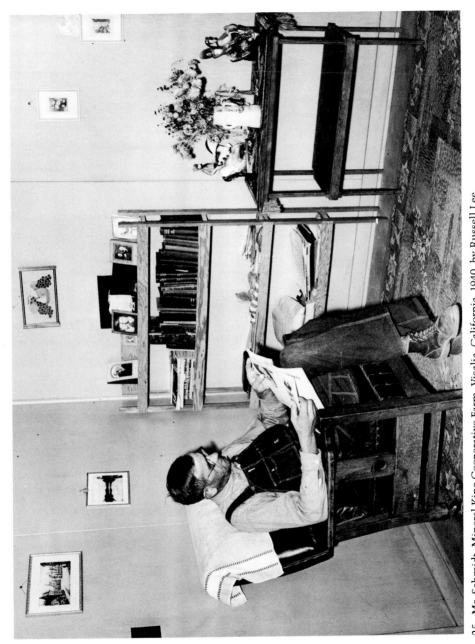

25. Mr. Schmidt, Mineral King Cooperative Farm, Visalia, California, 1940, by Russell Lee. Library of Congress, FSA Collection

26. Interior of a Home in the Tulare Camp for Migratory Workers, Visalia, California, 1940, by
Arthur Rothstein.
Library of Congress, FSA Collection

done in a dark schoolroom was that they look "a little bit ridiculous—here was a man obviously struggling to read by this poor light—and yet the room was almost as brilliant as daylight."[44] Like Lee, Rothstein wired together several flash guns for indoor photographs and for many of his portraits.

Letters from Rothstein and Lee were often filled with technical information and questions for the men in the lab about film developers, comparisons of film types and stock, and new equipment coming onto the market. Although Lange was aware of this dialogue and benefited from it when she was considering buying a new camera or switching to a new developer, she never took part in the exchange of technical information. The references to technology in her letters emphasized getting the equipment and materials rather than comparing and testing them.

The technical quality of Lange's photographs was not strong, and she often admitted that the technical aspects of photography were very difficult for her.[45] Once in a while her film was fogged, or her negatives contained little contrast, making them difficult to print. Stryker occasionally criticized the technical quality of her negatives in his correspondence with her, but no more frequently than he criticized the other photographers' work. Rothstein's and Lee's technical problems were usually due, Stryker thought, to careless use of the 35mm. cameras; their work occasionally looked as if they were counting on having many shots to select from. Rothstein had other problems that were the result of working long periods in the field without seeing the products of his work or having his cameras checked, problems which occasionally plagued each of the FSA photographers.[46]

Lange's outstanding photographs were not due to her technical skill but to her unusual ability to create an atmosphere that encouraged people to cooperate with her; she could weave the photographing event into the natural flow of her interaction with her subjects. She was more interested in making a few photographs that would summarize a person or a setting than in doing the kind of exhaustive photographic documentation Lee excelled in. In contrast with Rothstein, who would ask people to repeat actions for his camera, Lange was able to elicit similar actions from her subjects without overt requests. By listening to, as well as by photographing, the people she met, Lange made documents that were both visual and verbal. Although Lee shared Lange's ability to present himself to his subjects in ways that put them at ease, Lange's way of working with people was unusual, and she was the only one to return from the field with verbatim accounts to accompany her photographs.

Although the FSA photographers never worked in the same place at the same time, in a larger sense they were working together, documenting changes which were revolutionizing American agriculture. Lange, Lee, and Rothstein covered different aspects of two major subjects—the interlocking problems of farm tenancy and rural migration. In addition, they all worked to document the FSA's programs, the government's attempts to solve the farmer's problems.

Tenancy was a big issue in the press in the spring of 1937. Stryker wrote Lange that it was a primary concern of the Resettlement Administration, which had been receiving many requests from newspapers and magazines for more photographs on the subject.[47] Lange and Taylor spent that summer and the next traveling through Texas, Oklahoma, and the Deep South, surveying tenant conditions and the pattern of displacement from the land, already several years underway.

In 1937, Lange wrote Stryker that in Childress and Hall counties in the Texas Panhandle she found "people put off farms, tenants, often of years standing and established—with tractors coming in purchased by the landowners with soil conservation money. It is the story of the county. The ex-tenants are homeless and landless. How far across Texas the same story holds I do not yet know."[48] A federal report on farm tenancy the previous year had not mentioned mechanization as a factor in tenant replacement. Yet, across the panhandle and into central Texas, Lange and Taylor found that tenants either were reduced to wage laborers or were on relief in the wake of mechanized farming. Taylor reported to the Social Security Board that the impact of the tractor and the four-row cultivator was greater than that of the preceding years of drought.[49] Photographs Lange made the following summer reinforced the record. They depicted lone abandoned houses with tractor furrows right up to the door and people talking about getting "tractored out."

A group of seven men in Hardeman County, Texas, told Lange and Taylor a story they heard echoed across the South. Taylor said this was one of the few times he had to show his government identification, to convince the men that he was working for an organization that was trying to solve their problems.[50] They told Lange and Taylor that they were all on WPA relief, trying to support their families on $22.80 a month. "The landlord on this place bought a tractor and put five families of renters off," one of the men reported; "he has two families on day labor, at from 75 cents to $1.25 a day." The men had been disenfranchised because none of them could afford the poll tax. All of them were

27. Tractored Out, Hall County, Texas, 1938, by Dorothea Lange. Oakland Museum

under thirty-five, wondering what they were going to do: "If we fight, who we gonna whip?"[51]

Lange photographed the men as they stood in a row in front of the house and later as they crouched in a group, continuing their conversation. Taylor sent several of the photographs and portions of the men's discussion to his superiors at the Social Security Board.[52] Copies of his letters, together with the photographs and Lange's captions, were entered in the FSA files.

Cotton plantations replaced the wheat fields as Lange and Taylor traveled farther south, but the story was much the same. The landowners expected that within a year or two a mechanical picker would be developed to replace even the former tenants and sharecroppers turned "cotton choppers."[53] Lange photographed the juxtaposition of the new order and the old—black men driving the new tractors and hoeing in the fields of the Mississippi Delta, poor sharecroppers in front of their small houses or on the porches of the large plantation homes abandoned by the former occupants, men trying to sustain an old way of life against encroaching change.

Lee's work on tenancy was concentrated in the Midwest, where he had grown up. On his first field trip, to Iowa, he investigated the various types of tenancy and land leasing, the effects of the drought, and the living conditions of the hired man on the farm. He continued on to Illinois, photographing in the livestock and cash grain areas. During the winter months, the evidence of mechanization was less prominent; in any case, it had not made the inroads into traditional farming practices that Lange and Taylor saw in the South. Nevertheless, extended drought had forced many people to sell their land and face the hardships of winter with insufficient food and cash. In one house, Lee found children trying to make a Christmas dinner of bread and thin soup. "The conditions in this house and area really shook and angered me," he later said. "It was my first actual face to face meeting with our nation-wide problem at the time."[54] While his written documentation of tenancy was not as complete as Lange's, his visual record was more thorough and included many photographs of the details of the tenants' everyday lives.

Several years later, Lee went to Texas to continue the FSA's investigation of the impact of mechanization on the people there. He found several cases of poor health and malnutrition, "the result of plantation exploitation." He read catalogs published by tractor and implement manufacturers that cleverly referred to the "family farm" and ignored the magnitude of labor replacement.[55]

Rothstein also photographed in the Midwest, filling out Lee's report and adding new material, particularly on the small towns of Iowa and the fall corn harvest, and extending the picture of farm tenancy and sharecropping into Missouri. Over a three-year period, these three photographers had documented the broad scope of problems faced by small farmers across the country.

It was clear from the beginning that the problems of tenancy were influencing migrant labor, too. Early in 1935, Lange had photographed the first carloads of people entering California from the blown-out farms. California appeared to offer fertile land, green valleys, and plenty of jobs. What the migrants found was in sharp contrast to the promises they had read on the handbills back home.

Lange's photograph "Migrant Mother," of a woman sitting with her children in a dilapidated tent, is the best-known photograph in the FSA files, and it became a symbol of the California migrants' situation.[56] Lange made the photograph in the spring of 1936, at the end of a month-long field trip to the migrant camps in the central part of the state. On her way home she passed a crude sign, PEA PICKERS CAMP. She ignored it, her mind on the wet, gleaming highway and home. "I didn't want to remember I'd seen it, so I drove on."[57]

But as she continued down the road, her thoughts returned to the sign, and an inner argument arose: "Dorothea, how about that camp back there? What is the situation back there? . . . Haven't you plenty of negatives already on this subject? Isn't this just one more of the same? Besides, if you take a camera out in this rain you're just asking for trouble. Now be reasonable, etc., etc." After twenty miles she turned around and drove back. "I was following instinct, not reason," she said; "I drove into that wet and soggy camp and parked my car like a homing pigeon." Lange saw the woman almost immediately and went toward her. The woman did not ask her any questions, and Lange could not remember how she explained her presence or her camera. She told Lange she was thirty-two and that she and her children had been living on frozen vegetables from the field and wild birds the children caught. The pea crop had frozen; there was no work. Yet they could not move on, for she had just sold the tires from the car to buy food. Lange approached none of the other tents: "It was not necessary; I knew I had recorded the essence of my assignment." She spent only ten minutes in the camp.[58]

Lange had not followed her usual method in making these photographs. She was working alone and did not get involved in a long conversation with the

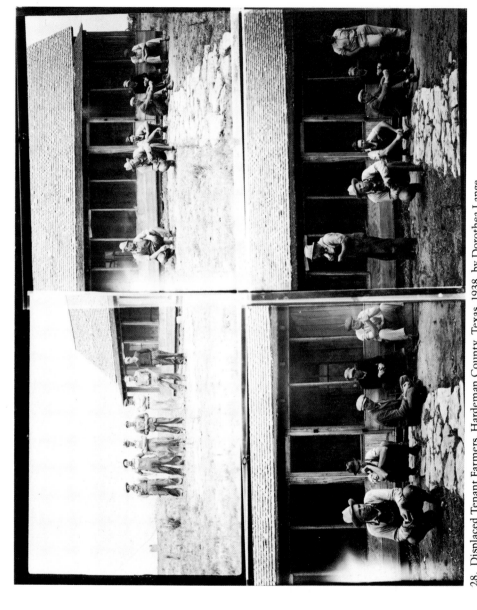

28. Displaced Tenant Farmers, Hardeman County, Texas, 1938, by Dorothea Lange. Oakland Museum

29. Displaced Tenant Farmers, Hardeman County, Texas, 1938, by Dorothea Lange. Library of Congress, FSA Collection

30. Christmas Dinner in a Tenant Farmer's Home, Southeastern Iowa, 1936, by Russell Lee. Library of Congress, FSA Collection

31. Migrant Mother 1, Nipomo, California, 1936, by Dorothea Lange. Library of Congress, FSA Collection

32. Migrant Mother 2, Nipomo, California, 1936, by Dorothea Lange. Library of Congress, FSA Collection

33. Migrant Mother 3, Nipomo, California, 1936, by Dorothea Lange.
Library of Congress, FSA Collection

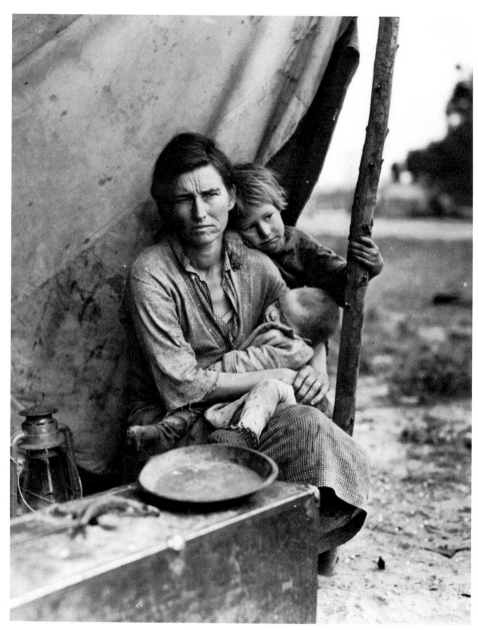

34. Migrant Mother 4, Nipomo, California, 1936, by Dorothea Lange.
Library of Congress, FSA Collection

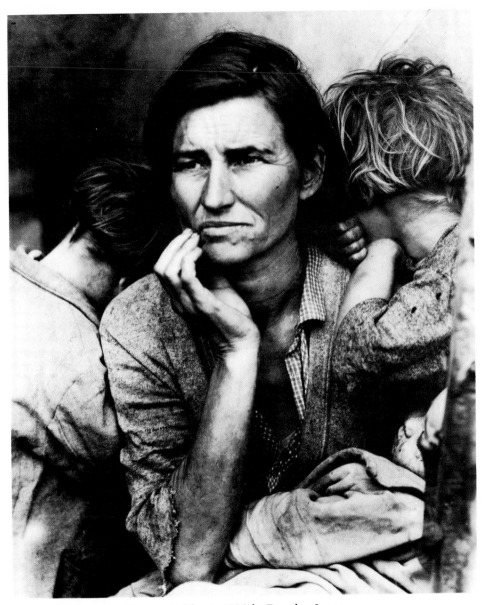

35. Migrant Mother 5, Nipomo, California, 1936, by Dorothea Lange.
Library of Congress, FSA Collection

migrant woman. She did not make careful notes about what the woman had said to her; only the photographs went into the Resettlement Administration file. And yet one photograph, the closest she had made, was immediately recognized as very special. According to Stryker, it was an exciting and disturbing picture that needed no words.[59]

Tracing the roots of the migrant problem in California required going back to the land from which the migrants had come. The abandoned tenant houses Lange found in the Texas Panhandle were part of the story. She wrote to Stryker in the summer of 1937: "This may turn out to be an important part of our California story. In fact, I know it is now."[60] In the dust bowl of Oklahoma, Rothstein found vivid evidence of the conditions that led to mass migration. In Cimarron County, he talked to farmers whose families originally had moved there from Missouri and Ohio. Using traditional farming methods unsuitable to the vast plains and high winds of Oklahoma, they turned the area into "a complete desert," the worst section of the dust bowl.[61] Rothstein made a few photographs of the remaining farm families, including his most famous FSA photograph (Photograph 18). His strongest photographs are of the sculptured landscapes of abandoned fields covered with drifting sand, clearly revealing the impact of the farming methods. Later that summer, Rothstein again traveled through the area with members of a committee investigating drought conditions. Perhaps because Roosevelt and Tugwell were accompanying the Drought Committee, Rothstein's photographs received front page coverage.[62]

The dust bowl continued to receive attention from the FSA photographers over the next several years. On a trip through the Texas Panhandle in 1938, Lange photographed some of the remaining tenants and their dust-blown farms. Complementing Rothstein's photographs of the area, Lange's included glimpses of what life was like for the people who were holding out.

When John Steinbeck's The Grapes of Wrath was published in 1939, its immediate popularity renewed public interest in the dust bowl. In Muskogee, Oklahoma, near where Steinbeck's Joad family had come from, Lee found a family in the process of moving to California. He photographed each step of their preparations as they picked the last vegetables, said good-bye to friends, preparations as they picked the last vegetables, said good-bye to friends, and loaded their truck. Lee then followed them down the road with his camera.[63]

Many people left home to earn a living following the harvests within their own states. Lee found this pattern of "resident" migrants in Texas: Americans and Mexicans who worked in the vegetable and fruit fields of southern Texas for

most of the year followed cotton picking to west Texas. Other families crossed into the Mississippi Delta region for seasonal work there. Conditions in the migrant camps were as bad as in California; people were on the verge of starvation and were suffering from tuberculosis and other diseases.[64] Lee traveled as far north as Minneapolis, where he found migrants working in the sugar beets. Stryker wrote Lange that some of Lee's photographs "look as though he might just as well have been in California as in the Lake States—same primitive houses, bad camps, and so on."[65] Rothstein made a series of photographs of the migrant workers in Florida, some of whom had been following the crops in that state for five years, living in poor camps, and working for below-subsistence wages. He softened the picture of utter poverty by photographing the citrus fields, where conditions were better and the work was more stable.[66]

Another chapter of the migrant story lay in the Northwest, in the Yakima Valley in Washington, where the pear and apple orchards and the hop fields had drawn migrants who could not find work in California. Lange's and Rothstein's photographs in the Yakima Valley camps, although made three years apart, show similar situations. Lange also provided extensive written documentation; people from Oklahoma, North Dakota, and Texas told her that they had tried farming in other states before finally taking to the road. The pear growers provided no housing and paid four cents a box for the fruit they picked. The work was highly irregular, and when they did work, $1.90 was an average day's wage.[67] The camp they lived in, euphemistically called Ramblers' Park, was almost an exact replica of the many camps Lange had photographed in California.

Throughout this period, the documentation of the California migrant situation continued. Rothstein and Lee each made field trips to California, but Lange was the principal photographer in the state. She followed the migrants as they moved from crop to crop, and when there were strikes against the growers or a major crop failed, she would take off for a day or two to photograph the situation. By 1940, Lange, Lee and Rothstein had documented in their photographs and notes that farm tenancy and rural migration were interrelated aspects of the overall pattern of change in American agricultural life.

The photographers were also assigned to document the FSA's projects for breaking the cycle of displacement from the land and mass migration. The cooperative farms, the homestead projects, the farmers who received rehabilitation loans to start over again, the federal camps for migrants, and other projects—all were worked into the photographers' assignments.

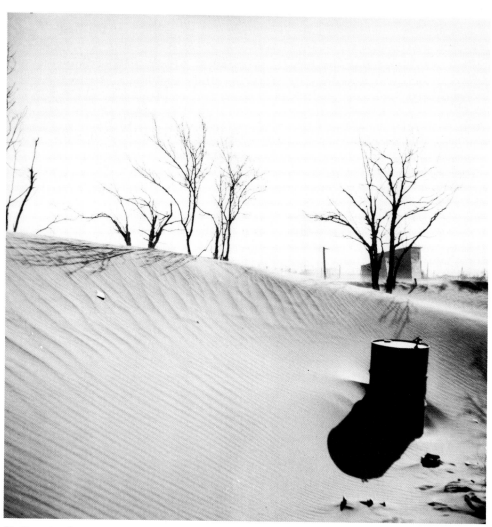

36. Dust Bowl Farm, Cimarron County, Oklahoma, 1936, by Arthur Rothstein.
Library of Congress, FSA Collection

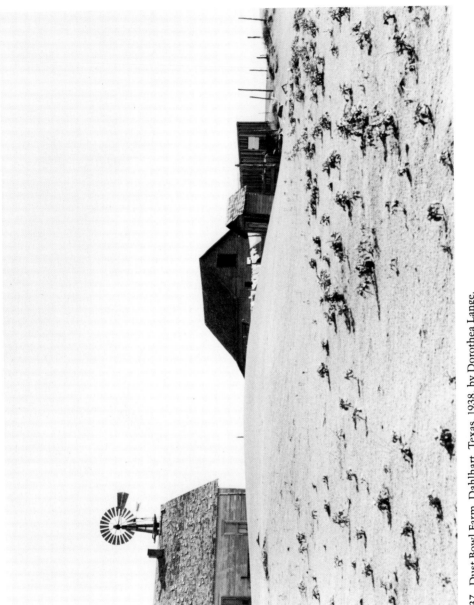

37. Dust Bowl Farm, Dahlhart, Texas, 1938, by Dorothea Lange. Library of Congress, FSA Collection

38. Woman of the Texas Panhandle, 1938, by Dorothea Lange.
Oakland Museum

39. Drought-stricken Farmers, Sallisaw, Oklahoma, 1936, by Dorothea Lange. "These fellers," said one of them, "are goin' to stay right here till they dry up and die, too."
Library of Congress, FSA Collection

40. Family Leaving Muskogee, Oklahoma, for California, 1939, by Russell Lee. Library of Congress, FSA Collection

41. Family Headed for California from Muskogee, Oklahoma, 1939, by Russell Lee. Library of Congress, FSA Collection

To the photographers, this was the least appealing aspect of their work. In general, they supported these projects but objected to the "hard-boiled publicity" photographs that many members of the FSA staff wanted. The local camp managers and project supervisors usually expected the photographers to show how well their projects were solving the problems. Lange later talked about the difficulty of fending off these assignments: "You'd be photographing the half-built buildings all the time, with the project manager and all his staff standing there, looking at the camera, you know. And the project manager would get hold of you as you came up and he would have it all lined up, all the things that to him were vital; but they weren't vital in the sense of what were the real underpinnings."[68] While many local officials provided sound information on the problems in their area and guided the photographers toward helpful sources, the photographers often found that they had to work around most of the camp managers and other officials assigned to them, trying to satisfy "official requests" but still fulfill their own sense of what was significant about each place.[69]

Most of the photographers appear to have supported the philosophy behind the projects. Lange, in particular, believed cooperative farming and government loans and grants offered solutions to the economic problems of rural America. Her work on the Oroville sawmill, her first field work for the government, grew out of her sympathies for the cooperative project. In one of her first letters to the Resettlement Administration, she requested authorization to photograph the federal camp for migrant workers in Kern County, California: "It represents a democratic experiment of unusual social interest and national significance."[70] Her photographs of rehabilitation clients, members of cooperative farms, and union organizers throughout the country were all motivated in part by her political and social commitment to the projects and to the FSA's efforts to build a new social and economic structure in rural America.

Stryker's instructions to all the photographers were usually more specific for government projects than for other assignments. "First, get pictures of the steel shelters of the federal camp for migratory workers at Farmersville," Stryker wrote Lange in February, 1939. "There is a most insistent call for this material, both from our own administrator's office and from the outside." When the FSA began operating a mobile health clinic in the California migrant camps, he asked her to "be sure that you get some inside flash shots showing the mobile clinic in operation; if possible any outside shots of people arriving at the clinic." When Rothstein was headed for a California assignment, Stryker wrote him that the

local FSA officials considered it necessary to emphasize the positive side of health care in the migrant camps: "Mothers and children are our best bet. Get nurses treating children, mothers coming in for post-natal instruction—anything that will demonstrate child welfare work."[71] Stryker sent out similar instructions for photographing the cooperative farms, rehabilitation clinics, and other FSA projects. The administrators insisted on photographic documentation of their successes.

The photographs Lange, Lee and Rothstein made on such assignments often look very similar. Photographs of the houses in each project and of the dairy herd on the Mineral King Cooperative Farm, for example, have a direct, almost formulaic sameness to them. However, the differences among the photographers clearly emerge in their photographs of people in the projects.

As FSA photographers, Lange, Lee, and Rothstein were working on interlocking pieces of a giant jigsaw puzzle. The changes that they recorded on the farms and in the faces of rural Americans could be understood only as part of a much larger state of flux. Small farms were being replaced by huge tracts of land. The corporate wealth that turned the farmer into a field hand was replacing him and his family with tractors and cultivators. The years of drought quickened the process and widened the gap between those who could afford to buy and the growing numbers of people who had only their labor to sell. The hundreds of thousands of people who poured onto the highways in search of work found the value of their labor further fragmented by the growing agricultural corporations that met them wherever they went. In California, Washington, Oregon, Texas, Florida, and elsewhere, farming was a big business in need of cheap labor to keep down overhead on the "factories in the field."

Within government, efforts were made to cushion the change for rural Americans and to provide them with alternatives to migrant labor. But while the FSA was trying to help laboring people, another part of the government was aiding the expanding corporate structures of agriculture and business to hasten the end of the Depression.

The pieces of this puzzle accumulated in the files of the Historical Section. Variations in the photographers' relations with their subjects, in their attitudes toward and competence with the equipment they used, and in their individual interpretations of their work yielded a rich and diverse record of the period. Lange, in particular, personalized that record through her ability to engage peo-

ple in conversation while moving naturally among them with her camera. The FSA represented for her the use of photography as a tool for exploring how individuals were uprooted by social change and how they adapted to it. She regarded social science photography, not as disinterested exploration, but as a vehicle for encouraging humane solutions to the problems of the Depression. The synthesis of words and photographs, intrinsic to her field method, carried over into the ways she wove together the material she gathered. The record was not complete until she had integrated what she had seen and heard in the field into the larger patterns of change. For Lange, field work was only half her job as an FSA photographer.

Chapter VI

Back from
the Field

Lange felt strongly that she should maintain personal control over her work from beginning to end, rather than trust it to the Historical Section's laboratory on the other side of the continent. Unlike the other photographers, she had a darkroom financed in part by the FSA.[1] She had requested it in a letter to Stryker.

I prefer very much to do my own [processing]. When the work gets too heavy, couldn't I have an assistant on a perdiem basis when I need him. You know I'd like to avoid sending in the negatives. I hope I won't have to. Couldn't we try it out, once I get my darkroom in good working order in this way. I feel it would be the best arrangement and I'll keep you well supplied with prints if you, in turn, can give me any sort of basis for operation. That is, a chance to get in the field, film, gross of paper when I need it, and a chemical or two without having to beg, borrow, worry, or steal to get it, plus a little help in running my laboratory.[2]

Stryker could only agree partially to this arrangement. He was willing to help pay some of the costs of setting up and running her darkroom, but he could not authorize her to hire assistants; she had to do that out of her own pocket.[3] Ron Partridge often developed her film, and occasionally Lange hired her friend Ansel

Adams to develop some negatives.[4] When the photographers worked in the field for long periods of time, Stryker encouraged them to send their undeveloped film to the Historical Section's darkroom in Washington, since field conditions prevented adequate control over processing. Although Lange balked at this policy, Lee and Rothstein usually sent their undeveloped film to Washington for the staff there to process, and only occasionally did they develop their film in the field.[5]

To Lange, maintaining control of her work also meant retaining her negatives in California instead of turning them over to the FSA office in Washington. "I appreciate fully how you feel as a photographer about your negatives," Stryker wrote her, "and I wish that there was some way that we could work out a plan so you could keep them." But he had grave doubts about whether she would be able to supply the demand for prints from his office as fast as necessary.[6] Cross-country mail carried by rail was slow, and letters between Stryker and Lange often crossed paths, sometimes with contradictory messages. In addition, the possibility of negatives and prints getting lost in the mail was a source of concern to all the photographers.

By January, 1936, it was clear to Stryker that Lange's negatives would have to be kept in Washington. He wrote her that it was impossible for her to continue to maintain a separate negative file: "The heavy demand for pictures will be coming from this end, and we just cannot wait to get word back to you in order to get additional prints." She was to make the prints needed for use in her region, then send her negatives to Washington.[7]

Lange was never satisfied with this arrangement, and the retention of her negatives continued to be an issue between her and Stryker. Lee and Rothstein, despite their concern about the technical quality of their photographs, were willing to cooperate with Stryker in this matter. They had more contact with the laboratory in Washington and may have felt their role in running that darkroom provided them with sufficient control over their work.

No great love of darkroom work lay behind Lange's desire to maintain a laboratory and make her own prints. Her deepest satisfaction occurred in the field. She spoke of the "terrors of the darkroom," the fear that what she thought she had captured on film could not be recreated on a negative or in a print. Although she could communicate precisely what she wanted to her assistants and took pride in what she called her "print sense" (knowing "what a good resonant photographic print is"), the printing process held little magic for her.[8]

There were other reasons for Lange's requests to keep her own negative file. Unlike the other photographers, she was working in close conjunction with the FSA office in her area, and many requests for her work came out of the San Francisco office. Access to photographs of current regional issues was important, and if such requests were not filled rapidly, conflict arose between the West Coast staff and Washington. Stryker reluctantly agreed that Lange could keep a set of negatives for the regional office, but he asked that she send her best work to him.[9]

A second reason that Lange would have liked to retain all her negatives was that she, unlike Rothstein and Lee, was responsible for a number of reports and exhibits.[10] Although Stryker agreed to loan her negatives for particular reports, Lange complained that it was hard to remember specific negatives and that, without immediate access to the entire range of her photographs, work on the reports was difficult.

These reports took time, which meant that the negatives Stryker did send to Lange were out of the files for several months. Meanwhile, requests for prints continued to come into the Washington office. Although Lange attempted to fill these requests from her end, the arrangements proved cumbersome and time-consuming. The slowness of the mail and the administrative problems of funding her supplies strained Stryker and Lange's relationship. While working on a Senate report on farm tenancy, Lange wrote to Stryker: "Here I am with no materials, I pay the water, the electricity, and am handling a big theme of national importance, and it isn't easy to have to buy my own supplies or have my work stopped. I've just ordered some paper and developer to keep me going for a few days, but the situation here in California calls for the work to get into circulation as quickly as possible."[11] Stryker, on the other hand, continued to chafe at the amount of time Lange kept her negatives. "We practically had to send the sheriff to get them back for the files," he later said.[12]

Most important, Lange wanted to retain her negatives as a personal record of her work and experiences in the field. Even after she was resigned to sending most of her negatives to Washington, she asked Stryker to send selected ones to her, so that she could copy them for her own file. As she told him, "It is not too much for a photographer to ask that he have one set of proofs, if only to have some sort of record of what he has been doing. It guides him, in how the work is building up, whether or not it is taking *form*."[13]

To compensate for her sense of loss, Lange began quietly to build up her own

private file by always keeping out a small number of negatives that were near-duplicates culled from those she turned over to the FSA, including a few she judged as the stronger photographs from a set. She exhibited some of these, and after her death they remained in her files alongside her nongovernment work, instead of being integrated into the FSA files (compare, for example, Photographs 13 and 28, from Lange's own files, with Photographs 14 and 29, from the FSA files).[14] Either Stryker was unaware of her practice, or he chose to ignore it. He explicitly rejected the idea of her keeping a duplicate negative file, apparently because he felt his office should have exclusive rights to distribute the phographers' work.[15] Taylor has said that, as far as he knew, she sent all her negatives to Washington.[16]

Another controversy between Lange and Stryker erupted when she asked Ansel Adams to make a set of prints for the Museum of Modern Art in New York. According to Beaumont Newhall, these were "fine prints of half a dozen of her favorite pictures . . . and they were very beautiful, on white mounts." Stryker was furious, accusing her of trying to create art out of working documents.[17] In addition, she had hired someone to retouch several of the negatives before having them printed for the museum, which further infuriated Stryker. To defend herself, she told him that she had hired "the best retoucher on the Pacific Coast" and that the job was done in her presence with utmost care. She said that she had "rectified" the poor quality of one negative and entirely eliminated a "glaring defect" in another, her famous "Migrant Mother."[18] This undoubtedly did not mollify Stryker. In his view, the FSA photographers could use any technique, such as overt posing, unusual angles, or artificial lighting, that would contribute to the statements the photographers were making; however, once the photograph existed, Stryker interpreted any alteration of the negative as evidence that the photographer had a "precious" attitude toward his or her work, an unwillingness to let the photograph speak for itself as a document of reality. Lange, on the other hand, did not think of herself as an artist improving upon reality but as a documentary photographer adding further clarification to the photographs she had made.

For Lange, captioning her photographs and combining them in ways that would convey fully and accurately what she had observed in the field was an essential part of her job. In her captions, she combined excerpts from her extensive field notes with social science studies and government reports. She did most of her reading after returning from the field, because it was easier to digest after

she had seen the conditions herself. Also, she said, "It's a somewhat questionable thing to read ahead of time in a situation like that, because then you're not going under your own power. It is often very interesting to find out later how right your instincts were."[19]

After a field trip, Lange gathered proof prints of her photographs and spent several weeks writing the captions—or "essays on the social scene," which she thought they should be—and combining the photographs in various ways, cross-referencing them for different uses. It was time-consuming, but, she said, "If this is not done, I believe that half the value of field work is lost." Although Stryker occasionally thought she took too long, holding needed material out of the files, he had only praise for the results.[20]

Stryker was not always so pleased with Rothstein's and Lee's captions. He asked Rothstein for fuller, more explicit captions, saying, for example, that Rothstein's Oklahoma dust bowl photographs were "excellent pictures on which we need much more data." Stryker found that Lee often belabored the obvious, and he described a photograph Lee had made of a man leaning against a post as being labeled "Man leaning on post." Stryker also said there was no need for Lee to identify black people as Negroes in his photographs, especially since he had not identified Caucasians as such. Consequently, Stryker asked Lee to revise some of his captions to avoid redundancy.[21]

Lange, on the other hand, tried to create a dynamic relationship between the caption and the photograph. "I don't like the kind of written material that tells a person what to look for or that explains the photograph," she said. "I like the kind of material that gives more background, that fortifies it without directing the person's mind. It just gives him more with which to look at the picture. A caption such as 'Winter in New England' only tells you that it's winter. That caption shouldn't be necessary. . . . You could say: 'people are leaving this part of the United States, which was the cradle of democratic principles bred there in the early days of our country.'"[22] The impact of this technique can be seen in two examples from a migrant camp in Yakima, Washington—one by Lange, the other by Rothstein. More typical of the way most FSA photographers captioned their prints, Rothstein documented his photograph of a mother and child simply, "Wife of a worker in the fruit orchards." Lange's photograph had a much longer caption, which carefully guides us beyond the obvious aspects of the image to an understanding of the woman's perspective on her situation.[23]

Lange also wrote general captions, which applied to groups of photographs.

42. "Toppenish, Yakima Valley, Wash. (vicinity) Aug. 1939. Champion hop pickers in a squatter camp before the season opens. This girl, married, age 23, has been on the road seven years, earned $5.00 a day in the 1936 season. 'I think I did pretty well, only have one baby. I want to get out of this living like a dog,'" by Dorothea Lange.
Library of Congress, FSA Collection

43. "Yakima, Wash. July 1936. Wife of a worker in the fruit orchards," by Arthur Rothstein. Library of Congress, FSA Collection

These essays contained aspects of a family's life history, for example, or the background of a collective farm. Lee also wrote general captions, which he thought were good for grouping and interrelating all the photographs of a particular setting. Stryker was pleased with these and suggested that the other photographers do likewise; the more written information the photographers supplied with their photographs, the easier it was to draw together effective reports for a variety of audiences.[24]

Lange's letters to Stryker were full of ideas for ways the photographs could be combined and presented, and she usually asked to assemble reports. For example, she proposed a report on the Hill House cooperative farm in Mississippi, and suggested that it be interlocked with the general topic of cotton in the Delta. In another letter she suggested "a beautiful study with publicity value" on the problems of the South as they occurred in the Suwannee River Valley. Most of her suggestions were based on integrating her own work with the other photographs from the files. She sent Stryker an article about the problem of disenfranchised voters in the South with a note: "We have in our files, with captions, negatives which show this situation. That row of young Texans, for instance. This would be a great assignment. Send someone into the South to do more on this. . . . It is part of the tenancy story and could be presented with great effect."[25]

Of course, Lange could not carry out all the ideas she proposed for reports, and the ones she did took time and effort. She assembled a series of photographs to illustrate Taylor's 1937 report to the Social Security Board on mechanized farming in the South, selecting the photographs with an eye toward a popularized version in *Colliers*.[26] Although Lange would not tailor her photographing style to suit a particular publication, she considered it entirely appropriate to edit her photographs differently for specific audiences and publication styles. When bills on tenancy were introduced in Congress, Lange wrote Stryker, "You are *loaded* for a really good photographic report, aimed at the place where it counts most, Congress." At the same time, she suggested that she assemble photographs to accompany the secretary of labor's report to the Senate on transients and migratory workers.

The spring of 1937 found Lange working simultaneously on three reports on migrant labor—one for the Senate, one for *Life* magazine, and one for a conference on social work in San Francisco.[27] Concerning this last project, she said, "We have here an excellent opportunity to demonstrate the function and pur-

pose of sociological photographs to a very high grade group of people. Also, and not second, we have an opportunity to make this same group aware of the problems presented by this migration of homeless. And this is the group who can make things move (that is, I hope they are)." The spread Lange was designing for *Life* on the migrant situation in California was built around an excerpt from a presidential report on farm tenancy: "Erosion of soil has its counterpart in erosion of our society." The basis of her approach to this topic was personal: "This is where *any* of us could find ourselves if 'we pack up our stuff in the car one day and hit the road,' as so many expressed the desire to do during the depression."[28]

Lange had the ability, unusual even for an FSA photographer, to grasp the scope and interrelationships of problems and to express them in terms of their impact on individuals. She wanted the file to be used in ways that would draw attention to problems and effect change. One way to accomplish this was by contributing sets of photographs to people who were working for social change in the same directions as the FSA. Another was to present visual reports to those who were in policy-making positions. Lange also saw this work as demonstrating the power and utility of sociological or documentary photography (which for her were identical) and so encouraging the development and further use of this kind of work. Finally, using the photographs in highly visible ways could help establish the importance of the work that was being done by the Historical Section and insure its continued support by the administration and Congress. "If our existence needs justification, here it is," she wrote Stryker.[29] Lange in no way resented having her work used as propaganda; her goals were entirely consistent with such use of her photographs.[30]

The other photographers were involved in various projects that held little interest for Lange. Rothstein, for example, worked briefly with the film division of the FSA, shooting some stills along the Mississippi while Pare Lorentz worked on *The River*. He also made photographs and scouted locations for *The Land*, a film with Robert Flaherty, for the Department of Agriculture. When Stryker decided that Rothstein's work with Flaherty was not in the interests of the Historical Section and pulled him off the crew, Rothstein was disappointed. "I was beginning to learn a lot about making movies and feel sorry that I had to leave," he wrote Stryker; "but after all, I am working for you and your interests must come first." This contrasts sharply with Lange's reaction to Stryker's suggestion that she join the film division as a way of keeping her on the payroll when the budget was low. She was very upset and wondered if Stryker had found fault with her

work.[31] Only once did she work with the film unit, as an adviser, when Lorentz was working on migrant camp scenes for *The Plow That Broke the Plains*.[32]

Lee and Rothstein worked on several major exhibitions of FSA photographs. They helped assembled the exhibits at the New York World's Fair in 1937 and in the Grand Central Palace the next year.[33] Unlike the reports Lange had worked on, the exhibits were aimed at a general audience and were circulated around the country. Lange wanted them to come to the Bay Area and offered to help make arrangements, but she had little to do with the exhibits themselves.[34] Nor did she take part in designing or producing the FSA photomurals in several public buildings. Lee and Rothstein took time off from field work to help assemble the murals.

Stryker occasionally loaned individual photographers to other government agencies. In most cases the photographer, planning to do FSA work in a particular region anyway, would simply make additional photographs for the other agency. At other times he or she was assigned to the agency for a longer period, doing whatever photography that agency required. As the Historical Section's reputation grew and as budgetary contraints became a serious problem for the FSA, the amount of cross-agency work increased, especially in the last two years of the agency's existence. Stryker cooperated (often reluctantly) because it established the legitimacy and importance of the Historical Section.[35] Rothstein worked for the Department of Public Health and the Bureau of Indian Affairs, and both Rothstein and Lee worked for the Bureau of Agricultural Economics, the Manhattan Department of Health, and several other government agencies. Lange's primary allegiance was to FSA and the use of photography for historical and social scientific purposes. She saw other agencies as being more concerned with publicity for themselves than with any broader significance photography had to offer; nevertheless, she did a few assignments for them. In 1937, for example, she made some photographs of airplane inspection for the Bureau of Entomology, and the next year did some photographs in the California migrant camps for Public Health.[36] She probably would have done more had she not left the FSA before such requests became common.

Although the Historical Section was not a tightly run bureaucracy, Lange's attitudes and her geographical distance from Washington created bureaucratic problems that Stryker found difficult to tolerate, beset as he was with the complications of balancing the needs of his section against the demands and criticisms of the press, Congress, other government agencies, and other sections

within the FSA. There were also misunderstandings between Lange and members of the FSA staff in her region, because they felt she provided neither the kind of photographs they needed nor enough of them. These conflicts, in turn, created problems between the regional and Washington offices.

Nevertheless, the high quality and consistency of Lange's work outweighed the bureaucratic problems. Her photographs, the rich documentation she provided to accompany them, the reports she assembled, and her beliefs about the value of documentary photography were entirely consistent with the highest goals of the photographic section and Roy Stryker in particular. Because of their basic agreement on these substantive issues, Stryker was willing to cooperate with her whenever possible. He valued her ideas, respected her work, and genuinely liked her.

Lange and Stryker seldom saw each other, getting together only on her yearly trips to Washington. She was never part of the pleasant, club-like atmosphere of the Washington office. She and Stryker did not exchange the many little practical jokes and gentle ribbings that run through his correspondence with Lee and Rothstein, and he never accompanied her on field trips, as he did, several times, the two men. However, over the years a deep friendship developed between Stryker and Lange. There was the strong sense, on both sides of the relationship, that they shared a vision of the potential for the kind of photography they were engaged in. Before any of the other photographers understood the implications of this work, Lange and Stryker were discussing ways that photographs could be used as historical documents and resources for creating social change.

Lange's work with the FSA was irregular; she was terminated twice during the four-year period, and occasionally she worked part-time. During the summer of 1938, she worked for a fee of three dollars per selected negative instead of a salary. When she was paid a salary, it was often less than the other photographers received. She would have preferred full-time, steady work, but when cuts had to be made, Stryker chose her as the photographer who could adapt most easily to these fluctuations. He undoubtedly, if unfairly, took into account the financial support she could receive from her husband's income. And, her dedication to documentary photography was clearly established; she would find a way to continue her work.

Lange's final termination coincided with a major budget cut. In the summer of 1939, when Stryker was told to reduce his staff of three photographers to two, a cumulation of events undoubtedly influenced his decision that Lange was the

one to go. She had been trying to assemble negatives from the files to use in a book on rural migration that she and Taylor were preparing. Stryker refused to lend her the negatives, insisting that the work be done in the Washington laboratory. In mid-June, Lange finally went to Washington, presumably to oversee the printing. Stryker had hoped to visit Lee, who was working in Oklahoma at the time, but decided he could not leave while Lange was in town. "Her coming here is a sad story," he wrote Lee. "She has pretty badly messed things up for us. Paul [Taylor] got all excited because we wouldn't let Dorothea have a whole flock of her negatives for Ansel Adams to print from. . . . We finally had to bring Dorothea to Washington. One thing is certain—she cannot work in the laboratory. If she does, I shall have to hire a whole new laboratory force. There is too much work to let the place be paralyzed by her silly ideas." Lee's response was sympathetic to Stryker's view. "She should realize that negatives especially should never be removed from Washington."[37] This was only a month after Lange had infuriated Stryker by hiring Adams to make some prints of her work for the Museum of Modern Art and by retouching at least two of her FSA negatives.

In November, 1939, Stryker gave her notice that she was to be terminated as of the first of the year. From the West Coast some mutual friends tried to intercede. One of them, Jonathan Garst, regional director of the FSA, wrote a personal letter to Stryker asking him to reconsider his decision. He reminded Stryker of the contributions both Lange and Taylor had made to the California migrant camp program, at the expense of Taylor's reputation with the conservative Board of Regents at the University of California, where he was employed. "Moreover," Garst wrote, "Paul Taylor is still violently in love with Dorothea Lange and takes her problems very much to heart. As a matter of fact, I think anything that would hurt her feelings would have very much more effect on Paul's feelings than anything that was done to him directly." He admitted "that Dorothea with her pellmell enthusiasm may be at times difficult to work with," but he urged Stryker to avoid further bitterness by reducing Lange to a temporary status instead of terminating her altogether.[38] Stryker's reply was coolly appreciative, but he defended his decision:

I am sure I did what anyone in my place would have done. I selected for termination the person who would give me the least cooperation in the job that is laid before me. I can assure you this was no easy job. I think I appreciate as fully as anyone, perhaps more so, the contribution Dorothea has made to the photographic file of the FSA, and certainly to

the presentation of the migrant problem to the people of this country. I know that judgments of art are highly subjective. And yet, subjective or not, I had a decision to make, I made it to the best of my ability.[39]

Lange's termination was final, and Stryker told Lee that she took it very hard: "It has been very apparent in her letters and to date I have had no letter in her old style."[40] She completed the captioning for her last field trip and submitted her final work to Stryker. It was an unpleasant parting with some bitterness on both sides, also involving staff members in the regional office in San Francisco.

Stryker and Lange's relationship remained cool for a short time, but eventually their mutual respect overrode the tension arising from her termination. They remained good friends and often consulted each other on issues related to the development of documentary photography. In later years, they minimized the problems they had had working together and emphasized instead the excitement and satisfaction of working and learning together on a project of such magnitude.

In 1938, Lange and Taylor had begun working on a book about the exodus from the land, a subject they had been documenting together since 1935.[41] The book was to represent ideas Lange developed working for the FSA; that is, it was to be a synthesis of words and photographs presenting the social and economic changes of rural America. Stryker had given her permission to "take out a little time now and then" from her FSA responsibilities to work on the book. She did not consider it primarily a personal venture. "It has been done from the first from the point of view of revealing and communicating a national problem," she wrote Stryker. "It's all the same job and when it comes out it will further your purposes, I hope."[42]

Books combining photographs and text had been published throughout the Depression, and they were a major channel for making the public aware of the problems the nation faced. Archibald MacLeish's *Land of the Free*, "photographs illustrated by a poem," and H. C. Nixon's *Forty Acres and Steel Mules*, on southern agriculture, are among the strongest examples of the new forms. Unlike any of the others, Lange and Taylor's book was a direct outgrowth of their documentary field method. In their foreword, they explained, "We use the camera as a tool of research. Upon a tripod of photographs, captions, and text we rest themes evolved out of long observations in the field. We adhere to the standards

of documentary photography as we have conceived them. Quotations which accompany photographs report what the persons photographed said, not what we think might be their unspoken words. . . . So far as possible we have let them speak to you face to face."[43]

Another team had published a similar book two years earlier. The author Erskine Caldwell and the photographer Margaret Bourke-White had spent the summer of 1936 traveling through nine southern states, gathering material for their book, *You Have Seen Their Faces*.[44] Photographs with quotations as captions, interspersed with pages of text, explained the situation they had found. Lange and Taylor's book was designed with a similar format; however, Caldwell's skill was in fiction writing, and his text lacks the depth of perspective that Taylor brought to the pattern of interlocking economic, social, and political forces. Unlike Lange and Taylor, Caldwell and Bourke-White did not probe into the relationships between southern agriculture and the rest of the nation. The captions they used were not direct quotations from the people they photographed; they were synthetic statements based on conversations, combined with the author's conceptions of what people in the photographs appeared to be feeling. *You Have Seen Their Faces* is a dramatic and moving account but lacks the depth, scope, and accuracy of Lange and Taylor's book. Lange explicitly rejected parallels drawn between the work done for the two books, because the methods set them apart. Lange saw her work with Taylor as being more closely aligned with that of Margaret Mead and Gregory Bateson, two anthropologists who had used photography in their study of socialization in Bali.[45]

Paul Kellogg, a friend and the editor of *Survey Graphic*, suggested that Lange and Taylor call their book "An American Exodus," an apt title for a study of the dramatic forms of migration throughout the nation.[46] They were anxious to have the book published as quickly as possible, so that it would not be a history. Taylor said they "were trying to spread the information of the current conditions and the need for doing something about it now."[47] They found a publisher in the summer of 1939, and the book came out that fall.

With the war raging in Europe and Americans gearing up for entry into the conflict, the book did not find many readers. The problems described in *An American Exodus* faded away as migrant workers got jobs in the shipyards and defense plants, and agricultural production soared. The publisher finally remaindered the book, and Taylor bought a dozen copies himself for a dollar apiece. Despite favorable reactions from Stryker, Eleanor Roosevelt, and others

who shared a concern for the problems described in *An American Exodus*, Taylor said that "it didn't have its chance at the market for which it was intended."[48]

Although the book emphasized a phase of American history that faded rapidly after 1939, it explained changes in rural life and trends toward urbanization that are still in progress. Furthermore, *An American Exodus* demonstrated the value of photography as a tool for exploring social conditions, and a method of combining photographic and verbal documentation in the creation of a substantive, moving description of the pattern of people's lives.[49]

Officially, the Historical Section of the FSA ended when it was incorporated into the Office of War Information in 1942. The value of the file, however, continued to grow. The passage of time has brought about a different perspective on the photographs made by the FSA photographers. Today their work is seen as a survey with a far broader application than it had when it was made—"a kind of timeless life panorama of great dramatic richness."[50] Lange later called it "a repository of cultural history that only gradually has crept into people's consciousness."[51]

Her contribution to the file also increased in value. Each time FSA photographs are published or exhibited, her work forms a significant part of the display, out of proportion to the amount of time she actually worked for the FSA.[52] And the words she recorded have continued to be coupled with her photographs, increasing the power of her work and of the file as a whole. Excerpts of her conversations with the people in her photographs were included, for example, in "The Bitter Years" exhibit, organized by Edward Steichen for the Museum of Modern Art in 1962.[53] Since her death in 1965, Lange's reputation as a documentary photographer has continued to grow, based largely on the work she did with the FSA. *An American Exodus*, the photography she did on a Guggenheim Fellowship the next year, her work for the government during World War II, her photo essays for the picture magazines, and the photographs she made of her own family were shaped in part by ideas she had developed during her four-year association with the agency.

Chapter VII

Photography on
the Home Front

With the FSA behind her and her book off to the publisher, Lange began to look for new work. Reopening her portrait studio or pursuing commercial photography would have meant retreating from the social science exploration to which she had devoted the previous five years. And picture magazines did not appeal to her. Other FSA photographers, including Rothstein, had been attracted by the salary and excitement of working for a fast-paced national magazine.[1] But Lange was neither looking for a national reputation nor willing to forfeit the personal control over the presentation of her photographs that the magazines demanded. She also had strong reservations about photographing only the newsworthy in the journalistic sense. The challenge of creating a national document was in her blood. As she wrote Stryker early in 1940, "Once an FSA guy, always an FSA guy. You don't easily get over it."[2] Clearly, her wish was to continue on the FSA team, but barring that possibility, she would settle for a similar project of photographic documentation.

By 1940, such opportunities were available. The FSA team's solid reputation for documentary photography encouraged other government agencies to follow suit. Photography exhibitions, no longer dominated by the salon photography of

the previous decade, now included sections devoted to documentary work.[3] And documentary photography was given recognition within the fine arts; the Museum of Modern Art in New York had included in its newly formed photography collection examples by Lange and other documentary photographers. This respect for documentary photography was fanned by the rising war fever. After America entered World War II, the urge to document the conflict from beginning to end grew. Photographs were used, not only for the record, but for intelligence, reconnaissance and propoganda purposes, as well as for journalistic information. The fact that ultimately all the photographs were to serve in the interest of national defense placed rigid contraints on the photographers. Wartime photography had its own set of rules, from procedures for getting clearance before photographing even the most innocent subject to censorship of the final print.

From 1940 to the end of the war, Lange found ways to continue documentary work. It took her first into government cooperative communities, then to traditional utopian communities, and after Pearl Harbor, into the camps where Japanese Americans were forcibly evacuated during the wave of racist hysteria that swept the West Coast. Her attitudes toward each of these subjects and her accommodation to the climate of the war are reflected in her photographs.

In February, 1940, Lange was hired as head photographer for the Bureau of Agricultural Economics, an agency within the Department of Agriculture that was carrying out an ongoing study of rural American life.[4] For Lange the occasional assignments that the bureau gave her during the year provided a natural extension to her previous work, and her approach varied little from the one she had used as an FSA photographer. On brief trips in California and Arizona, she made a series of photographs of people working on the cotton farms and wrote up long general captions describing the farming operations, the economic organization, and the social structure.[5] She found a few good camps operated by some of the cotton growers, labor contractors, and the FSA; but many others were unsupervised and had no sanitary facilities. Drawing on a WPA study of housing and social conditions, she described the situation and wove it into the larger pattern of migratory labor. A particularly poignant series of photographs she made of a small family stranded in an old trailer in the middle of a barren field, she titled with irony, "Children living in a Democracy."[6] She edited out some of this work for her personal file.

44. Auto Camp at Edison, Kern County, California, April, 1940, by Dorothea Lange. "Children of young migratory parents. They originally lived in Texas." The day before, their parents "traveled 35 miles each way to pick peas. They worked 5 hours each and together earned $2.25." National Archives, Photo No. 83-G-24-41542

Meanwhile, in hopes of being able to carry out an extended piece of social research, Lange had submitted an application for a Guggenheim Fellowship in photography. She proposed a photographic study of several religious cooperative societies, to determine the reasons for stability and continuity in communities that had tried radical social experiments. She was also curious about the quality of life in communities where people worked collectively for the good of the whole. The proposal was an obvious extension of ideas she had developed while photographing the cooperative projects of the FSA, and she was excited at the prospect of spending a year devoted only to this project. When notified that the proposal had been accepted, she was elated. Lange was the third photographer to receive the prestigious Guggenheim award.[7]

Lange selected three such societies: the Amana Colonies, the Shakers, and the Hutterites. She perceived three different patterns in their social organization and hoped to make comparisons among them. The Hutterites were prosperous but quite rigid—"very stark and bleak and very degrading of their people." The Amana Colonies were less constrained in their social organization and also had a sound economic base in furniture and household appliance manufacturing. The furniture no longer followed traditional designs—it was redesigned for a wider market—but exhibited a high quality of craftsmanship. The Shakers, on the other hand, were rapidly disappearing as a group but had maintained the beautiful simplicity of the traditional designs in the furniture and tools they made.[8]

Lange and Taylor started out in July, 1941. They traveled through Utah and Wyoming to South Dakota, where she photographed the Hutterites; drove down into Iowa to photograph the Amana Colonies; and then went to the Amish communities of Illinois. In Arthur, Illinois, as they had expected, they found a prosperous, if somewhat austere community: substantial farm houses without curtains, rugs, or shutters; no electricity, telephones, or cars; and strong resistance to using machines on their farms. A grade school education was quite sufficient for their children; above that level, she was told, they only learn how "they can cheat you."[9]

On returning home in early September, Lange developed the film and wrote Henry Allan Moe, head of the Guggenheim Foundation, that despite a few problems, she was encouraged by what she saw in her negatives and was "having a great time working." However, Lange looked back on this trip as having come during a difficult time. "I was tired out to begin with, truly exhausted from many duties and set out with a sense of depletion, pushed by Paul and his energies. It

45. Amish People, Arthur, Illinois, 1941, by Dorothea Lange.
Oakland Museum

was the beginning of my Guggenheim, which I cherished, but the circumstances were not right for me."[10] Her depleted energy must have been one reason they turned back after photographing in Arthur. And, before she had a chance to rest up for a fall trip to Utah to photograph several Mormon communities, her plans were interrupted by a family crisis. Her brother, Martin, was arrested and charged with fraud against the state unemployment insurance fund, and Lange felt she had to help him through the trial in whatever ways she could. She received a two-month leave of absence from her Guggenheim work.[11]

Throughout that fall, America's entry into the war appeared imminent and, according to Taylor, this was the most important factor in Lange's decision to postpone her Guggenheim indefinitely; the cooperative societies were strangely out of step with world war.[12] By the time World War II ended, the nation had undergone radical changes, and Lange said that she herself had come out "in a different place." Returning to the religious cooperative societies would have been "like going back into photographing something that was a relic."[13]

While Lange was photographing farm communities out of the nineteenth century, her former colleagues in the FSA were being urged to document the country's prosperity and preparedness for war, to obtain photographs "which show a hellish lot of food," Stryker told them.[14] They were frequently asked for identification and often had to check with local military officers before making any photographs. As early as June, 1940, Lee had been mistaken for a German spy while working in New Mexico, and such challenges grew more frequent as the months wore on.[15] The FSA and its Historical Section were clearly on the decline, weakened by attacks from Congress concerning its usefulness and by indecision within the agency about the direction it should be going.[16] One of its final tasks was to relocate farm families displaced when the government bought their land for war-related installations. The FSA was also responsible for insuring the proper use of land evacuated by Japanese Americans imprisoned in concentration camps.[17] It is a sad irony that the agency which had worked for six years to find ways for Americans to become self-sufficient on their own land was, in the final chapter of its history, participating in a program to remove people from their well-established, prosperous farms.

The "relocation" was the culmination of racism that had been active on the West Coast since anti-Japanese legislation at the turn of the century had limited Japanese migration and leasing of land. The irrational hysteria following Japan's

attack on Hawaii forced 110,000 Japanese Americans into concentration camps—70,000 of whom were citizens born in the United States.[18] The first step in officially legitimizing this operation occurred on February 19, 1942, when President Roosevelt, under pressure from military leaders and congressmen from the western states, signed Executive Order 9066, authorizing the establishment of "military areas. . . . with respect to which the right of any person to enter, remain in, or leave shall be subject to whatever restrictions the Secretary of War or the appropriate Military Commander may impose in his discretion." The next month the War Relocation Authority, a civilian agency at the federal level responsible for carrying out the order, was established. A new terminology was quickly developed to conceal the discriminatory aspects of the operation. People born in Japan and prevented by law from becoming American citizens were called aliens, though some had lived in the United States for as long as forty years. Their American-born children, who were citizens, were called either nonaliens or Nisei (second-generation Japanese) and were classified 4C by the Selective Service—"aliens ineligible to citizenship."[19] The Issei (first-generation Japanese), the second-generation Kibei (educated in Japan), and the Nisei were all placed in camps scattered throughout the nation's most desolate regions, primarily in the western states.[20] High level officials pondered what the camps should be called: "Lt. Col. Karl Bendetsen, representing the Provost Marshal's Office [U.S. Army], and Assistant Secretary of War McCloy urged the term 'concentration camp' not be used. He recommended the phrase 'reception center' for the first phase and 'resettlement center' for the rest. Dr. Dedrick [Bureau of the Census] said he agreed on the terminology and added he had thought of calling the whole thing a 'residence control program'."[21]

Despite fancy semantics, "relocation centers" clearly were concentration camps. Japanese Americans were forced to sell their land, homes, and businesses at a great financial loss and take only what they could carry to the camps. Families were confined to poorly ventilated two-room barracks with communal toilet facilities. They were subjected to loyalty tests and censorship of their mail and newspapers, could receive visitors only on a restricted basis, and were not allowed to leave until they had official clearance. Some people lived under these conditions for four years.

The explanation for this massive injustice was military expediency. According to military commanders, many Japanese Americans were assumed to be loyal to the United States, but there was no way of efficiently separating this

loyal majority from those contemplating acts of sabotage. Throughout the entire war, no incidents of sabotage by Japanese Americans were established, either in Hawaii or on the West Coast. Eventually, the absence of acts of disloyalty became a basis for internment; the army's "Final Report" on the relocation stated, "The very fact that no sabotage had taken place to date is a disturbing and confirming indication that such action will be taken."[22]

More frightening than the total lack of justification for the internment on military grounds was the willingness to waive the civilian authority, whose primary responsibility was checking the abuse of power by the military. The checks and balances built into the War Department by a civilian administration were ignored for military reasons that had no foundation whatsoever.

The treatment of enemy aliens was based, not on issues of military necessity, but on the issue of race. There was no internment of American citizens of German or Italian descent; nor was there any action taken against Japanese Americans in Hawaii, where they formed over one-third of the population and were two thousand miles closer to Japan. Arguments made for waiving the rights of Japanese Americans could have been made more legitimately for German Americans and Italian Americans. For example, Japanese-language newspapers were pointed to as evidence of continued loyalty to Japan, although only 19 of the 1,076 foreign-language newspapers in the United States in 1937 were Japanese, compared with 197 in German and 135 Italian papers.[23] Japanese Americans were accused of maintaining dual citizenship, since Japanese law based citizenship on descent rather than on nation of birth. However, recent legislation in Japan made it easier for people to give up their Japanese citizenship. Although German and Italian law defined citizenship more rigidly according to descent, German Americans and Italian Americans were not accused of being dual citizens.

Newspaper headlines declared, "Treachery, Loyalty to Emperor Inherent Japanese Traits"; official military reports called the Japanese "an enemy race"; on the floor of the House, John Rankin of Mississippi argued for putting all Japanese in "concentration camps." "Damn them, let's get rid of them now!" he said.[24] As cases went up through the courts to the Supreme Court, the suspension of Japanese Americans' rights was upheld.

Most of the civilians involved in implementing and documenting the evacuation and imprisonment were appalled by the operation and were dedicated to insuring that it be carried out as humanely as possible. Families were kept in-

tact; there were no beatings or tortures in the camps; limited self-government was enacted; classes were held for children and adults. And in many ways, the internment did function to "Americanize" the people in the camps. However, this in large part was the result of uprooting people and putting them in a disorienting new environment.

The complex reasons for photographing the evacuation and internment were to show how humanely it was being done, to insure that the maximum consideration would be shown to the victims, to show the inhumanity of imprisoning people who are guilty only by reason of their race, and to fulfill the bureaucratic desire for a record of the operation from start to finish. There was no team of photographers like the FSA Historical Section, dedicated to creating a historical document. Several FSA photographers, including Lee, documented portions of the evacuation, but these photographs received little attention at the time, and the FSA was too close to dissolution for the photographs to form a significant part of the file. Within the War Relocation Authority, a number of photographers were documenting the operations of their agency, but there was no attempt to coordinate their work as a team effort. Several of them had been newspaper photographers, but none of them had a background in documentary work similar to Lange's.[25]

In the spring of 1942, she went to work for the War Relocation Authority under its first director, Milton Eisenhower, and remained on the staff for a year and a half.[26] Motivated by her anger at the injustice of the entire operation, Lange's photographs document many aspects of the relocation. She photographed people in rural and urban areas, preparing to leave their homes and businesses. The initial evacuation was to several assembly centers, and she photographed people moving into the Tanforan and Stockton racetracks, which were converted for this purpose. People were then moved from the assembly centers to desolate camps such as the Manzanar Relocation Center, which she photographed as it was gradually transformed into a community of relative charm and comfort.

Lange's documentation of these events is comparable to that of her friend Ansel Adams in his treatment of the camp at Manzanar. Adams, though too old for military service, wanted to do something to contribute to the war effort.[27] Appalled by the injustice of mass internment, he desperately wanted to show the loyalty of Japanese Americans, as a way of easing the discrimination they were likely to face upon leaving the camps. This opportunity came when, a year after Lange had begun her work, Ralph Merritt, director of the Manzanar Reloca-

tion Center, asked Adams if he would be willing "to interpret the situation as it had developed in time."[28] As Adams explained to his friend Nancy Newhall, the object of the project, which he undertook for no pay, was to clarify the distinction drawn between loyal citizens of Japanese ancestry and the disloyal Japanese citizens and aliens. In documenting life in the camp, he wanted to emphasize individuals, hoping to draw attention to the fact that they were loyal Americans whose constitutional rights were being violated.[29] His photographs of Manzanar appeared in an exhibit and in the book *Born Free and Equal*, which he assembled in 1944.[30]

Adams, however, would not go so far as to state, either in his book or in looking back on the episode, that the internment as a whole was unjustified: "The fact remains that we, as a nation, were in the most potentially precarious moment of our history—stunned, seriously hurt, unorganized for actual war." From his point of view the incarceration represented a temporary threat to democratic principles, and Manzanar was "only a rocky wartime *detour* on the road of American citizenship, it is a symbol of the whole pattern of relocation—a vast expression of a government working to find suitable haven for its war-dislocated minorities."[31]

Lange's approach to her War Relocation Authority assignment, on the other hand, was motivated by her belief that the evacuation and internment were totally without legitimate foundation. The only part of the operation that Lange considered justifiable was the camp at Tule Lake where "actively disloyal" Japanese were segregated. The Japanese Americans she knew, many of them her husband's university students, impressed her with their loyalty to the United States. She photographed the University of California student who achieved the highest scholastic record of the class of 1942, a Japanese American unable to receive the award in person because, as the university president announced, "His country has called him elsewhere."[32] Yet her documentation emphasized these individuals only as a way of pointing out that no Japanese American, no matter how exceptional, was excluded from the government's judgment of mass guilt.

This assignment offered Lange an opportunity to document a highly significant social phenomenon. She saw the evacuation and internment, unlike the Depression, as having a "sharp beginning to it, a sharp end." However, the further Lange got into the project, the broader she found it, for example, as she came to understand the connection between the evacuation and the history of

agriculture in California.[33] She also wanted to follow up as Japanese Americans were released, to learn how the forced confinement had changed them. A major conflict arose within her because, although she knew her photographs would not be used as she wanted, she felt it essential that this chapter of American history be documented.[34]

Despite the differences in their attitudes, Lange and Adams considered their work on the Japanese internment to be documentary photography. In 1935, Adams wrote that "the most important contemporary photography is that which related to the contemporary scene and the contemporary aesthetic tendencies," and he used Lange's "White Angel Breadline" as a significant example of this genre.[35] However, Adams believed that the subject itself was not so important as the photograph of the subject. He was critical of photographers who tended to "transfer the importance of *subject* to the *photograph of the subject* without actually achieving importance or quality in the photograph." "A commonplace picture of a person or persons may evoke a tremendous reaction because of the subject alone," Adams argued, "irrespective of the communicative, interpretive, or esthetic quality of the image itself."[36] Without these qualities, the documentary photograph would remain a shallow representation of only the immediate impression of the subject.

For Lange, a photograph that effectively presented the human condition became a significant document when it related the individual subject to its social, cultural, and sometimes its geographical environment. Like Adams, she felt this required going beyond the surface appearance of the subject, but she placed far less emphasis than he on the delicate balance of the technical and aesthetic aspects of making a photograph. To Adams, the primary significance of a documentary photograph was the virtuosity of its aesthetic performance; to Lange it was the photograph's social impact. In this respect, Lange, unlike Adams, was on familiar ground as she documented the internment.

Prior to the evacuation, Lange photographed the everyday life of the Japanese Americans—their farms, the large old row houses in San Francisco where many of them lived, the street life of that neighborhood—which gave way to confusion and worry as the exclusion orders were posted and people were forced to sell their possessions and register. The impact of the war runs throughout her photographs, which show advertisements for defense bonds and newspapers bearing headlines with news from the front—a constant reminder that misguided patriotism and fear were behind the evacuation.

46. San Francisco, April 7, 1942, by Dorothea Lange. "While American troops were going into action on far-flung fronts, residents of Japanese ancestry were being evacuated from this neighborhood on Post Street." National Archives, Photo No. 210-G-2A-69

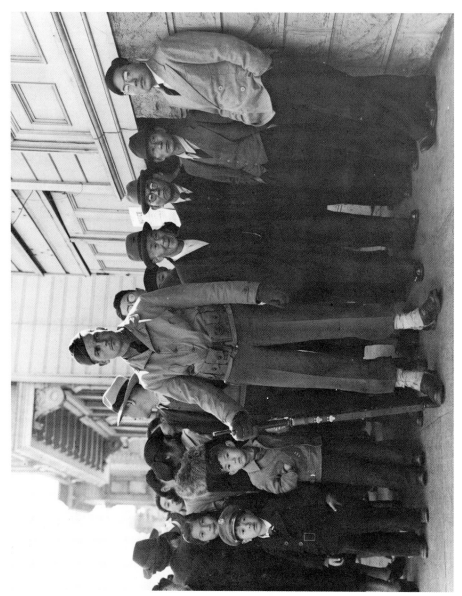

47. April, 1942, by Dorothea Lange. "A crowd of onlookers on the first day of evacuation from the Japanese quarter in San Francisco, who themselves, will be evacuated within three days." National Archives, Photo No. 210-G-2C-426

Lange's photographs emphasized the pride the Japanese had in their work and in their successful American-born children. They included a sixty-four-year-old man who had emigrated to the United States at the age of nineteen. His daughter and son-in-law operated a large prosperous farm. Another depicted an elderly man who had operated a dry goods store in San Francisco for forty years; his son, a college graduate, shared the business and was raising a family of his own. Lange followed these and other families through the sad procedures of closing down their homes and businesses in the spring of 1942. Throughout the process, she found examples of the loyalty many people had for the United States: a large sign stating "I Am an American" was proudly displayed on the window of a Japanese American business, and an elderly Japanese-born man wore an American flag button when he went to register for evacuation. Throughout Lange's notes and captions are scattered references to the people against whom no allegation of guilt could possibly be made: the Japanese American doctors and nurses who took responsibility for the mass inoculations before being evacuated along with the others; the aging Japanese-born women, proudly casting their first vote inside the barbed wire at Manzanar; the people with as little as one sixty-fourth Japanese ancestry who were imprisoned with the rest. It was this pattern of mass blame and its effects that Lange wanted her photographs to reveal, not any one family but the range of family businesses and farms of years standing, bought out by junk dealers, destroyed by the evacuation.[37]

Lange's photographs of the registration and evacuation operations show the people's sadness and concern in the face of degradation and the pride they maintained as, dressed in their best clothes and wearing identification tags, they quietly passed by armed guards. She was sensitive to such small, touching aspects of this upheaval as a pile of luggage in front of a sign with a falsely reassuring message and a woman wiping her eyes just before the train moved out of the station to Merced Assembly Center.

Lange photographed the process of transforming the assembly and relocation centers from horse stables into cozy dwellings, while Adams photographed the completed community—landscaped gardens and comfortable little cubbyholes where families lived. The differences between their photographs is due in part to the time that elapsed between them. Also, Adams wanted his photographs to reassure rather than upset the American public by revealing the success of the Japanese Americans' adaptation. His desire was translated into images of smiling people and serene landscapes. Consequently, his documentation of Manza-

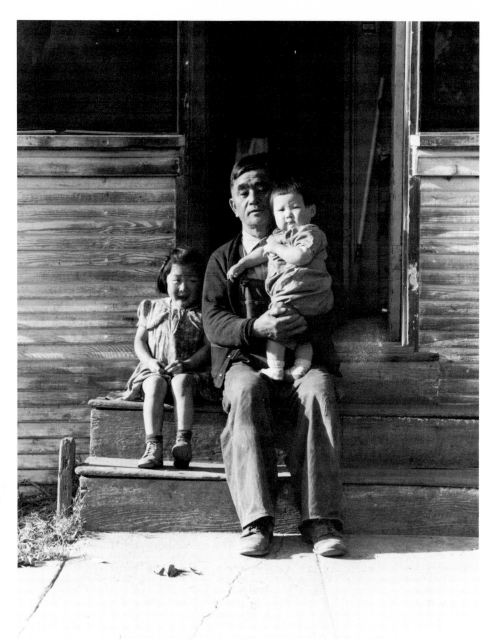

48. Mountain View, California, April, 1942, by Dorothea Lange. "Grandfather of sixty-four who came to the United States from Japan at the age of nineteen. He now lives with his daughter and son-in-law, Henry Miterai, a prosperous farm operator, but will soon be evacuated."
National Archives, Photo No. 210-2A-536

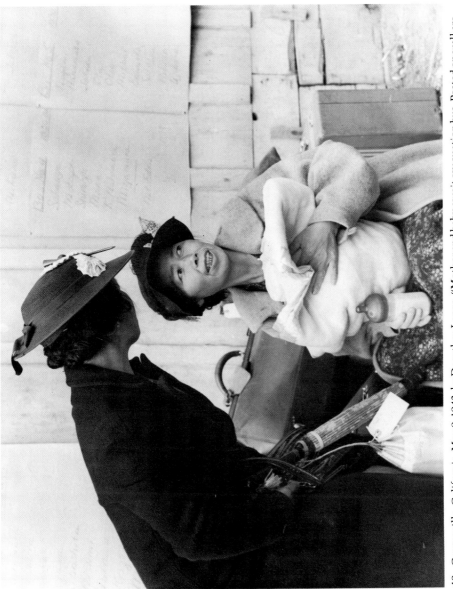

49. Centerville, California, May 9, 1942, by Dorothea Lange. "Mother and baby await evacuation bus. Posted on wall are schedules listing names of families, buses to which they are assigned, and times of departure." National Archives, Photo No. 210-G-2C-234

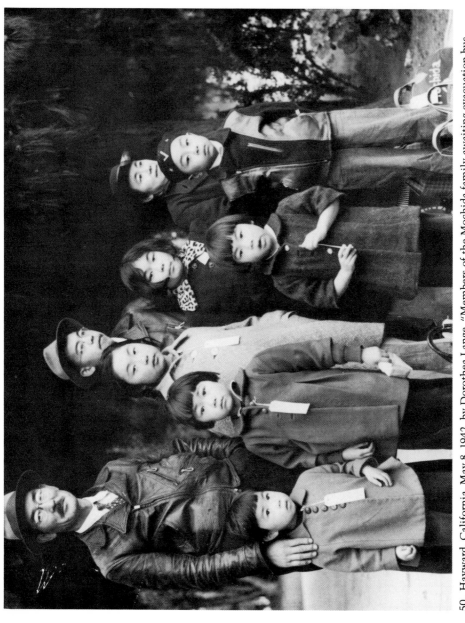

50. Hayward, California, May 8, 1942, by Dorothea Lange. "Members of the Mochida family awaiting evacuation bus. Identification tags were used to aid in keeping the family unit intact during all phases of evacuation. Mochida operated a nursery and five greenhouses on a two-acre site in Eden Township." National Archives, Photo No. 210-G-2C-153

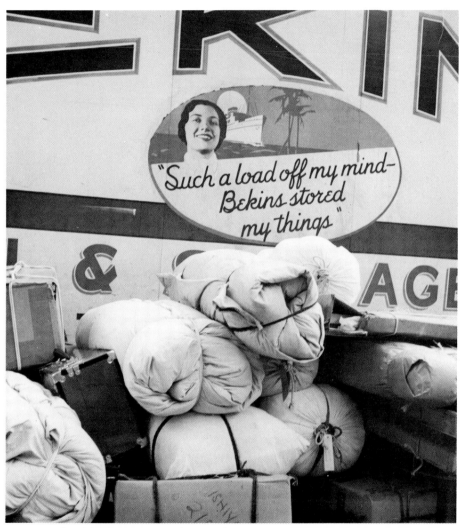

51. Hayward, California, May 8, 1942, by Dorothea Lange. "Baggage of evacuees of Japanese ancestry ready to be loaded on moving van."
National Archives, Photo No. 210-C-149

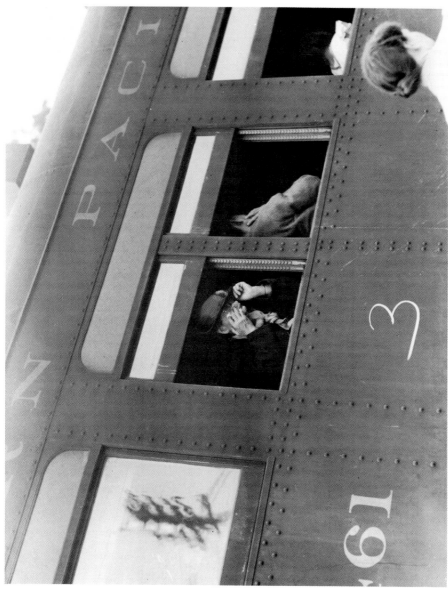

52. Woodland, California, May 20, 1942, by Dorothea Lange. "Ten train cars are now filled with evacuees and the doors are closed. . . . Evacuees are leaving their homes and ranches, in a rich agricultural district, bound for Merced Assembly Center, 125 miles away." National Archives, Photo No. 210-C-514

nar is static, not showing the activity that had gone into its creation. Lange created a more dynamic view of the life of the people by showing the social processes underlying the development and continued existence of the community.

Lange and Adams looked for evidence of the care people had taken to make their small barracks comfortable and homelike. However, his images of families inside the barracks conceal the smallness of the rooms and the relationship between the cozy interiors and the harsh exterior. The little touches of home life he photographed—the arrangement of letters and family mementos—are intimate but give no evidence of the environment from which they grew. Lange's photographs showing the way people adapted to the environment include the everyday sight of crisp curtains at the windows and laundry hanging out to dry against the context of barren barrack walls and cramped quarters. She made fewer photographs at the Manzanar barracks than at the assembly centers where people were crammed into horse stalls. Her photographs of home life present a harsher view than Adams' photographs, for in most cases they include reminders of how little the people had to work with.

A significant portion of Adams' book is devoted to the small businesses and enterprises that grew in the camp: the garment designer working in the cooperative garment factory at Manzanar; the mechanic servicing the tractors and other farm equipment; the artist designing signs and posters in the commercial art studio. Adams portrayed these activities as opportunities the people were given to pursue vocational interests and to develop skills they could apply after leaving the camps. Part of his goal was to show the readers of his book that these were skilled people, serious about their work and able to make important contributions to any community; they were not wasting away at Manzanar.

Lange was more cynical about these activities, which she saw as stemming entirely from the ingenuity of the incarcerated. She said their work was totally isolated from the larger American community: "None of it extended outside the watchtowers; . . . they were not allowed to compete in any way, not even in the making of souvenirs, with the American business."[38] She saw none of the continuity of maintaining and developing business skills that Adams regarded as a strength of Manzanar. In her captions, Lange told of the man who had owned the successful dry goods store or the farmer who had raised select varieties of chrysanthemums for eastern markets, implying that these skills were being wasted in the camps. When their imprisonment was over, they would have to start all over again.[39]

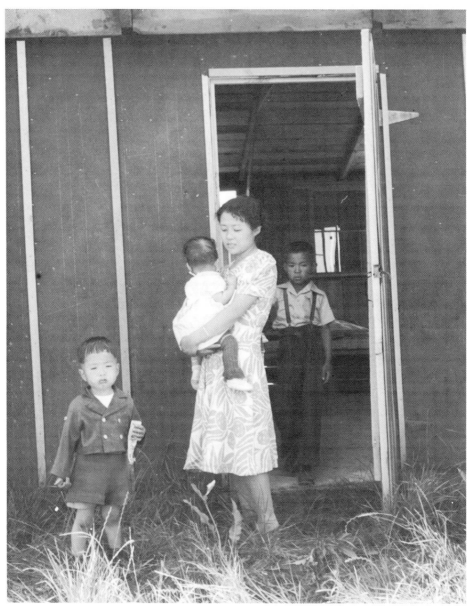

53. Stockton Assembly Center, May 19, 1942, by Dorothea Lange. "The mother and children wait at the door of the room in the barracks to which they have been assigned, while the father is at the baggage depot where the bedding and clothing are being unloaded and inspected for contraband." National Archives, Photo No. 210-G-2C-408

54. Vegetable Garden Mrs. Fujita Planted in Front of the Barracks, Tanforan Assembly Center, June 16, 1942, by Dorothea Lange.
National Archives, Photo No. 210-C-611

55. A Young Lawyer and His Family, Manzanar Relocation Center, 1943, by Ansel Adams.
Library of Congress

56. The Pleasure Park, Manzanar Relocation Center, 1943, by Ansel Adams.
Library of Congress

57. Manzanar Relocation Center, October, 1943, by Ansel Adams. "Interior view of the barracks quarters of the Yonemitsu family. The portrait is of their son Robert, who is serving in the U.S. Army's Japanese-American Combat Team. Next to his portrait are some of the letters he has written to his sister."

Library of Congress

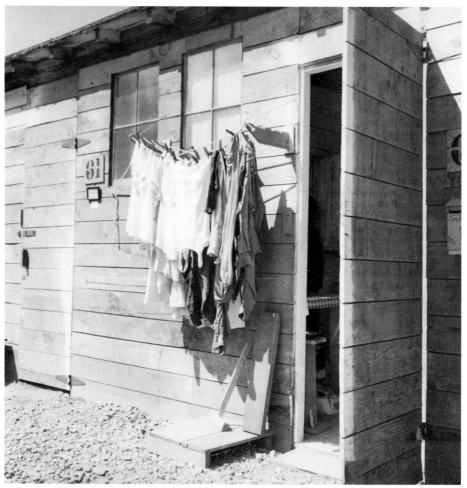

58. Tanforan Assembly Center, San Bruno, California, June 16, 1942, by Dorothea Lange. "These barracks were formerly horse stalls. Each family is assigned two small rooms. The interior one has neither door nor window."
National Archives, Photo No. 210-C-598

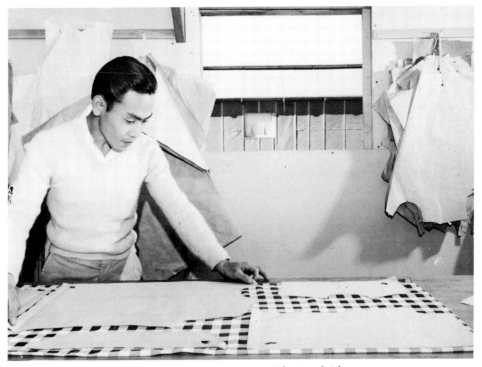

59. Cutting Patterns, Manzanar Relocation Center, 1943, by Ansel Adams.
Library of Congress

Consistent with his emphasis on the individuals at Manzanar, Adams included in his book more close-up portraits of single persons than any other type of photograph. Most of his subjects were photographed against plain backgrounds in natural outdoor light, often in their occupational dress—a priest in his robe, a nurse in her uniform, a corporal in military dress. People associated with indoor activities were photographed with a simple two-flash arrangement approximating natural room light. Adams kept his technique simple for these portraits, because, he said, "Not only does the subject react unfavorably to waiting, but prolonged arrangements and setting up lead to a 'posed' feeling, which of course defeats the mood of reality. Reality and conviction are absolutely essential in any photo-documentation; and the natural cooperation of the subjects must be secured from the start."[40] These photographs appear to have been done according to a method he had described in an earlier article: "I photograph heads as I would photograph sculpture . . . the head or figure is clearly presented as an

object. The edge, mass, texture of the skin and general architecture of the face and form is revealed with great intensity. . . . The expression—many possible expressions—are implied."[41] His subjects at Manzanar are carefully posed yet seem relaxed and natural. Many do not confront the camera directly, appearing comfortably removed from the photographer and the viewer.

Lange made far fewer direct close-up portraits, and her subjects appear less controlled, even slightly uncomfortable having their photographs made at such close range. Yet her portraits appear to be more spontaneous than Adams', and the slight sense of awkwardness between the photographer and subject make her photographs less formulaic than his.

The geography of Manzanar was important in the lives of the residents. Diaries and reports from each of the camps include descriptions of the harsh wind blowing layer upon layer of dust through the cracks in the barrack walls and of the extreme heat and cold. Adams, far more than Lange, believed that placing a subject in a context meant revealing the individual's relationship to nature, to geographical environment.[42] His affinity for the beauty and harshness of the natural environment comes through in virtually all his work, and his photography at Manzanar was no exception. He had photographed in the Sierra Nevada range for many years, and when he went there again in the fall of 1943, he wrote: "In these years of strain and sorrow, the grandeur, beauty, and quietness of the mountains are more important to us than ever before. I have tried to record the influence of the tremendous landscape of Inyo in the life and spirit of thousands of people living by force of circumstance in the Relocation Center of Manzanar. . . . I believe that the acrid splendor of the desert, ringed with towering mountains, has strengthened the spirit of the people of Manzanar." Adams interpreted the relationship of the people at Manzanar to their environment as a triumph, for the beauty of the place helped them develop the strength and courage to convert it into a livable community: "The huge vistas and the stern realities of sun and wind and space symbolize the immensity and opportunity of America—perhaps a vital reassurance following the experience of enforced exodus," he wrote.[43] His most stunning photographs show the spread of rugged mountains and sky, without any evidence of the camp. When he photographed the rows of barracks, they were dwarfed by the majesty of the mountain range behind them, and thus the personal hardship of the place was deemphasized.

From Lange's perspective, the physical environment of Manzanar epitomized the oppression of its residents. The heat, the dust, and the extreme cold were a

challenge to be sure, and the people reacted to the challenge with strength and courage. According to Lange, environmental hardships were part of the pattern of obstacles these people faced, not vehicles for developing qualities of personal strength and spiritual freedom. Adams' photograph of people working in the fields is dominated by the pattern of the cultivated rows at the foot of the towering mountain peaks, whereas Lange chose a closer perspective of the people bent over rows of corn growing up through the dry soil. On her three trips to Manzanar, Lange photographed the landscape—the rows of barracks standing in the open plain at the foot of the mountains and the dust storms that swept through the camp. She did not make any photographs of the majestic landscapes apart from the camp environment.

Lange's skill in documenting the internment lay in her ability to develop a natural relationship with the people she photographed. People who have worked with Adams and Lange have said that there was no comparison between them in this respect; Adams was far less sensitive to the emotional tone of human relationships than Lange.[44] It has been said that Adams, able to photograph "rocks as if they were people," presents people "as if they were rocks."[45]

He consistently placed more emphasis on technical skill to achieve a meaningful aesthetic representation of the subject. "Perfect technique," he said, "is really more an *attitude* than a command of apparatus and chemicals."[46] Technique, including the equipment used and the processing of photographs, should only be as complex as necessary for the subject matter; yet it should also be flexible enough to allow for changing conditions.[47] In his "Note on Photography" at the end of *Born Free and Equal*, Adams specified the camera, lenses, and developers he used.[48] Nowhere did Lange ever systematically specify the cameras and lenses she used on this project.

While photographing at Manzanar, Adams had the full cooperation of his subjects and the camp overseers. Lange, on the other hand, had problems getting military clearance, and her photographs were censored. She described her working situation as being extremely difficult: "I had a lot of trouble, too, with the army. I had a man following me all the time. . . . The War Relocation Authority themselves were out of sympathy with the army in some respects at that time. The whole thing, the feelings and tempers and people's attitudes, were very complex and heated." She had to get clearance for everything she photographed, and she always carried letters proving her official status. However, she never felt she was under any suspicion from her subjects—a situation, she said, that would

60. Corporal Jimmie Shohara Home from Training Camp, Manzanar Relocation Center, 1943, by Ansel Adams.
Library of Congress

61. Young Man at Manzanar Relocation Center, July 3, 1942, by Dorothea Lange. "His Caucasian wife is living with him in the camp, together with their small child." National Archives, Photo No. 210-G-C-711

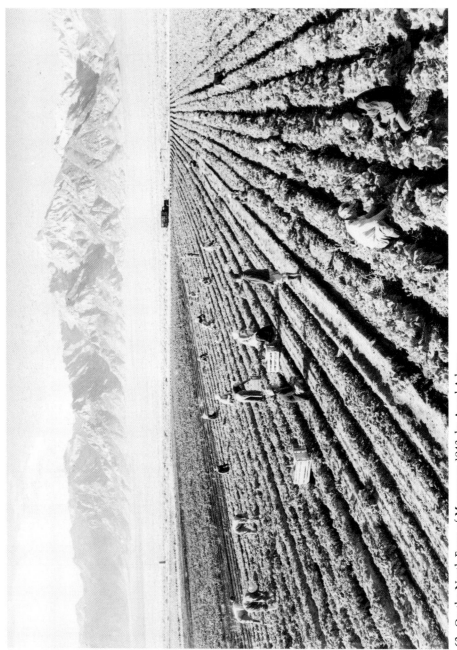

62. On the North Farm of Manzanar, 1943, by Ansel Adams.
Library of Congress

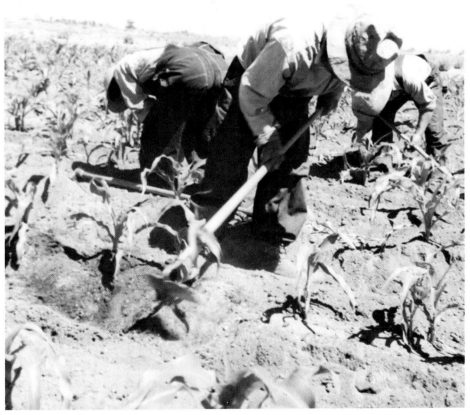

63. Field Laborers Hoeing Corn, Manzanar Relocation Center, July, 1942, by Dorothea Lange.
National Archives, Photo No. 210-C-764

have made her work impossible. There is evidence, though, that at least some of the people who were being evacuated resented the presence of official photographers.[49]

Lange had a reputation for what Adams has called "advanced political liberalism," and her sympathies with the Japanese Americans were well known.[50] At one point she thought she was being officially investigated about her attitudes toward the operation, and on two occasions she was called to the War Relocation Authority office to account for the alleged misuse of her photographs. She suspected that the officials were merely trying to trap her in both cases. This aura of suspicion made her work difficult and limited her photography far more than it had been when she worked as a government photographer during peacetime.[51]

Because of the sensitive nature of the subject matter, both Lange and Adams had difficulty getting their work before the audiences they wanted to reach. Adams' exhibit, scheduled for the Museum of Modern Art, was canceled at least once. Before it finally opened, in November, 1944, it was revised to give more emphasis to the artistic qualities of Adams' work. And, under considerable pressure from his publisher, U.S. Camera, Adams had to compromise on the content, quality, and format of his book in order to get it published quickly and at a cost most people could afford. Despite widespread favorable reviews, many of which mentioned the contribution *Born Free and Equal* could make to national tolerance of the Japanese Americans, the book did not sell well outside San Francisco. Because each of his previous books had sold out, Adams attributed this poor showing to U.S. Camera's "cold feet" about actively promoting a book on a sensitive topic.[52] He even had reason to believe that the publisher had destroyed a vast number of the books.[53] Suppression of such a positive view of life at Manzanar indicates the degree of tension surrounding the issue of Japanese American participation in American society.

Lange's work received even less attention than Adams' at the time, and few of her photographs were published. Although the army wanted a record, it did not want a public record. A Major Beasley working with the Wartime Civil Control Agency went through Lange's photographs and marked many of them IM-POUNDED, not for release until after the war. These included many photographs that were made in the assembly centers when the people were first admitted, others that showed people working on national defense projects within the camp, and some that implied the people were imprisoned. One of the last group

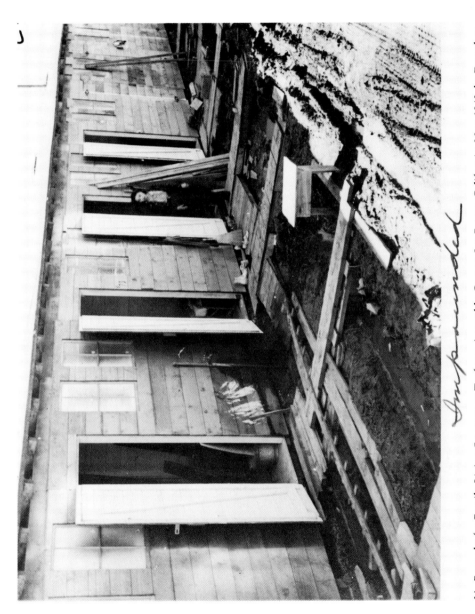

64. Barracks for Family Living Quarters at Tanforan Assembly Center, San Bruno, California, May, 1942, by Dorothea Lange.
National Archives, Photo No. 210G-3C-324

showed men working in a greenhouse where the lattice pattern of the roof cast shadows of bars across them.[54]

A few of Lange's photographs were used in pamphlets during the war, for instance, in the report of the Select Committee Investigating National Defense Migration, headed by Representative John Tolan of California.[55] One of the photographs they selected from Lange's work was also used by Caleb Foote, a pacifist who put out a small publication on the evacuation. Major Beasley challenged Lange's right to let this man publish the photograph, but it was an empty threat since the Tolan committee had already published it. In another instance, an old woman died during the internment, and Lange received permission to give a photograph of her to the family.[56] For the most part, however, the photographs were used very little, and Lange's concern that she had no control over their use proved to be justified. Unsure of her success on this project, it was years later before she saw that she had effectively revealed portions of the tragedy.[57]

Lange thought Adams had not gone far enough in his condemnation of the camps. Although she had tremendous respect for him as a craftsman and an artist, she strongly disagreed with the positions he took on social issues. She disregarded the constructive role Adams' more positive view might have played in encouraging widespread acceptance of Japanese Americans. Instead, she evaluated *Born Free and Equal* as being simply a repetition of the official justification for the camps. She said that even though his book was "shameful," he was not "vicious" in his approach; and she admitted that, given his social attitudes, "it was far for *him* to go." To her, his ignorance in matters of social conflict and change meant that he supported the institutional rationale justifying the internment.[58] Adams was displeased with the technical quality of the book and its narrow circulation but took pride in his documentation. "The people had done a wonderful job of adjusting to the inevitable," Adams later said, "and I think that my series of pictures and the text of my book was a rather acceptable interpretation. It did not have the tragic overtones of Lange's work, although there was always a lingering sense of resentment and regret."[59]

Lange photographed other aspects of the effect of World War II on Americans. Between 1941 and 1949, the federal government invested over $1 billion dollars in the construction of new industrial plants in California, with an additional $400 million dollars coming from private investors. This was all new industry, not conversion from previous businesses as in other states. California's population

increased by one-third, and employment increased by half again what it had been in the late thirties.[60] "These were defense years, war years, shipyard years," Lange said. "Everyone was working and there was overtime and swing shift and graveyard shift. And everyone in the family worked, and the migratory workers settled down and slept under a roof. And the Negroes kept coming in droves, leaving the cotton fields of the South. And everyone was welcome!"[61] This was the atmosphere that Lange tried to capture in the photographs she made in the cities around San Francisco Bay.

She did much of her work in recording the changes in the California economy from poverty to wartime prosperity independently. Occasionally she did assignments for *Fortune* magazine, working with Adams to show the changes the war had brought to Richmond, California. They did other stories together on the new industries and on California agriculture for both *Fortune* and the Office of War Information. Despite Lange's and Adams' different approaches to photography, they found working on these assignments rewarding, as each of them concentrated on what seemed most important to him or her.[62]

Working independently, Lange photographed workers coming off their shifts in the shipyards, people crowding the streets of Oakland and Richmond, their arms full of groceries, and the "signs of the time," as she called them. The signs were all part of the process of small towns along the Bay becoming cities and blending into each other to form a huge metropolitan area. Many years later, upon finding a photograph she had made at the end of a shift in Richmond, Lange recalled: "It was a mass of humanity, from all parts of the country. They had their tin hats on, and they came down in this *river*. But what made the photograph so interesting was that they were all looking in different directions. They were *not* a group of people united on a job. It showed so plainly—a very revealing photograph."[63]

Using her home as her base throughout this period, she would take her cameras out for a day or an afternoon of shooting. She was not always pleased with the results of her efforts; her notes show that she went back eight times to the Tenth Street Market in Oakland to photograph the people with their groceries. "Never did get anything very good," she wrote, but at least one photograph taken at this market went into her retrospective exhibition, to show the "new California."[64] Lange said that she was watching a curious world grow up before her eyes, and with her camera she attempted to scrutinize and explain what she saw.[65]

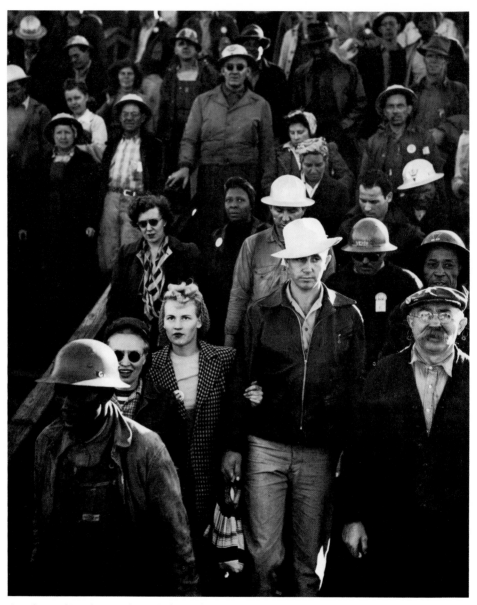

65. Shipyard Workers at the End of a Shift, Richmond, California, 1942, by Dorothea Lange.
Oakland Museum

66. Tenth Street Market, Oakland, California, 1942, by Dorothea Lange.
Oakland Museum

In 1943, Lange went to work for the Office of War Information, to interpret "the American spirit to war-torn Europe."[66] She photographed minority groups within the United States for the agency's magazine, *Victory*, a large-format publication distributed throughout Europe. Copies of the magazine, which appeared in different versions and languages, were dropped from planes in advance of American troops—in Italy and Yugoslavia, for example—and distributed throughout the neutral nations.

It was clearly propaganda, but that did not bother Lange: "Everything is propaganda for what you believe in, actually, isn't it? . . . The harder and more deeply you believe in anything, the more in a sense you're a propagandist."[67] She did not regard her work as advertising but as the conscientious expression of her beliefs. Thus, her work for the Office of War Information was not so different from her work for the FSA or the War Relocation Authority. With Adams, Lange made photographs of Spanish American agricultural workers at Vacaville and Italian Americans in Los Angeles.[68] She also photographed the Yugoslav Americans near San Pedro. In each case, she photographed the life and work of the people—their food, shopping areas, style of dress, places of work. She had to be careful that her photographs did not "look as though during the war we had a surfeit and plenty to go to people who were suffering the ravages of war."[69] In *Victory* there was no mention of racial problems or the internment of the Japanese Americans; America was made to look like a country of equal opportunity for all.

Lange had to get military clearance for each assignment, and she was forbidden to photograph certain places. In a letter to Stryker, she described an assignment in Los Angeles as "a tough job for more than one reason—had me just about licked, what with clearances from army, navy, Coast Guard, etc. etc. to get into the area where the Jugo-slavs are (fishermen), then fog and no boats and couldn't get a bed to sleep in for love nor money—so had to drive 40 miles each way etc. etc. The life of a documentary photographer in war-time is quite a thing to tackle in this area."[70] After making the photographs, Lange usually developed the negatives and made some initial work prints, which she documented with individual typed captions. There was lots of paperwork, but she was not allowed to hire an assistant, except occasionally when she had to carry her equipment over long distances.[71] All the material was turned over to the Office of War Information, which did the layouts for the different versions of the magazine and rewrote the captions for different language groups. The photographers were never credited for their work in *Victory* magazine.

Beaumont Newhall recalled picking up a copy of *Victory* when he was in Italy during the war and finding a photo essay on the "Four Freedoms" that looked like the work of photographers he knew. He sent the article to his wife, Nancy, who wrote back that, yes, the photographs were by Lange and were part of an assignment she did with Adams.[72]

Victory was not distributed in the United States. It was an ephemeral publication, now difficult to locate. The fact that individual photographers were not credited makes it impossible in many cases to establish who made the photographs. At the end of the war, all Lange's negatives and prints for the Office of War Information were lost in transition from the New York office to the Washington headquarters. The only record in Lange's files is a few "duplicate and unsuccessful negatives," which were not pertinent to the particular stories she worked on.[73] Thus, it is impossible to reconstruct her work during this year and a half.

It was 1945 and the war was drawing to a close when delegates from around the world gathered in San Francisco to draw up the charter for the United Nations. Lange was there, making photographs for the Office of War Information, which had been transferred to the State Department. The assignment marked the end of the Roosevelt era, in which she had begun her most important work, as well as the beginning of a new international agency that carried many hopes for a future of peace for all people.

Lange was worn down and experiencing severe abdominal pain. The stream of wartime work had taken its toll, and her doctors warned her that she should be taking it easy, cutting back on the amount of work she was doing. "How can a photographer take it easy?" she asked, and continued to work.[74] It proved to be too much for her. A few weeks later she was in the hospital being treated for gall bladder disease. The operation did not relieve her symptoms, and the following March she was operated on again, this time for a duodenal ulcer, a serious ailment with a long and painful recovery period.[75]

The illness brought an end to Lange's career as a government photographer. Except for an occasional afternoon out with her camera, it was eight years before she began to work again, cautiously going out to make some photographs of San Francisco street scenes, testing her eye to see if she still had the photographer's vision she had cultivated over many years of hard careful work.[76] She never fully regained her strength; the remaining twenty years of her life were marked by

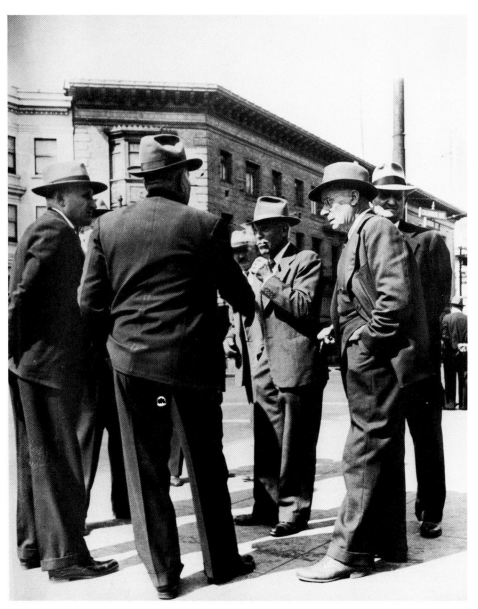

67. Freedom of Speech, by Dorothea Lange.
National Archives, Photo No. 208-VM-IV-32

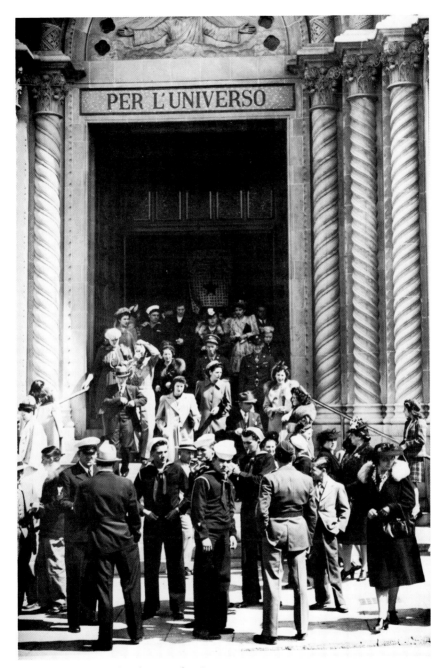

68. Freedom of Worship, by Dorothea Lange.
National Archives, Photo No. 208-VM-IV-33

periods of chronic fatigue and recurring illnesses. To continue to photograph at all, she was forced to change her approach to her work by choosing short assignments and leaving time enough between them to restore her energies. In light of a reevaluation of her own capabilities, she began, in her postwar work, to redefine what documentary photography meant to her. She began to turn inside herself, to use her camera to speak of what was close and meaningful to her own life.

Lange's wartime photography has received far less attention than the photographs she made during the Depression, and the body of her work from this period is sadly truncated. Yet there is her record of America's version of concentration camps—a powerful reminder of the injustice brought on by racism and wartime hysteria. Lange's War Relocation Authority photographs have been used as visual evidence in many of the books that document the internment of Japanese Americans.[77] The published photographs are not credited to her but to the agency, and they are scattered among the work of other photographers. Lange's work stands out, however, for she was the one who showed most effectively the toll the evacuation and internment took on its victims.

Japanese Americans have remembered her contribution. When she died, her obituary appeared prominently in the San Francisco *Nichi-Bei Times,* a daily Japanese American newspaper, and told of her empathetic record of their hardship.[78] In 1967, on the twenty-fifth anniversary of the evacuation, the Japanese-American Citizens League awarded an honorary plaque to Taylor, in recognition of the contributions he and Lange had made.[79] Simply knowing that a photographic record of the experience exists has helped the victims work through the painful memories. Jeanne Wakatsuki Houston, a Japanese American who spent part of her childhood at Manzanar, described the effect of meeting a woman— probably Lange—who had photographed in the camp. Houston said she could barely speak to the photographer, although she desperately wanted to: "It was not the pain of memory. It was simply her validation that all those things had taken place. Someone outside the close community of Japanese-Americans had actually seen the camp with its multitude of people and its swarm of buildings on the plain between the mountains. Something inside me opened up then. I began to talk about it more and more."[80]

It was 1972 before public attention again focused on the effect of Executive Order 9066. Maisie and Richard Conrat assembled an exhibit and a book of pho-

tographs and written documentation on the impact of the evacuation.[81] The bulk of these collections was Lange photographs. The Conrats had become familiar with her work when Richard was her assistant during the last two years of her life. An hour-long NBC television documentary, *Guilty By Reason of Race*, covered the exhibit, and included interviews with Japanese Americans and other persons involved in the evacuation. And the program included many photographs, over half of them by Lange.

Her photographs are seen as evidence, not simply as good examples of graphic design or objects of art. When the "Executive Order 9066" exhibition went to the Museum of Modern Art, reviewer A. D. Coleman wrote in the New York *Times* that Lange had served "as our national eye of conscience in the internment camps. Her constant concerns—the survival of human dignity under impossible conditions, the confrontation of the system by the individual, and the helpless innocence of children—were perfectly suited to the subject." Her photographs, he wrote, "happen to be superbly made pieces of evidence, documents of such a high order that they convey the feelings of the victims as well as the facts of the crime. But there is no way of abstracting oneself from them . . . no way to step back into an appreciation of their composition or tonal range."[82]

A few years before she died, Lange talked about how long ago the tragedy of the internment seemed. That in itself she found heartening, she said, because the ability of the American people to admit the mistake of Executive Order 9066 was "a sign of our mental health."[83] Her photographs have helped us to remember that tragedy and to confront a great error in our history. Perhaps they can also help us prevent its repetition.

Chapter VIII

The Golden Age
of Photojournalism

W hen Lange cautiously picked up her camera again, the nation had returned to "normalcy" and begun an era of unprecedented prosperity. The peace of the Eisenhower years was marred only by the specter of cold war and its heated embodiment in McCarthyism. White Americans migrated, not from blown-out farms to burgeoning defense plants, but to the spanking new suburbs. From that insulated vantage point, they watched on their televisions the McCarthy hearings, the nation's first war in Southeast Asia, Sputnik's ascent, Cuba's fall, and school desegregation. Their primary concern was their children's education: Were they learning as much, or as fast, as their Russian counterparts? Were they being taught about the evils of communism? How would going to school with Negroes affect their education and their social lives?

The big, shiny picture magazines such as *Life* and *Look* were particularly suited to telling armchair America photographic stories about people and events around the world. *Life*'s staff of photographers had grown from four in 1936 to forty-five in 1952, with another forty-five regularly hired for special assignments. Of the 350,000 photographs a year presented to the editors, 200 were selected for each issue.[1] *Look*'s photographers made fewer pictures, 150,000 a

year, and 160 a week were published.[2] In comparison, the FSA's file of 270,000 photographs, culled over a six-year period, looks meager.

Of the 500 or so photographs shot on a single *Life* or *Look* assignment, 5 to 15 were brought together into an essay form, which used short captions and a small body of copy to complement the telling photographs. The photo essay had come a long way from the few small photographs used to illustrate the gray copy in the magazines of the early thirties. After *Life* and *Look* began publishing, the photo essay evolved into a highly sophisticated form, drawing the viewer to the print only for more information on these intriguing, often beautiful images. Seldom were these photo essays direct; even when the topic was shocking, its treatment was generally tasteful and suitable for the family audience.

Life and *Look* photographers were the first to have a mass audience for their work and the first to consistently receive a credit line. Henri Cartier-Bresson, the French pioneer of 35mm. photography, said: "It is the magazines that produce for us a public, and introduce us to that public, and they know how to get picture-stories across the way the photographer intended. But sometimes, unhappily, they distort them. The magazines can publish exactly what the photographer wanted them to show; but the photographer runs the risk of letting himself be molded by the taste or the requirements of the magazines."[3] Robert Frank, who had to go to Europe to find a publisher for his antiheroic book of photographs, said that during the fifties, "the *Life* magazine view of photography was on top."[4] The magazine photographer enjoyed the high status of those whose work brings both fame and an exciting life. According to *Life's* long-time editor Wilson Hicks, the photographers who worked for the picture magazines combined the attributes of the pictorial photographer, who was concerned with presenting the beautiful; the "old-line news photographer," who worked on newspapers; and the "documentarian," whose photographs often included a social viewpoint.[5]

The FSA's Historical Section is often credited with having inspired many of the magazine photographers and indeed the magazines themselves.[6] Certainly the FSA photographers interpreted events of the 1930s to a mass audience, and several members of the FSA later worked for *Life* and *Look*. Yet this group included none who specialized in spot news photography, a skill the magazines required in addition to an ability to interpret unfolding events. As Roy Stryker said, "We had no people especially gifted at knowing how to get the dog fight, how to get to the place where the excitement was, point a camera and get out."

Even when the magazine photographers worked on subjects of social signifi-
cance that required a thoughtful examination, they pushed for the dramatic,
eye-catching view. Stryker, who became critical of the magazines, recalled an
argument he had with a *Life* photographer and editor over how to present the
family of a drowning victim: "The *Life* men argued that it would have been a
better picture had the photographer taken it from the front. I could not possibly
agree. Theirs was the attitude of the news photographer—always show the face,
even if it's awkward. . . . Too often what is communicated by this kind of over-
statement, this reliance on the obvious, is not the essence of the situation, but
only the insincerity of the photographer."[7] Stryker urged his photographers to
avoid overstatements. The only exception was when photographers were shoot-
ing something for possible use in a picture magazine; then Stryker encouraged
them to use unusual angles, for example, to heighten the drama of the subject.[8]
FSA photographers had been characterized as propagandists, a label few of them
shied away from, and the editors of picture magazines did not want their pub-
lications to be viewed in this light.[9] As Hicks stated, the magazine photograper
"is most interested in finding drama in everyday life, in singling out the com-
monplace, in delving into human problems; unlike the documentarian, he is
not interested in doing so only for the purpose of social criticism, or to plead a
cause."[10]

The photographers working for the picture magazines were young and aggres-
sive for the most part and prided themselves on their versatility, both in the
equipment they used and in their ability to adapt their technique to any subject.
According to Hicks, on his staff at *Life*, "the never-ending, daily demand is for
the photographer who can 'cover anything.'" The ideal photographer, he said,
was one-half picture taker and the other half technician, artist, reporter, stage
director, athlete, ballet dancer, and diplomat.[11] The four photographers who
were on the staff when *Life* began in 1936 filled this bill: Margaret Bourke-
White, who had done photo essays for *Fortune* magazine before most American
photographers knew what a photo essay was, whose story on life in Montana
boom towns had been on the cover of *Life's* first issue, and whose book, *You
Have Seen Their Faces*, was to receive prominent coverage in the magazine;
Alfred Eisenstaedt, a German immigrant who had made dramatic photographs
illustrating Mussolini's power and had documented the Italian invasion of
Ethiopia; Thomas McAvoy, who had spent ten years as a newspaper photogra-
pher before becoming a successful free-lance photographer; and Peter Stackpole,

THE SOUTH OF ERSKINE CALDWELL IS PHOTOGRAPHED BY MARGARET BOURKE-WHITE

Author and Camerawoman collaborate on book showing decline of Cotton Country

Through his novels, short stories and his fabulously successful play *Tobacco Road*, it has been the aim of Erskine Caldwell, son of a Georgia Methodist minister, to depict the most squalid and turbulent jungles of the South. In Northerners his dramatic prose has wrung degrees of incredulity, amusement, revulsion; in Southerners varying degrees of resentment against the author.

Several months ago, Mr. Caldwell sought for his *tour histoire* a medium more vivid than language. Teaming up with Photographer Margaret Bourke-White he journeyed through the South's worn-out agricultural empire, visited sharecroppers and tenant farmers, blacks and whites. The result, a 95-picture book, *You Have Seen Their Faces*, was published by the Viking Press, Nov. 4.

Critics at once remarked two motifs in the volume: the ugly economic tragedy of the sharecropper, already intimately familiar to the U. S. public; and the strange mordant humor that runs through all of Mr. Caldwell's work. Beneath LIFE reproduces a few of the pictures that are both most poignantly the sharecroppers' peculiar fatalism and the bitter laughter that even hunger cannot obscure on their lips. Quoted captions are by Mr. Caldwell.

"I SPENT TEN MONTHS GETTING PLANKS TO BUILD THIS HOUSE AND THEN THE FLOOR WASHED THE RAIN OFF. DOGGONE IF I DON'T LIKE IT BETTER"

Marshall, Arkansas: "It never fell much like Sunday to me until I pitched the guitar away."

Ross Bell, Arkansas: "I reckon when that automobile was a mighty pretty thing to ride around in."

CONTINUED ON NEXT PAGE

Clinton, Louisiana — In the shadows of this great portico, Margaret Bourke-White and Erskine Caldwell saw the ghosts of the South's depleted cotton empire. Mr. Caldwell quotes this woman as saying: "I don't know what ever happened to be family that built this house before the War. A lot of families live here now. My husband and me moved in and got two rooms for five dollars a month."

69. Pages from an article on the book *You Have Seen Their Faces*, with photographs by Margaret Bourke-White. Reproduced by special permission from *Life*, November 22, 1937, © Time Inc.

who had established himself as a formidable free-lance news photographer in California and was working out of San Francisco for *Time* magazine when he began doing stories on the side for *Life*.[12] The pattern was similar, if slightly less glamorous, for the *Look* staff. All had the versatility of the experienced news photographer and the creative energy to push their photography toward new definitions of photojournalism.

They were also able to adapt to editor-dominated publications. Usually they were out on assignment when their next assignments were being drawn up. And when they returned with their film, the editors and art directors decided how their photographs were to be used. Their job was to make photographs showing every possible aspect of the situation, so that their editors could have maximum flexibility in laying out the story. Beaumont Newhall told of Eliot Elisofon's description of shooting for *Life* magazine: "You have to show all the buildings that are around, so that you can show you couldn't get up on top of a building because there wasn't any there."[13] The few photographers who were not willing to submit to this regimen yet kept their positions on the staff were those who made themselves indispensable to the magazine. Bourke-White maintained both her strong individualism and her job. In her twenty years as a *Life* photographer, the magazine published more than a hundred of her photo essays on an astonishing variety of subjects, from the life cycle of the praying mantis to the battlefield of the Korean War.[14] W. Eugene Smith, whose sensitive photo essays on a Spanish village and a country doctor are hallmarks of magazine photojournalism, had difficulty compromising his principles to accommodate *Life*'s constraint. In 1954, Smith had undertaken a photo essay on Albert Schweitzer's hospital in Gabon after assuring Schweitzer that the piece would not focus on the doctor's eminence. When it became apparent that the editors were not going to respect this promise, Smith resigned in protest. On that occasion, he wrote: "I do not accuse them of lack of integrity, for as they relate within the concept framework of their magazine factory, as they relate to its dominant precedents, they are apparently sincere and honest men. However, I cannot accept many of the conditions common within journalism without tremendous self-dishonesty and without it being a grave breach of the responsibilities, the moral obligations within journalism, as I have determined them for myself."[15]

Lange, like Smith, had established herself as a photographer with a sensitive way of portraying the human condition, and the photo essays she did for the picture magazines are evidence of her ability to adapt to some extent to the

A Man of Mercy

Africa's misery turns saintly Albert Schweitzer into a driving taskmaster

"No one knows me," Albert Schweitzer has said, "who has not known me in Africa." In Norway last week, where he had come to acknowledge a Nobel Peace Prize, crowds jammed streets to cheer a great figure of our time. As they cheered they were convinced that they knew him well: he is the humanitarian, warm and saintlike. In full manhood he had turned away from brilliant success as a preacher, writer and musician to bury himself as a missionary doctor in Africa.

All this was truth—but admirers who have followed Dr. Schweitzer to French Equatorial Africa know a different man. There, amid primitive conditions, Europe's saint is forced to become a remote, driving man who rules his hospital with patriarchal authority. For those seeking the gentle philosopher of the legend, he has a brief answer: "We are too busy fighting pain." Then he turns back to the suffering and the work that make up the African world of Albert Schweitzer.

70. Page from *Life* article, with photographs by W. Eugene Smith.
Reproduced by special permission from *Life*, November 15, 1954, © Time Inc., and John Morris

constraints of magazine photojournalism. Besides doing four photo essays for *Life* (two of which were never published), Lange also synthesized a number of previous photographs she had made of American women for publication in the trade journal *Harvester World* and began work on a photo essay for *Look*, on the freedom her grandchildren experienced at the family cabin on the Marin County coast.[16]

It is curious that Lange's work did not appear more frequently in these publications, for her photographs had appeared in the picture magazines during the 1930s, and the work she did for *Fortune* and *Victory* during the war conformed to the format of *Life* and *Look*. In addition, Stryker, demanding as he was, had tolerated her strong-mindedness for several years because of the high quality of her work. Her previous work, however, was out of step with the prosperity and complacency of the 1950s, and throughout her career she had resisted being characterized as a news photographer.

Lange's approach to field work was certainly at odds with that common to the picture magazines. Bourke-White, who was able to spend over two years on assignments to India, where she explored that country's painful steps toward nationhood, was an exception to that pattern. Lange would have found intolerable the assignments of most of the magazine photographers. Their work often focused on such minor issues as the pattern of "going steady" that had emerged during the fifties, the popular dress designs from Paris, or a person currently in the limelight.

Lange's insistence on the autonomy of her work—her desire to see each assignment through to its final layout design and copy—would not have conformed to the practice of turning photographs over to editors for these crucial steps of constructing a photo essay. Nor was she pleased with her work when she had to follow a strict schedule defining time spent in the field and rigid publication deadlines.

Perhaps the overrriding factor that prevented more of her work from appearing in the magazines was her physical weakness. She could not have withstood the rigorous schedule required of a magazine photographer in the 1950s. She was handicapped in part by her age—"You know you can't do quite as much in your sixties as you could in your forties." But more serious limitations were forced on her by the chronic-ulcers that had ended her career with the Office of War Information in 1945.[17] Also, in the aftermath of her surgery, she had contracted esophagitis, a constriction of the esophagus that made it difficult to swallow

food.[18] She characterized the several years following as a "total loss" as far as her work was concerned, and the recurrence of the illness kept her in a weakened condition well into the fifties.[19] Taylor said, "She would get out with her camera on a narrow tether once in a while, go down into Oakland or a little further out, for a day maybe." But then she would have to spend time in bed, recuperating from the effort.[20]

The period of enforced inactivity was introspective for Lange. Her gradual acceptance of her physical limitations was coupled with a thoughtful examination of how she could adapt her photography to her curtailed strength. Narrowing the scope of her work, she began to focus on the more intimate relationships that had not been her primary concern when she was exploring larger social problems. She often talked over these ideas with friends and family; in 1952, Dan Dixon quoted her in an article he had written about her new direction:

In the past, events have always played a major role in the work I've done. First there was the depression, then the dust bowl, then the war. All of these were big, harsh, powerful things, and it was related to them that, as a rule, I tried to photograph people. Now, however, I'm trying to get at something else. Instead of photographing men in relation to events, as I have, today I'm trying to photograph men in relation to men, to prove the exchanges and communications between people, to discover what they mean to each other and to themselves.[21]

Lange was not seeking a new direction for its own sake; in fact, she was critical of the tendency among photographers to continually try for something different. They became so absorbed in their search for a new angle, she said "that they miss the world." Although a photographer should have some idea of how his or her work was to be used, she believed that "if you follow a subject or undertaking far enough there will be a place for it somewhere. A prime requisite for success is that the subject be something that you truly love or hate."[22] This belief is an intrinsic part of photographing the small exchanges from which human relationships are woven. The nuances of human communication are only apparent when one is photographing a subject one is personally involved with; showing relationships always entails a point of view.

Several years earlier, when Lange began to go through all her past work to regroup photographs in new ways, her emphasis on communication *within* photographs emerged. In 1948 she wrote Nancy Newhall that she had torn her studio apart and thrown away "mountains of photographic trash." She emerged with

groups of photographs held together, not by the time or place, but by certain ideas or emotional tones expressed in each and reinforced by the group as a whole. The first of these was a group of faces of American women, "all kinds, from all walks of life."[23] Eventually, she paired each portrait with a photograph of the woman's environment and published sets of these in two articles and, posthumously, as a book.[24]

Ten years later Lange's contribution to the Newhalls' *Masters of Photography* consisted of pairs of photographs. The following statement, which accompanied them, was not published until later: "I find that it has become instinctive, habitual, *necessary* to *group* photographs. I used to think in terms of single photographs, the Bulls-eye technique. No more. A photographic statement is more what I now reach for, therefore these pairs, like a sentence of 2 words. Here we can express the relationships, equivalents, progressions, contradictions, positives and negatives, etc. etc. Our medium is particularly geared for this. (I am just beginning to understand it.)"[25] Eventually, all Lange's photographs were thematically filed, together with notes, clippings, and examples of other photographers' work. She added to these over the years until finally her life's work, concretized in words and pictures, had been divided according to abstract concepts. "Killing Time" included photographs of people relaxing and notes on leisure ("time not owed to others"). "Pleasantries" contained mild photographic jokes like her husband's shirt hanging to dry in a Korean hotel room and a large Berkeley woman digging in her garden whom Lange had photographed from the rear. A phrase by Paul Vanderbilt, "not stateable, but photographable—therein lies the wonder," inspired the file she labeled "The Indescribables," in which she gathered photographs by Minor White, Wayne Miller, and Imogen Cunningham. There were dozens of such files.[26] Lange had a studio built in her garden and covered its walls with series of photographs and quotations she was combining. She asked friends and visitors for their reactions to them, and Beaumont Newhall said "it was always stimulating to see her latest 'show.'"[27]

The walls of Lange's studio were usually dominated by photographs of the familiar things around her. Because of her physical limitations, she had chosen subjects close at hand. More influential on her choice of subjects, however, was her increased appreciation of looking closely at everyday things: "I'm trying to do this in the most ordinary, familiar, usual kind of way. By this I mean the relationships of a gardener to the planting season, or of a young father to his first born son. Sometimes . . . these relationships can be comic, sometimes moving.

71. John, Helen, and Gregor. First Born, 1952, by Dorothea Lange.
Oakland Museum

But almost all of them are subdued and subtle, things you have to look very hard to see, because they have been taken for granted not only by our eyes, but by our hearts as well."[28] In contrast, she said that for the professional news photographer, "the spectacular is cherished above the meaningful, the frenzied above the quiet, the unique above the potent. The familiar is made strange, the unfamiliar grotesque . . . the world is forced by the professional into unnatural shapes. Landscape, season, occasion—these are compelled to a twisted service in which they need not be interpreted but, like a process, invented."[29]

Photographing the familiar meant working in the province where photography "proves to us how little our eyes often permit us to see" of our lives. Of the photographer's relationships to his or her subjects, Lange said: "Rather than acknowledge, he embraces; rather than perform, he responds. Moving in a world so much composed of himself, every image he sees, every photograph he takes becomes in a sense, a self-portrait. The portrait is made more meaningful by intimacy—an intimacy shared not only by the photographer with his subject but by the *audience*." She believed that "most of us live in worlds at least cousin to each other." In this regard, she thought of the photographs she had been making at the family cabin as possibly being appropriate for public display. For, she said, even when the photographer's world is unfamiliar to us, if he or she succeeds in capturing that secret and showing us, "we are, as always, warmed with the honor of being told."[30]

Most of Lange's themes communicated in ways others could share. "The Trees in All Seasons" in her yard, for example, which she had watched through the years of her illness, formed one group of photographs. Another, entitled "A Circle of Friends," showed family, neighbors, and close friends. "Home Is Where . . ." included, she said, "abstractions, or rather symbolic fragments to suggest Deep things about the place and what goes on here."[31]

Other photographs presented Lange's secrets, feelings many had not shared, which grew out of years of pain, illness, and memories of what it was like to grow up crippled. One series, begun as "Death and Disaster"—photographs of a family watching their home burn, a man with no legs, a defendant on trial—she thought of as showing examples from the lives of "the walking wounded." The theme of this group gradually evolved so that the title became "The Last Ditch." She described why this was also an example of her photographing the familiar: "You do, really, what you must do, no matter what it costs. And with me it was

always expenditure to the last ditch. . . . It is where you just can do no more. As I say, from childhood, I knew."[32]

Few such utterly personal statements are to be found in the picture magazines of the fifties. And because the magazines were geared to current events, the kinds of themes Lange was developing had no place in their pages. The pace and style of the magazine photographers' work was at cross-purposes with an introspective examination of their relationship to their subjects. The magazines were open to suggestions from their better photographers for assignments that the photographers were personally interested in pursuing. Bourke-White's photographic studies inside Russia, for example, grew out of her long-time fascination with the politics and economy of that nation, though assignments for *Life* often focused on Russia at war.[33] Her passion for flying can be seen in many of her photo essays, in which aerial photographs are used to establish the scene, and photographs of a variety of inhabitants round it out. Far less common was the photo essay on a photographer's own life and family. The one example that comes close to the work Lange did within her family is W. Eugene Smith's photo essay on his eight-year-old daughter, which made the cover of *Life*.[34] Despite many points of contrast between Lange's style and that of the magazines, her work did appear in several of them during the 1950s. Examining how she approached these few photo essays illustrates how they flowed out of her ideas on photography and her other work during this decade.

Lange initiated the four photo essays she undertook for *Life*. In 1954, she and Adams together developed the idea of photographing three Mormon towns, and they went to Utah with Taylor and her son Dan.[35] Taylor helped gather information for the article and Dixon wrote the copy. The next year she went to County Clare, Ireland, with Dixon to do an assignment they had developed on the subject of Irish country people. Another series grew out of her brother's trouble with the law, because Lange realized that the cost of legal aid, for which Martin had family sources to draw on, was far beyond the reach of the indigent. The rapidly spreading public defender system had begun in California in 1914, she learned, to provide attorneys' services out of tax funds. Lange proposed a story for *Life* on a public defender, and George Nye, the superior court judge at the Alameda County Courthouse, introduced her to Martin Pulich, the young lawyer with whom she worked closely on that assignment for a year and a half.

An essay on the fertile Berryessa Valley was another long-term project she

The Connecticut River

A MORNING MIST RISES FROM THE RIVER, ADMITTING THE SUN TO CLOTH-SHADED TOBACCO FIELDS BELOW MT. SUGARLOAF, MASS.

Man works to improve valley that served him well

PHOTOGRAPHED FOR LIFE BY MARGARET BOURKE-WHITE

As gently as sweet Afton, the Connecticut River flows through four states in search of the sea. Almost everywhere it meanders it gives New England a lovely old English look. In such rural reaches, as Sunderland near Deerfield (above) and in the towns that line its terraced banks, it preserves throughout its length a polite and placid air of domesticated tranquillity that few American rivers ever attain. The Connecticut has served man better than he has served it. It rarely rebelled while he stripped its forested slopes, polluted its waters and silted its bottom with topsoil. But at times it rose to repay his despoliation with disastrous floods. Now, for the first time since the white man wrested it from the Indians, one generation is in position to improve the river for the generations to follow. A comprehensive plan for reforestation, flood and erosion control has been drafted by the U.S. Forest Service and Soil Conservation Service and awaits state action. While it would cost $53 million (about half in public, half in private funds), it calls for no surrender of Yankee autonomy to a river authority, and in terms of readily realized benefits it would be fairly cheap as river rehabilitation goes. On these pages LIFE takes a tour of the endangered beauties and riches of the Connecticut to report on the commerce and culture it has spawned.

CONTINUED ON NEXT PAGE 123

72–73. Pages from *Life* article, with photographs by Margaret Bourke-White. Reproduced by special permission from *Life*, November 6, 1950, © Time Inc.

A new age, new pilgrims

The faces on this page illuminate the changing character of the population: now about 1,250,000 of the Connecticut River Valley. The English pilgrims who settled it first, outnumbering the Indians, are being outnumbered themselves, so that it is possible to drive the length of the valley and hear French, Polish, Italian but not a word of English on your car radio. Desc001 from the Vermont dairy farms, still largely operated by Yankees, the rich bottom lands and pastures are worked in a mixture of Poles, Lithuanians, Ukrainians, French, Irish and Italians. To many of them the culture represented by Amherst and Harriet Beecher Stowe is at first incomprehensible. But even while the Zakrzewskis have been inheriting the earth and the river, the Connecticut has been something of them in turn.

GREAT-NIECE of Harriet Beecher Stowe, Kate Day, lives in Hartford. Bust is of Uncle Tom author.

AMHERST PRESIDENT, Charles Woolsey Cole, stands in his institution-filled office beneath portrait of Lord Amherst, for whom the college town was named.

THE ZAKRZEWSKIS of Sandy Brookfield, Mass., are of hardy immigrant stock that has thrived and multiplied along the Yankee valley. The father, Alexander, came from Poland in 1905, worked as a farm laborer and miner, bought inland now grows onions and potatoes on his 26-acre farm, has nine children.

AT RIVER'S MOUTH the Connecticut flows past Essex, lower right, to meet the sea. The sailboats are in the fleet of the Essex Yacht Club. In the background U.S. 1 and the New York, New Haven & Hartford Railroad (on back) cross the river a mouth between pretty old towns of Saybrook, on the right, and Old Lyme.

132

133

BY W. EUGENE SMITH

My Daughter Juanita

A perceptive photographer displays the many moods of his 8-year-old

Most fathers take pictures of their children out of fondness
and their snapshots reveal more love than art.
Juanita Smith's father takes pictures of his daughter
not just because he is fond of her but because
she is a delightful photographic subject. And because
her father is Gene Smith, photographer of such distinguished
picture essays as "Spanish Village" and "Nurse Midwife"
(LIFE, April 9, 1951 and Dec. 3, 1951), his pictures
of Juanita (*see cover*) make an extraordinarily perceptive album.
 "I took my first picture of Juanita," writes Smith,
"when she was 2—walking through the woods with her brother.
Now she is 8, a child of easy intensity. Here she is sad-faced
but in a moment the mood will quickly dance away."

CONTINUED ON NEXT PAGE 165

74. Page from *Life* article, with photographs by W. Eugene Smith.
Reproduced by special permission from *Life*, September 21, 1953, © Time Inc., and John Morris

proposed to *Life*. A dam was under construction that would flood the area for the California coastal cities, and people were moving from the valley's farms and small towns. Lange asked Adams to work with her on the assignment and when he turned her down, she asked his assistant, Pirkle Jones.[36] He accepted and their work continued for a year and a half, concluding with photographs of the water flowing through the valley.

Each of these assignments required a different kind of intensity than Lange's work for the government had. Taylor described the difference: "When she was doing an article for *Life* she was focusing on a narrower subject; when she was out in the field photographing for the government, it was catch as catch can—whatever aspect of the general situation might pop up, we stopped by the road side and that she took. Whereas, for the three Mormon villages, you worked those villages and worked them over until you felt you had them presented. . . . When you were with the FSA, you grabbed what you saw."[37] Lange and Adams made hundreds of photographs in Utah, a pattern she followed on her other work with *Life*. The photographs during the two months in Ireland constitute the largest single set of photographs in her collection, four volumes of contact sheets. The public defender series fills another volume.[38]

Her primary camera was still a 2 ¼ Automatic Rolleiflex, the one she had used most often as a government photographer and which she believed offered the widest range of possibilities. She also used a 4 x 5 Graflex for "a very deliberate job," a 3¼ x 4¼ Zeiss Jewel for occasional landscape or architectural shots, and 35mm. cameras primarily for photographs of home and family, although she did take one to Ireland with her in 1955.[39] By that time, the 35mm. format had become standard for most photojournalists, but Lange felt that to be successful with a 35mm. camera, one had to use it exclusively on a job; otherwise it would become a "fill in" camera and would weaken the structural line of the job. "What the 35mm. camera can deliver is almost always within a certain stylistic frame. You accept that and there's plenty you can do within it. . . . But to have it in the car with you 'just in case' or to have it around your neck while you're using another camera and go from one to another, becomes a matter of adapting your style to too many different kinds of things. It jumbles you. It rocks you—which means you're always looking for the perfect camera."[40] For similar reasons she never used color film, either. "I am not very much in sympathy with color photography that is done on a 'switch on, switch off' basis with two cameras around

the neck," though she acknowledged some stimulating examples of color photography.[41]

As in her earlier work, Lange avoided using artificial light, except under "unbearable circumstances." She felt there was no substitute for natural light, even under conditions of near darkness.[42] For example, she made a set of photographs of an Irish woman in her dark cottage; in her notes Lange wrote, "Please print on contrast, never mind that there is nothing in the shadows; watch the face."[43]

Lange's camera technique and attitudes toward her equipment, although securely grounded in her philosophy of her own work, often appeared casual and even irritated other photographers. She was still insistent about maintaining personal control over the quality of her prints and the way her work would be used, but she had never been concerned about a precise shooting technique. Adams, in particular, was often annoyed at her apparent nonchalance in determining correct exposure. He, on the other hand, was meticulous, making careful meter readings and planning how he would develop the film to assure the best detail in his negatives. Ron Partridge, who had worked with both of them, said that Lange enjoyed teasing Adams about their different techniques. As Adams was carefully taking readings and figuring out how he would shoot a subject, he would turn to her and ask, "What are you giving it, Dorothea?" She would glance up at the sky and answer, "Oh, I don't know; f.11 at 125, I guess."[44]

Lange and Adams had other, more serious, difficulties working together in the Mormon villages. According to Adams, Lange and Taylor had gone to the church authorities in Salt Lake City and discussed a proposed photographic exhibition and a book but did not mention the *Life* magazine feature. Adams discovered this when they were working in the field and became extremely disturbed because he felt their work had been misrepresented to the Mormon people, an action he believed to be extremely unethical.[45] According to Taylor, who thought they had received clearance, when they arrived in the town of St. George, the local church authorities had been notified that an "unauthorized" party was coming to take pictures. At that point little could be done to smooth things over. They met with the church committee for several hours, and finally, when Taylor pointed out that he had helped make the photomural in their sanctuary at nearby Gunlock, they agreed to let Lange and Adams make photographs. They encountered fresh difficulties the following Sunday, however, for some of the people refused to attend church if photographs were going to be made during the service. Lange suggested that Taylor join the congregation in

the church, and immediately the atmosphere changed; they began to preach to Taylor the virtues of Mormonism, seeing him as a potential convert. Similar problems arose in the next town, but in the third, no questions were raised, and the bishop received them with open arms. The range of receptions made their work difficult, and having her motives questioned always bothered Lange very much.[46]

When the essay was published, further problems arose, for one woman demanded a thousand dollars, claiming that the photographers had misrepresented themselves to her.[47] The claim would not stick, but Lange and Adams were disappointed by the entire venture. As he wrote her later, "The fact remains that the Mormon Story turned out very sour indeed; a very inadequate presentation which did no good to the Mormons, to either of us, or to photography. It started off on the wrong track, and ended on one, frankly."[48] It is not surprising that Adams was not interested in working with Lange in the Berryessa Valley.

Obtaining signed blanket releases from her subjects was an important part of magazine photojournalism that Lange had difficulty learning. To her, the requirement implied that her motives were not in her subjects' interest. She and Dan Dixon failed to get these signatures or even the names of all her subjects while working in Ireland, and *Life* ended up sending two staff members back with the photographs to track down and identify the people. At other times, Lange retraced her own steps. She described going into a black neighborhood in Oakland with two policemen to locate the "witness" in her public defender series: "We rode around Oakland in a police-wagon while I explained to him just what this was about. That would have made an interesting tape, me explaining to this big, black homosexual why I wanted his picture, and his responses. It finally came round that if it was for the general welfare, he was all for the general welfare."[49]

With the exception of her work in the Mormon villages, however, Lange had few difficulties in her relationships with her subjects. Working closely with Judge Nye and Pulich on the public defender series really paved the way for cooperation from the people in the court. She had access to virtually all parts of the courthouse and did some surreptitious shooting, for example, of defendants' backs as they were being questioned by the public defender. However, she refrained from photographing when she felt it would be too much of an intrusion. Phil Greene, who worked with her on the series, described riding down in an elevator with a young man who had just murdered his wife. He was unaware of

75. Martin Pulich, Public Defender in Court, Alameda County Courthouse, 1957, by Dorothea Lange. Oakland Museum

76. Public Defender Talking to a Client, Alameda County Courthouse, 1957, by Dorothea Lange. Oakland Museum

her presence, in a state of shock brought on by grief and guilt, yet she did not photograph him, "newsworthy" and relevant to her story though he was. Similarly, she refrained from photographing the "Monday morning line-up" of prostitutes.[50]

Lange had a long-standing belief that cameras should not invade those moments of extreme stress when people are experiencing a loss of personal pride, and because of her emotional makeup, she could not bear to photograph the stark tragedy or horror that magazine photographers occasionally encountered. A comparison of her photographs in *An American Exodus* with those of Bourke-White in *You Have Seen Their Faces* reveals the effect of Lange's attitude; her subjects appear sad or even desperate, but they are not distorted by illness and poverty, as many of Bourke-White's subjects are.[51] Bourke-White was able to close off a part of herself when working among scenes of horror, as when she photographed the death camps at Buchenwald, only to be so deeply moved when she saw the results of her work that she wept and was incapable of looking at the photographs again for days.[52] She photographed the vultures eating victims of a Hindu and Muslim riot in the streets of Calcutta, but Lange could not even bear to ride through old Calcutta, the crippled beggars crawling around the car affected her so deeply.[53]

Lange was motivated to do the story on the Berryessa Valley with Pirkle Jones by her respect for the way of life that was rooted in the rich farmland and small towns there. As she and Jones explained, "It was a place of settled homes and deep loam soil. It was a place of cattle and horses, of pears and grapes, alfalfa and grain. It had never known a crop failure. . . . And the valley held generations in its palm."[54]

An essential part of the story recounted the way people there felt about the drastic changes the dam construction had brought to their lives. Greene accompanied Lange on several trips to the valley and described how impressed he was with her ability to converse with strangers on many different levels, from humor to serious discussion. One day, on their way to the valley, they stopped at a truck stop for a meal, and she joined a group of men who were talking. Within five minutes, Greene said, these men had accepted her into their group and she was cracking jokes with them.[55] She heard one of them, a construction worker, say, "Dammit, it's getting so a person can't stand *still* in one of these here fields without you get mowed down, raked up or painted."[56] As in her earlier work, this

77. Buchenwald, 1945, by Margaret Bourke-White.
Reproduced by special permission from *Life*, © Time Inc.

78. Dorothea Lange in the General Store at Monticello, Berryessa Valley, 1956, by Pirkle Jones.
Courtesy of Pirkle Jones

79. Woman of the Berryessa Valley, Memorial Day, 1956, by Dorothea Lange.
Oakland Museum

80. Farm Auction, Berryessa Valley, 1956, by Dorothea Lange.
Courtesy of Pirkle Jones

kind of exchange yielded conversational excerpts that added a down-to-earth richness to her documentation.

The last photo essay Lange proposed to a picture magazine was early in the 1960s. She had begun to make photographs of her grandchildren at the family's weekend retreat, a rough cabin on the rocky coast at Steep Ravine, in Marin County north of San Francisco. Out there, she sensed a quality of freedom creeping into the children's relationships that she believed was caused by the "wet and the wildness" of the place. She wanted to document this, not to show people having a good time at the beach, but to reveal the new levels the family found in their relationships there.[57] She took her idea to George Leonard, her friend and editor of *Look*. He was receptive to the idea and liked the few prints she showed him. However, Lange did not live to finish the story. Some of the photographs she made were gathered into a book by Margaretta Mitchell, a photographer who had spent time with her own family on the same spot.[58] One of the photographs was included in an article on Lange's work that *Look* published after her death.[59]

Lange had played a role in the editing and layout of the photo essays she did shoot, subject to the approval of the magazine editors. She came back from Ireland with a harvest of photographs that included many warm and lively portraits of the people. Ireland for her was "a country of mist and rain and wind," and, because of this, she said, "I *wanted* to make the entire article a picture of Ireland in the rain." The editors did not cooperate on this point; the essay included photographs that showed a range of town and country life in County Clare, and Lange's reaction was that "it was well done, though, from their point of view. They didn't come out with anything that was bad."[60]

The essay on the Mormon villages was apparently laid out more to Lange's liking, although Adams disagreed with her selection. He did not like the "sociological considerations" she injected, for he believed that she sacrificed some of the more effective images and thereby reduced the emotional and aesthetic impact. He described the published story as a "meager and reduced form" of the material they had gathered.[61]

Lange was a skilled editor who cropped and grouped photographs in quite effective ways. Good negatives were important because they were easier to print well, but the technical quality of a negative was less significant than the content. She would choose a poor negative over a good one of the same scene if she thought the nuances within the image were presented better in the weaker negative. From a series of photographs she had made of a highway with wrecked cars

81. At Steep Ravine, May, 1957, by Dorothea Lange.
Oakland Museum

82. People of County Clare, Ireland, 1954, by Dorothea Lange. Oakland Museum

83. Market, County Clare, Ireland, 1954, by Dorothea Lange. Oakland Museum

On Watch over a kreel
in the bend of Market Street, Ennis,
is a cheerful boy of 15 or so
who must do his share of the work.

Irish Country People

SERENELY THEY LIVE IN AGE-OLD PATTERNS

THE forefathers of the Irish around the world who are celebrating St. Patrick's Day looked very much like the smiling lad above from County Clare in western Ireland. He is of the seed stock, the rural people of the towns and countryside who for 100 years and more have been exporting Irishmen. His home is near Ennis, in poorish farming country although boiled potatoes come as mealy and mellow there as elsewhere in Ireland. Here as always the families worship, work stubborn land, bend to bitter winds together, and are quietly content. His people live to the ancient Irish ways and a visitor finds them, as the following pages show, humorous, direct and generous—good ancestors to have.

Photographed for LIFE by DOROTHEA LANGE

135

84. Page from *Life* article, with photographs by Dorothea Lange.
Reproduced by special permission from *Life*, March 21, 1955, © Time Inc., and the Oakland Museum

85. Pages from *Life* article, with photographs by Dorothea Lange. Reproduced by special permission from *Life*, March 21, 1955, © Time Inc., and the Oakland Museum

in the ditch beside it, she chose a 35mm. negative, although she had 2 ¼ negatives of the same scene. The smaller negative was the only one that pictured a truck carrying new cars passing by on the highway above the wrecks in the ditch. She would also crop her photographs extensively to increase their impact, again with more regard for the content of the negative than for the quality. Occasionally she would crop a 35mm. negative to as little as a quarter of its content and enlarge it beyond what most photographers would accept.

Lange worked best when she had a chance to edit her photographs and then go back to reshoot aspects of a subject that had not been covered or had been presented poorly. She had no opportunity to do this in Ireland or in the Mormon villages, but for the public defender series, she edited and returned to the courthouse repeatedly. Meanwhile, the essay took form on the walls of her studio, and she would ask people to criticize its progress. She felt that there was a hole in the series and kept asking for help in figuring out what it was. Finally when she made the photograph of the defendant bent over his chair, his hand on his head, she felt the series was complete.[62]

Usually, Lange did not have this much time to work over her ideas for the magazines, and despite the large numbers of photographs she made on each of these projects, the magazine editors considered them insufficient. Her selective way of photographing gave them less to choose from as they assembled the photo essays. The published essays show little of Lange's daring use of her photographs, for her editing style did not conform to that used in the magazine layouts. Thus, her photo essays appear quite different in their published form than the way her photographs of the same subjects were presented in other contexts. The photographs from Ireland, for example, showed up much more effectively in her retrospective exhibition because they had been edited to reveal the misty tone of County Clare in the rain.

Lange also had to face the frustration of having her photo essays cut from the magazine at the last minute. The essay on the Berryessa Valley never appeared in *Life*. By the time the photographs were assembled in their final form, in the spring of 1957, the magazine had been carrying articles on storms and floods in the South for several consecutive issues, and the editors decided there had been "too many articles on water."[63] The public defender series never appeared either. In the fall of 1957, when Lange had completed the photo essay, *Life* was carrying a five-part series on the American court system, but for some unexplained reason, the editors did not see fit to include Lange's work in their coverage.

86. Horse Play, Gunlock, Utah, 1953, by Dorothea Lange.
Oakland Museum

Four young riders in summer

94

Gunlock is young and beginning to meet the future

Nine miles of riding dirt road lead from the highway to the hamlet of Gunlock, a flash of green in a narrow valley. Twenty-two families live here on 347 irrigated acres. The lands are watered from a gentle stream which can rise within hours to flood stage, washing out ditches and roads and leaving the fields covered with gravel and boulders.

Life in Gunlock is most often pleasant and simple, full of friends and horses and children. Mail comes three times a week. The general store sells horseshoes, fly swatters, overalls, soda pop, a few groceries. Outside the store, at the edge of an irrigation ditch, stands the town's only gas pump. There is an old adobe schoolhouse and a new church, which the people built with their own hands as they built the farms and houses which lead up to the church on either side of the road.

It is not altogether an easy life in Gunlock. The people here, large families which share their farms are often too small and their cattle too few to support. Some of the men now go daily to St. George, 33 miles away, and work for wages. As the United States worked over and against and through it for over a half century ago, so now the world outside is reaching toward Gunlock, which in a few years will no longer be what it has always been, an isolated hamlet at the edge of the wilderness.

Main Street full of children

The future's his grace

95

Abundance from the garden

A miner's powsmaker

Pause to talk cattle prices

CONTINUED ON NEXT PAGE

87. Pages from the article "Three Mormon Towns," with photographs by Dorothea Lange and Ansel Adams. Reproduced by special permission from *Life*, September 6, 1954. © Time Inc., Ansel Adams, and the Oakland Museum

88. U.S. Highway #40, California, 1956, by Dorothea Lange. Oakland Museum

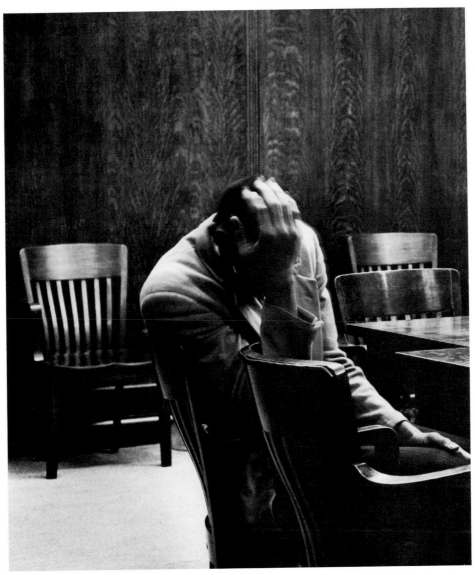

89. Defendant, Alameda County Courthouse, 1957, by Dorothea Lange.
Oakland Museum

These two sets of photographs reached the public through other channels. Two years later, Lange and Jones hung an exhibition on the Berryessa Valley in the San Francisco Museum of Art, and the art photography magazine *Aperture* devoted an entire issue to the "Death of a Valley."[64] In the introduction, Lange and Jones explained that they saw the photographs as containing overtones that extended beyond the story of Berryessa: "They have to do with changing values. The old life in this small valley was part of the California legend. We attempted to reveal this, and in addition, to lightly remind our viewers of the price of progress."[65]

Excerpts from the public defender series were distributed overseas by the United States Information Agency and to several newspapers by a feature syndicate. Some of the photographs were used in brochures. The National Legal Aid Society published the photo essay to encourage communities to develop public defender services, and the National Lawyers' Guild used Lange's photographs to illustrate their publication *Minimizing Racism in Jury Trials*.[66] Lange also included the series in her retrospective exhibition at the Museum of Modern Art. Despite these effective presentations, neither "Death of a Valley" nor "Public Defender" ever reached the wide audience or had the social impact they would have enjoyed in the mass circulation magazines.

Many of Lange's professional efforts during the 1950s were dedicated to creating a base for documentary photography. She was concerned that so few people in photojournalism and social science had recognized that the camera in the hands of a sensitive documentarian could make valuable contributions to their discipline. She proposed that a counterpart to the Nieman Fellowships in journalism be established by Magnum, the international cooperative agency of photographers, to aid practicing photojournalists who were "developing the field of nonverbal communication," and she tried to help find jobs for other photographers who shared her concerns.[67] At the California School of Fine Arts, she taught a photography workshop in which she and her students worked to interpret the theme, "Where Do I Live?," an obvious extension of her attitude toward photographing the familiar.[68] And in 1952 she participated in a photography conference at Aspen, Colorado.

Yet, within the context of magazine photojournalism, Lange is notable primarily by her absence, mainly because her work grew out of different concerns. The magazines were merely one vehicle for trying to show what mattered

to her. True, the magazines had emerged from the same seedbed as the photog-
raphy of the FSA, from the urge in the 1930s to document our national life and
from the recognition that the camera was especially suited to this task. After
that era, however, the magazines had followed their nose for news and had con-
tinued to expand their scope in the arena of current events, often relating these
events to individual people. Lange had taken the documentary mode in the op-
posite direction. Starting from individuals in their social context, she had begun
to explore the continuities in their relationships and the subtle exchanges of
which their lives were woven, regardless of changes in the political, social, or
economic arenas.

Thus, there was little evidence that Lange's work had an impact on the golden
age of photojournalism. According to Eugene Smith, "It is a downright crime, in
my opinion, that the largest and most influential publications of our time have
made so little use of her reportorial ability, that they have realized so little from
her reportorial accomplishments."[69] Other photographers during the fifties and
early sixties, many of them much younger than Lange, were similarly concerned
with how people related to each other within the fabric of our society. They
usually turned from the major magazines to small-circulation magazines, ex-
hibits, and privately printed books to find an audience for their work—the path
Lange was forced to follow during her last years. Despite her dedication to ex-
tending the uses of photography and communicating her concerns to a wide
audience, her work was curtailed in both respects by her own loss of energy and
by the view of photography that dominated the decade. By not seeing the kinds
of reports Lange made during the 1950s, Americans missed an opportunity to
look inward, to reflect on the quality of their lives, on things shared with others
different from themselves, and on the direction their world view was taking
them.

Chapter IX

Photographing the Familiar at Home and Abroad

Although Lange, toward the end of her life, sought to explore the things closest to her, to bring fresh insights to the significance of everyday life, she also traveled widely during her last eight years and took her cameras with her. In foreign countries, among people who were strange to her, Lange sought out situations in which she could work close to her subjects in the manner she did at home. Maintaining a balance between her home and travel photography was a challenge for her and an unusual goal for one who had established herself as a documentary photographer; her work reflected the differences between herself and others who had chosen to photograph either in foreign lands or in their own environments.

Lange became impressed with the power of family photographs during her first job in San Francisco, working behind the counter of the photography store in 1919. There, she said, "I got interested in the snapshots and I realized at that time something that's never left me, and that is, the great visual importance of what's in people's snapshots that they don't know is there. . . . They never see them in any way but personal."[1] She had considered her work as a portrait photographer important, primarily because of the value her photographs would have for the members of her subjects' families.

Throughout her career, she photographed her children and grandchildren. In the twenties and early thirties, she mounted some of these photographs in albums for her mother and for the Lovetts, with whom her family had vacationed one summer.[2] These were casual pictures, made "much as you or I would take snapshots," a friend later said, and were intended to be family mementos (Photograph 6).[3] Several other photographs of her family, however, have been frequently exhibited, including one of her son, John, carrying his firstborn child (Photograph 71).[4]

During the last years of Lange's life, she and Taylor often took their grandchildren out to the cabin at Steep Ravine on weekends, and sometimes the children's parents went along. Some of the early photographs Lange made of this spot became the roots of the assignment she cut out for herself—a serious document of her family's life together at the cabin. The subject was an extension of the theme "Home Is Where . . ." that she had developed during the 1950s.

A sense of family was always important to Lange. She occasionally expressed a yearning for the close-knit qualities of family life that she had missed, thinking perhaps of the painful experiences of her father leaving home when she was a child and the necessity of placing her own sons in boarding school during the Depression. The home she established with Taylor eased some of that pain, and her sense of responsibility to the large and diverse group of people who made up her family remained a constant for Lange.

At the memorial service following his mother's death, Dan Dixon said that "within the family, as within a religion, she believed in ceremony as a renewal of faith and in ritual as an act of devotion." She took great pleasure in the everyday tasks of running a large household, which she did smoothly and creatively. Dixon described his mother as "an intensely domestic woman—one whose feeling *of* family, *for* family, was almost mystical."[5]

As grandchildren were added to the family circle, Lange tried to give them a sense of security she had missed in her own childhood and was unable to provide for her own children when they were young. According to Dixon, "Around her circled a complex kinship of lives—lives that shared nothing so much in common as that each was shaped and enlightened by this extraordinary woman. Her influence was felt in everything from imposing matters of finance to the care of the household plants. The highly colored details of family life—nothing was more important to her than that. At nothing did she work harder. In nothing, I believe, was she more successful."[6]

Initially, Lange's photographs at Steep Ravine were simply an extension of the

family photographs she made throughout her career. Gradually, however, she began to think of the family's experiences at the cabin as having a larger significance, and she reinterpreted the photographs she made there as more than a private record of their shared experience:

It became our special place to be together and be with the children, and then we found that another element was creeping into it which we caught in the children, and that is they thought of it as a place where they were free. Then I began to wonder what it was that made us all feel, the minute we went over the brow of that hill, a certain sense of—not peace particularly or enjoyment—freedom; and I kind of looked at that. I tried to make up my mind what it was, then I thought I could do a real sequence, series of photographs on the subject of freedom, of which the cabin would be the device.[7]

Further, she said, this was not simply a vacation house: "This cabin represents something to me that is much more elemental. This cabin is a protection from the wind and weather, one board thick. And it shakes when the ocean is high and beats on the rocks. That cabin shakes and you feel every wave. And the children respond to that. They get elemental, too." She wanted the photographs to show that at the cabin, family members "get down to another base in our relationships with each other." The morning after one grandson had spent his first night there, Lange said that "he stationed himself on a rock and he looked way up the hill where the gate is and he kept looking and kept looking and all of a sudden he let out a yell, 'I see my friends, I see my friends.' He meant his mother and his father, way up there; they were coming."[8]

Taylor's son Ross had given Lange a quotation that she felt was especially fitting to the kinds of photographs she was trying to make: "What would the world be, once bereft of wet and wildness? Let them be left, oh, let them be left, wildness and wet. Long live the weeds and the wilderness yet."[9] She wanted the photographs from Steep Ravine to be a legacy for her grandchildren, revealing the freedom they felt there, as well as a document to communicate that sense to others.

The atmosphere Lange wanted to create in her photographs was not that of an observer but of a participant. When she realized she did not have the strength to continue the project, she asked Ron Partridge to make the photographs. He was a close family friend who shared the life at the cabin, and Lange had confidence in his work.[10]

Lange's approach differed from that of other well-known fine-art photogra-

phers who have photographed their families.[11] Many of Harry Callahan's multiple images include the figure of his wife, Eleanor, superimposed over a pattern of trees or a cityscape.[12] Ralph Meatyard's children were often the subjects in his highly structured photographic allegories.[13] Emmet Gowin has focused on his wife's family, using aspects of the graphic form of the amateur's home snapshot to express his special relationship with his subjects.[14] Lange's intention was not to manipulate her images or to adopt techniques that would characterize her family photographs as art photography. Her approach was similar to Cunningham's. Throughout her career, Lange's friend had frequently photographed members of her family, usually in natural settings—her parents at home, her husband on their honeymoon at Mount Rainier, and her sons in the mountains. Although Lange's subject, freedom in family relationships, was more abstract than much of her previous work, her approach was an extension of her earlier documentary photography.

It was unusual for documentary photographers in the early sixties to regard their families as possible subjects for any photographs other than informal records. Occasionally, a photographer has reinterpreted his or her photographs as being appropriate for a larger audience. Elliott Erwitt, for example, photographed his young wife with their newborn daughter between professional assignments, and some of these family photographs have been included in collections of his work and in the "Family of Man" exhibition.[15] Jacques Henri Lartigue, who began photographing as a child, used his camera almost exclusively to record his active, boisterous family, and these documents are now widely recognized as a valuable and beautiful record of turn-of-the-century France.[16] Before undertaking the series at Steep Ravine, Lange herself had occasionally selected for public display a photograph she had made as an informal record of a family event, such as a grandson getting his hair cut. Eugene Smith is one of the few documentary photographers who was making photographs of his family in the 1950s with an eye toward public audience.[17] In recent years, as documentary photography has come to include many more personal images, it is less unusual for a photographer with a documentary orientation to focus on his or her family life.

Traditionally, documentary photographers have been attracted to subjects outside their own culture. Eugene Smith's photographs in a Spanish village and at Albert Schweitzer's clinic, and Henri Cartier-Bresson's photographs of urban Americans are examples of the insights good photographers can provide into

90. The Family at Steep Ravine, 1962, by Dorothea Lange.
Oakland Museum

91. Tuoloume Camp, 1959, by Dorothea Lange.
Oakland Museum

92. Andrew, 1959, by Dorothea Lange.
Oakland Museum

cultures other than their own.[18] Lange's work outside the United States followed this pattern, but with some important differences. Her reasons for choosing to work in foreign countries and the perspective she brought to this work diverged from most previous documentary photography.

In 1958, the United States International Cooperation Administration sent Taylor to Asia as a consultant, and he and Lange spent seven months traveling through Japan, Korea, Hong Kong, the Philippines, Thailand, Indonesia, Burma, India, Nepal, Pakistan, and Afghanistan. They returned via Europe to the United States. In 1960, they spent two months in Ecuador and Venezuela, where Taylor studied community development and agrarian reform as an adviser for the United Nations. Two years later, after he retired from teaching at the University of California, they went to Egypt on a Ford Foundation-financed project. He was hired to teach community development and land reform at the University of Alexandria, and they were in Alexandria through the academic year 1962–1963. They then traveled home through Iran and Western Europe.[19]

Each time she left the United States, she went because Taylor had asked her to accompany him. She was reluctant to leave home and the grandchildren she enjoyed so much, and her poor health continued to reduce her stamina for travel and work. She was ill right up until the time they left for Asia, and she had to spend some of the time in bed during their travels. The trip to Egypt followed closely a long period in the hospital, and Lange would have preferred to use her energies to photograph the United States.[20] She told her husband she felt as though he had "dragged her around the world." Despite her reluctance to make the trip and a serious bout of malaria toward the end of the journey, she made many photographs and later was proud to announce that she had been all around the world.[21]

Lange was on no special assignment on these trips, and she seems to have had no pretensions of understanding each country or its culture. Rather she began to photograph as she gained an understanding of small corners of each place. Unlike her documentary techniques of the 1930s and 1940s, when she tried to anchor a subject in time and place, her new method was an attempt to make photographs that cut across chronological and geographical labels, that were symbols which spoke of the human condition.

She was sensitive to the fact that she was a stranger in each place and described a hypothetical person coming up to her in a foreign country—"a person *really* wanting to know what the dickens you were doing with a camera when you stand in a strange country surrounded by people you don't know, *nothing* that

you understand. What are you doing there, for the love of God, with a camera. I mean it's a fair question."[22] One of her favorite quotations, from Johann Peter Eckermann's *Conversations of Goethe with Eckermann*, helped her solve the dilemma of working in countries that were strange to her:

"I [Eckermann] mentioned how pleased I was to see how, in that journey, he had taken an interest in everything: shape and situation of mountains, with their specie of stone, soil, rivers, clouds, air, wind, and weather; then cities, with origin and growth, architecture, painting, theatres, municipal regulations and police, trade, economy, layout of streets, varieties of human race, manner of living, peculiarities; then again, politics, martial affairs, and a hundred things beside.

He answered . . . 'Each traveller should know what he has to see, and what properly belongs to him, on a journey.'"[23]

Yet the pace of travel prevented her from working as she had on her previous field trips. She was often frustrated by the way her husband's work dictated their travel plans, by the brevity of their visits to each place, and by uncooperative drivers who refused to stop when she wanted to photograph. She had to accept that she was just traveling through, and, unlike the photographers who try to avoid the tourist's-eye view in an attempt to get "truer" documents, she recognized that her photographs would reflect only those aspects of a culture which made the deepest impression on her.

In Bali, Taylor said, it was easy for Lange to work; the people seemed to be unconcerned that there was a foreigner in their midst. In Korea, however, the people reacted quite differently: "Often when she started to photograph a person at a distance of ten feet, crowds of children and women would pile around, and the ones behind pushing in to see what was going on. So that finally she didn't even have a clear line of sight between the camera and the person she wanted to photograph."[24] Sometimes, as in Karachi, Lange was able to use this curiosity to make some close-ups of the people who crowded around her.[25] At other times, when Taylor was with her, he inconspicuously guided their attention away from her, letting her photograph around the fringes of the crowd.[26] In Egypt, Lange encountered great animosity toward photography. "The little black box is brewed with hostility," she wrote from Alexandria.[27] In a letter to Cunningham, she said, "Photographing here is very difficult for reasons that I cannot enlarge on by letter, in addition to the fact that photography is always difficult for me. My ineptitudes plus camera hostility is a bad combination."[28] Although she lived in Egypt for eight months, the hostility toward "the evil eye" of her camera

never lessened, and her frustrations grew. Taylor said that having her motives questioned was a strain and that she would break into tears at times, like the day they went to Rosetta and some people "tried to slap her camera right out of her hands." [29] In some cases, she was able to express this mutual lack of understanding in her photographs. George Elliott wrote of one photograph Lange made in an Egyptian village: "How can an American interpret the complex expression on this Egyptian's face without knowing the meaning of those other people's hands, one laid on and one descending toward his head? But it is possible that the photographer herself did not know what this meant. . . . For an American to see this picture is for him to see a man in some sort of distress and to realize just how profoundly we rely upon cultural cues in order to understand one another." [30]

Lange often used some small task as a point of departure for making photographs. As she later told one of her darkroom assistants, "The chances of getting a photograph when you're going to the drugstore for a tube of toothpaste are better than when you're hanging out on the street corner waiting for the great photograph." [31] So she would go to a little Saigon shop to have dresses made for her daughters-in-law or ask a simple question, like how to get to a particular place, and often would end up photographing in these situations. In a temple in Bali, she was fascinated by the women descending the steps of the temple wearing elaborate wedding headdresses. She found out more about how the headdresses were made and used and photographed the women wearing them. She even bought one and took it home, where she hung it in the entrance hall of her house. [32]

Lange was not averse to posing a small scene, either at the family cabin or in her travels, to make a photograph that typified the setting for her. In one case, she arranged her own jewelry on the sand at the cabin and photographed it. [33] On another occasion, she asked her granddaughter to hold some rocks she had found on the beach, so that she could make some photographs. [34] Looking for smooth, shiny rocks along the beach was a typical family activity, and it had been turned into a game. The children all searched for the "perfect rock" as a present to their grandmother, and members of the family would carry the small stones around in their pockets from week to week. [35] Lange made a similar series of photographs of an Indonesian dancer's hands. She and Taylor had gone to watch some young women practice traditional dancing one Sunday morning in Djakarta, and she asked one of them to hold each gesture as she photographed it. [36]

Lange was especially sensitive to foot gestures, and her hatred of her own

93. Street Scenes, Karachi, 1958, by Dorothea Lange.
Oakland Museum

94. Pakistani Youth, Karachi, 1958, by Dorothea Lange. Oakland Museum

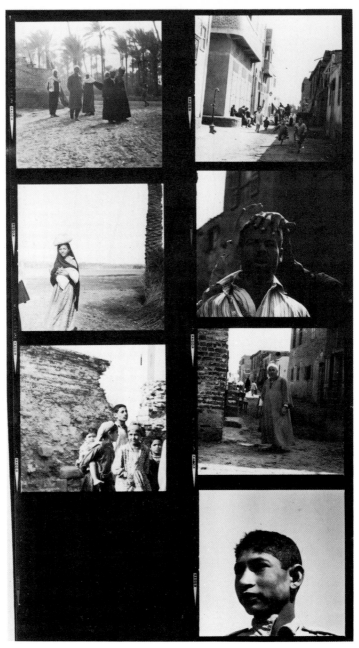

95. Egyptian Village, 1963, by Dorothea Lange.
Oakland Museum

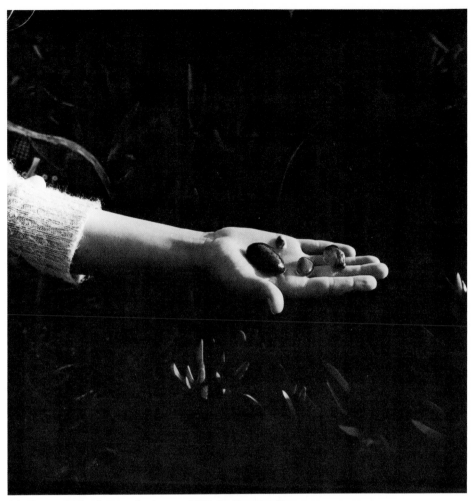

96. Dyanna's Hand, Steep Ravine, ca. 1957, by Dorothea Lange.
Oakland Museum

97. Indonesian Dancer, Java, 1958, by Dorothea Lange.
Oakland Museum

crippled right foot led her to watch for the beauty in others' feet. She made a series of her granddaughter's feet against a rock at Steep Ravine, wanting something in particular that Dyanna could not quite understand.[37] Other photographs were of her children's bare feet and legs on the beach. She carried the theme overseas, as can be seen in some photographs taken in an Indonesian market. This attraction was so noticeable that their twelve-year-old guide in Bali asked whether Lange had a special camera for photographing feet.[38]

The spontaneous, unposed photographs of the family group in the cabin and of a young man walking down a Saigon street on his hands in the rain were made as immediate responses to settings that moved Lange and symbolized a human quality she wanted to remember.[39] Several members of the family suggested that her prejudicial view of the family influenced many of the photographs she made. According to Dyanna Taylor, many photographs were what Lange wanted to see and expressed the way she wanted her family to be.[40] Partridge said many of Lange's photographs were "loaded with external lies" that revealed only the "peaceful, joyful" side of family life. He saw some exceptions to this. "She observed in one case her daughter-in-law smoking a cigarette, her head down. It was a time when she came to Dorothea and said that her son [Dorothea's] was leaving her. And Dorothea photographed it. . . . It became a *gut* photograph . . . the pictures of the kids activities, and the shoes and the feet, are not gut activities." According to Partridge, within her family, Lange did not generally use her camera as a tool of discovery. She had a notion of what she wanted to say about these subjects, then looked for photographs to fit it.[41] Taylor disagreed, saying that she was able to see and photograph her family "quite objectively—even their problem aspects."[42] A few others, however, have noted a sentimental quality in these photographs that distinguishes them from much of her other work.[43] Lange herself said: "Mine was never the long shot, the middle distance." "When I work close, it's right for me." Yet, she said, "I, who realize the great potential there is in it, to photograph your family, I haven't done it either. For these things that of course are very near to you are *very* difficult. And the camera has not touched it."[44] Her photographic exploration of her feelings about the family and the cabin was colored by her deep involvement in the life there and the quality she wanted it to have for herself and for them.

Similar qualities have been noted in her photographs from other countries, particularly those she made in Asia. Richard Conrat characterized them as being "very aesthetic" images, among the most beautiful she made, and having a

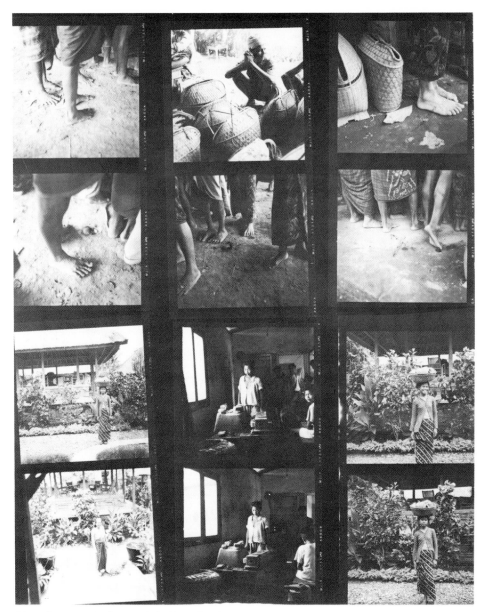

98. Indonesian Market, 1958, by Dorothea Lange.
Oakland Museum

99. The Family at Steep Ravine, ca. 1957, by Dorothea Lange.
Oakland Museum

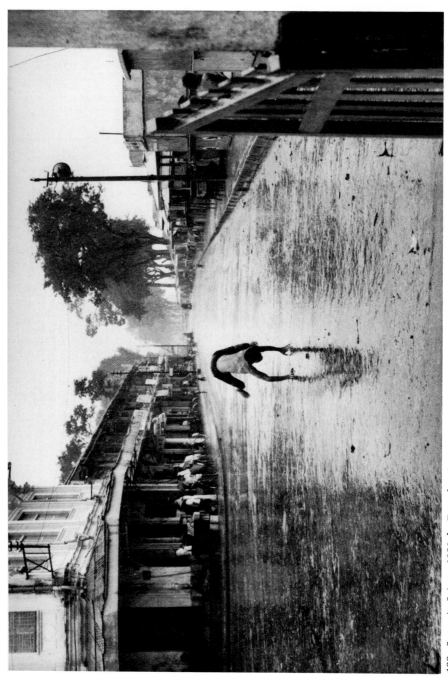

100. Street in Saigon, 1958, by Dorothea Lange.
Oakland Museum

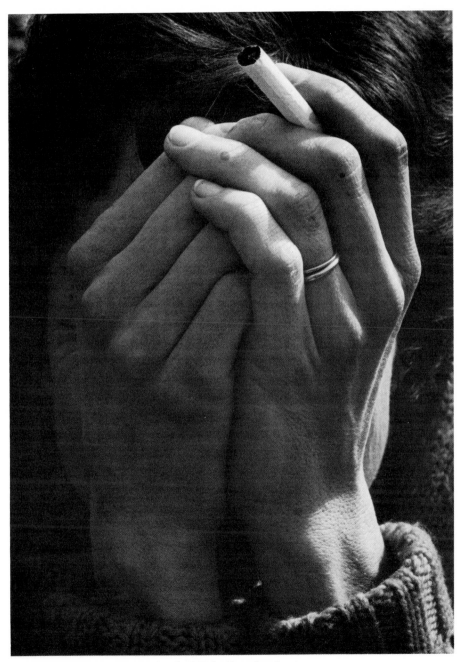

101. Bad Trouble over the Weekend, 1964, by Dorothea Lange.
Oakland Museum

carefully studied quality unlike her earlier work.[45] Partridge agreed that many of
Lange's photographs from Asia resemble the pictorial quality of her family pho-
tographs.[46] Arthur Goldsmith, reviewing Lange's retrospective exhibition for
Infinity magazine, found her foreign work to be the weakest in the show.[47] He
had overlooked Lange's intentions in making these photographs, however. They
are different from most of her government photographs, harking back instead to
her portraits from the Sutter Street studio in the 1920s. But she was trying for
something different, a universal, timeless quality, in the photographs she made
of her home and her travels. "I have a third eye in my head now, which living in
Asia and the Middle East gives you," she said. "I see the different perspective and
I see us in a different relationship than I did when I was working just within the
country."[48] This perspective marked a new direction in her work, one still evolv-
ing at the time of her death.

The photographs Lange made of her family at Steep Ravine and on her travels
were not appropriate for the channels she had previously used to present her
work. They were neither the stuff of which government reports were made nor
news photographs. Unsure, perhaps, of how these projects would turn out, she
expressed the belief that if a photographer follows a theme with enough dedica-
tion, the resulting photographs would find a place.[49]

When Lange showed the first Steep Ravine photographs to her grandchildren,
she wrote down their comments as captions. On the introductory page to an
album of them she gave to her son John and his family at Christmas, 1961, she
wrote: "'These are pictures about our cabin,' says Paulie and that is exactly right.
They are to a cabin and a life surrounding a cabin—a life independent of 'things'.
. . . I hope to *really* photograph this, but in the meantime, these snapshots are a
beginning, and will show you that to watch the natural growth of the children
there, and to see them so happy and free there is the joy of Grandma Dorrie."[50]

Once she began to "*really* photograph" at Steep Ravine, she wanted the photo-
graphs to reach a larger audience. She took a small portfolio of them to her friend
George Leonard, to see if he would be interested in publishing them in *Look*. He
encouraged her to keep working on it; the theme had possibilities for the
magazine. Because Richard and Jill Grossman of Viking Press had published
several photography books she liked, she approached them about publishing a
small book of the photographs and received their tentative approval.[51]

Lange returned from her travels abroad with many photographs but no written
documentation.[52] The references she would use in grouping and captioning

these collections were all in her head, or as she would have said, in her heart. She wanted to edit her photographs to say just what she wanted, then find an appropriate format, "whether it be a magazine, or a museum display, or a book." She overcame her earlier reticence about thinking in terms of exhibitions; in 1960, she told a reporter for the Berkeley *Review* that she was simultaneously working on half a dozen such exhibits. An exhibit of her Korean photographs was "an effort to get others to behold what I beheld," she said, "to be interested, to be involved in it."[53] "Remembrance of Asia," for example, was not laid out country by country like a travelogue. Rather, she said, "It is things that have come to my mind about Asia, based on what I saw there, which recall it to me." She designed it in five episodes, according to how the photographs grouped together in her memory. Some were direct statements without "an oblique thing" in them; others were the opposite, with only indirect presentations of what she saw. One section was to be on villagers, "not particularly localized, and they don't have to be. They should be so heavily Asian that it doesn't make any difference; the section would be on the village as characteristic of Asian life. I'd want it understood by Americans; and there would have to be some words."[54]

Lange tried combining her negatives in different ways, cropping them differently and grouping them with other photographs, to show what could be done with the same material.[55] In some cases, she chose only a small portion of the negative, as for example when she cropped the 35mm. negative of the group of Karachi children to show only the top half of one child's face (Photograph 103).[56] It changed the photograph drastically, from an image of a group of children crowding in to have their picture taken, to one of a child's eyes, large and watchful. The cropped photograph is more arresting, and for Lange, more representative of what she saw and felt in Pakistan.

"Rememberance of Asia" appeared in *Photography Annual, 1964*, and her Asia photographs were included in a one-woman exhibition in March, 1961, at the Siembab Gallery in Boston.[57] By the time Lange recovered from her trip to Egypt, she had begun assembling photographs for her last important work, the Museum of Modern Art retrospective exhibition, in which the photographs from that journey were first presented together with representative work from her entire career.

In the summer of 1964, Lange began to have new difficulty swallowing and felt especially weak. An X-ray and biopsy revealed a malignancy in her upper esophagus, unrelated to her previous illness. This inoperable and painful form of

cancer might allow her only a few months to live, and her doctors told her that most patients die within a year.[58] Sadly, she put aside photographing the family at the cabin to work on her retrospective exhibition and several other projects that she hoped would establish a place for the kind of photography she believed in. She wrote to the Grossmans, "There will be no beautiful little book about which I spoke so hopefully. Of all the unfinished business which I now face, this item hurts me the most. I would rather have done this little book as I see it in my imagination than any of the other undertakings which will now be interrupted. There would have been more of what I feel and wish to speak about in this little book than in any of the other things, including the exhibit at the Museum of Modern Art."[59]

The only channel remaining for her family photographs was the retrospective, which was also to include many photographs made in other countries. And she designed one panel on her Asia work and another on her photographs from Egypt. As she originally planned, these were distillations of her memories of each place, not photojournalistic reports.

The photographs she selected for the home panel of her retrospective are in a sense a synthesis of her home life and her experience overseas. Her house and garden were now full of things she had brought home: the large Korean chest in the dining room; the bronze drums from Thailand by the fireplace; wooden carvings from Bali on the kitchen cabinets and in the garden; copper trays from India on the shelves in the kitchen. These things she incorporated into many of her home photographs, as evidence that exotic trophies of foreign travel had become inseparable from her image of life at home in Berkeley.

The home panel also included the Steep Ravine photographs and some photographs of her house and garden, of family and friends in the environment she created. Discussing this panel with John Szarkowski of the Museum of Modern Art, she insisted on including some photographs he thought were inferior. Securely identifying one's home, Lange told him, "is a very deep and serious subject, especially a *family like ours*, which for lack of a better word is irregular and extended. We've lived in this house since 1941, I think. And many have grown up here, left home, returned here with *their* families. This could be an attempt to describe an environment—that's what it is." By presenting these photographs in her retrospective, she said, "I've made myself wide open, which I like to do." This feeling suggests the unfinished work she wanted to pursue—to complete a document of her own life, to speak to others of what she had seen and felt, to

make the personal public, that we might share it and see its commonality with our own lives. "You really believe in that kind of risk taking?" Szarkowski asked her. "I do," she replied. "At my age, and in my situation? It's the only chance you ever get." [60]

As Lange readily admitted, it is difficult to single out particular photographers as having specific kinds of influence on the work of the ones who follow. But looking back to her last work, we can see the signs of a trend toward more personal subjective photography within the documentary tradition. Since her death, increasing numbers of photographers have considered the lives of their immediate families as worthy of serious documentation, containing significant statements about personal relationships that can be shared with others.[61] Their work remains primarily in small editions of special photography books and journals, unfamiliar for the most part to those who see only the photographs that appear in wide-circulation magazines and newspapers. But a pattern has developed, and Lange, if she did not establish that pattern, pointed the direction in her last work.

Chapter X

Looking Back:
Lange's Synthesis of
Her Life in Photography

The task of preparing the retrospective exhibition was more
demanding for Lange than any she had ever undertaken.
She went back through year after year of photographs, reliving field experiences
and editing her work into a form that would tell others of her life in photography.
"A photographer's files are in a sense his autobiography," she said. "More resides
there than he is aware of. Documentation does not necessarily depend upon
conscious themes. It can grow almost of itself, depending upon the photogra-
pher's instinct and interests. As fragmentary and incomplete as the archeolo-
gist's potsherds, it can be no less telling."[1] A decade earlier, she had said she
was unable to judge a photographer's work without seeing its entire breadth;
from this perspective she could then understand the photographer as a whole
person.[2] Assembling the retrospective was an opportunity to understand herself
as a person and a photographer.

For several years Lange had been concerned about how her work would be kept
and used. In 1960, she wrote Roy Stryker, "The additional values which time
bequeaths are beginning to be apparent to me, and I should like my files to be
useful and in good hands after I am through with them."[3] Edward Steichen had

tried to convince her for six or eight years to do a retrospective for the Museum of Modern Art, but she kept postponing it to do other projects.[4] As she fought bouts of serious illness, she realized that her time was limited. In February, 1964, Szarkowski, who directed the photography division, made a formal request to the museum's exhibition committee and notified Lange that "like it or not, you are down on the schedule for a one-man show two years from now."[5] Lange finally agreed: "I would very much like to avoid it, and on the other hand, I feel I can't. I must do it: get that exhibition together and put it on the wall for other people to look at which will spell out what I would like to speak about in photography."[6]

Lange wanted to control this first definitive presentation of her work rather than have others carry it out after her death. The exhibition would be an opportunity for her to show others that she was more than a Depression photographer, that her primary concern throughout all periods of her life had been people.[7] Willard Van Dyke saw this direction in Lange's photographs in the early thirties: "She sees the final criticism of her work in the reaction to it of some person who might view it fifty years from now. It is her hope that such a person would see in her work a record of the people of her time, a record valid of the day and place wherein made."[8] However, Lange wanted her exhibition to reflect a larger message than her ability to anchor people in time and place; she extracted photographs that would express "an *essence* of a situation, the universality of a situation, not the circumstance." She designed the exhibit to stir people's minds, "not by the variety of things *I* have looked at, but by the immense variety and richness of human life." She hoped the exhibit would stimulate what she saw as a new direction for photography, as a medium suited, not only to communication, but to communion among people.[9]

Although important to the direction of her work, Lange's system of filing her photographs according to abstract themes made it impossible to find any given photograph. According to Richard Conrat, her files were a shambles when he began to work with her in August, 1963. In preparation for the retrospective, he began reviewing the photographs with Lange and refiling them according to the time and place they were made.[10]

Lange had a long desk and bulletin board built along one wall of the living room, and the house became a bustle of activity as people came through to watch the exhibition take form and to offer advice. Conrat and Taylor were on hand constantly. Dan Dixon came to help, and Szarkowski flew out from New York

for several weeks. Two films on Lange's life and work were being made by a crew from television station KQED in San Francisco. And several grandchildren were usually on hand, taking it all in and offering comments.

Lange was physically weak and often lay on the couch as she went through the boxes of photographs and watched the groups take form on the wall.[11] Selecting photographs was like passing sentence on her past. "Not good enough, Dorothea," she would say, leafing through them; "'A' for effort, that's all." The process raised questions for her such as "Why was I working so well that two weeks and then all of a sudden no good at all?"[12] She saw patterns in her photography, reflected from the work she did as far back as the days in her portrait studio on Sutter Street: "I can see plainly that I'm exactly the same person, doing the same thing in different forms, saying the same things. It's amusing sometimes to me to look at my own endeavors and, 'There she is, there she is again!' It's built in. Some things are built in."[13]

Time was her editor, she said, as she passed over negatives she had thought were among her best when she made them and rediscovered others she had previously overlooked. "No one can assure you where you've been successful and where you haven't," she said; but from the perspective of time and distance, she thought her vision was clearer.[14] Looking back to the early thirties, among her first photographs of breadlines and street demonstrations, she found that several of them still held for her. As on other occasions when she was asked to make a selection of photographs to represent her work, she found that "no group that I ever make up really comes close to me without the inclusion of one of the photographs that I made in the early days when I first got out on the street . . . when I was just gathering my forces." But from the photographs she had made just a few years before in Asia, her selection was now utterly different from previous exhibitions of this work.[15] She could not explain why this should be so, why the appeal of some photographs was more consistent than others. Nor could she account for why a few of her photographs, including the "Migrant Mother," had taken hold and functioned as images in their own right: "It embarrasses me; they're no longer my own. For some peculiar reason that I don't understand, that I don't have the answer for—why these? There is something in them that has reached people all over."[16]

As the editing progressed, some of Lange's photographs were grouped by subject in the same order as they originally had been made; others were combined according to themes she had been developing since the early fifties. In both

cases, the groups reflected her concern for relationships within and between photographs. One set emerged as "The Old South," photographs she made on her two field trips through the southern states for the FSA during the summers of 1937 and 1938. Another large group of her FSA photographs was combined with others she made in California, showing the changes the state underwent during the thirty years she had photographed its people. Consistent with her desire to transcend her reputation as a Depression photographer, her goal on this panel was "to explore old familiar ground in new terms of prosperity and abundance, rather than stagnation and depression."[17]

The panel on Asia, more personal and symbolic, formed another chronologically and geographically unified group. Photographs Lange had made in Utah in 1953, in Ireland in 1955, and in Egypt in 1963 were presented on separate panels. For each of these groups, Lange selected images held together by one aspect of her experience in that locale: the sense of time and history of the Mormon people of Utah, the misty tone of Ireland, and the continuity with the ancient culture of Egypt that she saw in the people there.

Other groups in the exhibition were formed to show explicitly Lange's perspective on the rich unity of human experience. As she assembled the photographs of people's faces, made over a forty-year period in many parts of the world, she said, "The human face is the universal language. The same expressions are readable, understandable, all over the world. It is the only language that I know—communicative thing—that is really universal. Its shades of meaning, its explosions of emotion and passion, all concentrate on just this part of the human anatomy, where a slight twinge of just a few muscles runs the gamut of that person's potential."[18] Each of the photographs in this group was to be hung using the same size mat, in a single row, to emphasize this statement.

One wall was designed to express Lange's ideas on people's relationships to each other and their environment. The subjects in these photographs were diverse: a man stepping from a cable car, his foot seemingly suspended above the pavement;[19] a young girl and her mother on a Yakima Valley farm; three churches on the plains of South Dakota; a man and a woman having an argument in a California trailer court; a woman working in her garden in Berkeley. As this group took form, Lange thought it showed "an interest in human life," then expressed a worry that maybe she was just kidding herself, that what she saw in those photographs might not be apparent to her viewer: "When he looks at such a wall on relationships, what my hope would be that he would say to

himself, 'Oh, yes, I know what she meant. I never thought of it; I never paid attention to it;' or something like, 'I've seen that a thousand times, but won't miss it again.' You've told about the familiar, the understood—but in calling attention to what it holds, you have added to your viewer's confidence or his understanding."[20]

On another panel, which she hoped would be no less familiar to her viewer, Lange presented photographs of her own home—the sunlit oak trees arched over her house; her son John holding his first child; her husband's hands on his brief-case; her grandson Gregor running through the garden. This panel was not com-pleted at the time of Lange's death, and Conrat made the final selection in con-sultation with the family. Szarkowski eliminated several of these photographs from the New York exhibit, for throughout the selection process he had consid-ered Lange's home photographs to be inferior; and he did not send them to the Oakland Museum for the exhibit there. When Taylor and Therese Heyman of the Oakland Museum insisted, Szarkowski reluctantly complied. Lange's home photographs were presented in Oakland as an evolving body of work for those who had personal memories of her.[21]

Lange selected photographs for the panel she called "The Last Ditch," on the finality of rootlessness, deprivation, alienation, the damage to one's humanity from being wounded in the broadest sense.[22] The wall included her famous "White Angel Breadline," made on her first venture into the streets of San Fran-cisco (Photograph 7); a "damaged child" of the Oklahoma dust bowl; a defendant in the Alameda County Courthouse (Photograph 89); the photograph of her daughter-in-law taken the weekend her husband told her he was leaving her (Photograph 101); and others spanning Lange's entire career. At least one critic considered this group the strongest in the exhibition; Goldsmith wrote in *Infin-ity* magazine that her "reputation could stand on these few photographs alone," which represented "the climactic summary of Lange, the documentarian."[23]

Lange made no pretense to consistency in her attitudes toward cropping, a practice that in some cases would heighten the intensity of an image, in another might falsify her view of a situation. For the front cover of the exhibition catalog, she selected a photograph of a Korean child with his eyes closed; it was cropped from the 35mm. negative of a group of Korean children. However, she decided for the exhibition to leave her photograph of the row of Texans nearly whole, in spite of the small man on the right who seemed to break the line of men. As she explained to George Elliott, who was writing the catalog's introduction: "I

know that little man on the far right is not strong or burly like the others, and is a weaker spot in a *wall* of men, but I saw that is the way it was, and that is the way it *is* so often—an area of uncertainty, a contradiction, maybe a doubt. Let it stay that way, I say."[24]

During the processes of selecting and grouping the photographs and deciding on their size and relationship, a printer was called in and a whole new set of decisions was made. Early in August, 1965, Irwin Welcher of Compo-Photocolor in San Francisco was hired to do the job, and Szarkowski gave his permission for the photographs to be printed on the West Coast. Welcher and his assistant, Edward Dyba, consulted with Lange several times about how she wanted the work done.[25]

It was apparent by this time that Lange was in great pain, and Welcher recalled that she occasionally would leave them to lie down for half an hour or so. He said Taylor "was in constant attendance, administering injections and seeing that she drank the liquids prescribed for her." Through the pain, Welcher "could feel the sheer driving force and determination of this remarkable woman." He met with her three times, and she was able to communicate to him precisely how she wanted specific photographs printed, and her overall conceptions of how the exhibition prints should look. She wanted to avoid "glossy stark black and white prints," for she agreed that although such prints have a place in photojournalism, the glossy finish presented a barrier to the viewer. They selected a warm paper available in the range of sizes needed for all the prints. To avoid the "drying down" effect of this paper, which would block up the shadows, Welcher and Conrat hit upon the idea of spraying them with a lacquer to bring up the tones.[26]

Lange recognized that the accurate translation of the mood or spirit of each scene into a good print could not be done without precise manipulation in the darkroom. This "print sense" came through as she described to Welcher and Dyba how she wanted her Irish photographs to look: "We should enlarge this photo of the freckle-faced girl so the peak of her hat comes closer to the top of the photograph when we crop it. Don't brighten the face—the photograph was taken in the rain and I want to keep the dark misty grey look." Another, of people coming from church, had "the threat of rain in the sky." "Watch the sky," Lange told them. "Just a bit of glow at that horizon, then deeper and stronger at the top." Others, taken when the sun was peeking through the clouds, had strong highlights, and she urged them not to try for detail in the highlights— "The light is strong and should be clean."[27]

102. Korea, 1958, by Dorothea Lange.
Oakland Museum

103. Korean Child, 1958, by Dorothea Lange.
Oakland Museum

When several photographs formed a unit, she wanted the same tones to carry in each, as, for example, in three photographs from Utah:

I took this photograph of old Mrs. Savage in the thirties. Years later I photographed her tombstone. Her son, Riley Savage, now an old man, heard I had a photo of his mother and asked me for a copy. I took this photograph of him. Now in printing this face make it dark and rich but keep the flowing silvery feeling in the wave of the hair over the ear. The print of the gravestone should have the same tonal values as the photo of Mrs. Savage—and the print of her son should also be kept in the same tonal scale.[28]

Many of Lange's negatives were poor. She had made them according to no formula, and they varied widely in density, making it a challenge to print them. Several of the prints were completed by early in October, and Lange was pleased with the results. She died a few days later, and Welcher continued to work on the printing with Conrat. They sent for the original negatives of Lange's FSA photographs from the Library of Congress and for others that were not part of her own collection. "Dick Conrat brought in each series with the negatives, guide prints and size orders," Welcher said. "He knew what Dorothea wanted and we went over each print and noted moods to be achieved, details to bring out, areas to be darkened, etc."[29] The prints were processed to archival standards and placed on white mounts. The final result was superb; the print quality was commended by several reviewers of the exhibition.[30]

Lange decided to caption the prints with simple titles, primarily date and place. Statements she had written or collected to go with her work were selected from her files to accompany several of the groups. "The Last Ditch," "The New California," and the Asia photographs each were presented with several lines of text. The exhibit included far less written material than most other presentations of her work. Captioning, she said, "depends on the nature of the job. There's hardly anything that couldn't be enhanced and fortified by the right kind of comment."[31] For a major exhibition like this, minimal captions were appropriate, for they would guide viewers into the work without directing them toward preconceived notions of what they would see. Lange wanted her audience to be able to explore her work themselves.

George Elliott was given the selection of prints that would appear in the catalog, and he wrote from these a critical analysis of Lange's work. He asked her questions about her influences, her background, and specific photographs and then submitted drafts of his essay to Lange for approval. Reading it, she said she

was "overcome with some sort of shyness, which makes it hard for me to read it well and with perspective." Taylor was pleased with it and told her, "I think you're lucky, and he will advance the understanding." She was impressed with Elliott's insight and approved the manuscript.[32] Beaumont Newhall appraised the essay as "a brilliant critical analysis and appreciation of her work."[33]

Lange's determination to see this work through to completion, to present her work as she wanted others to see her, sustained her a year longer than her doctors had told her to expect. She died on October 11, 1965, a few days after seeing the first exhibition prints. She left only the final printing and her home photographs to be completed by those she had chosen to help her. In her last moments of consciousness she exclaimed, "This is the right time. Isn't it a miracle that it comes at the right time!"[34]

Lange felt she had completed her final work to her satisfaction. It was up to time—her major editor—and future audiences to assess how close she had come to revealing the human condition.

104. Dorothea Lange, 1965, by Rondal Partridge.
Courtesy of Rondal Partridge

Chapter XI

Dorothea Lange
in Retrospect

The Dorothea Lange retrospective exhibition opened in New York in March, 1966. Among those who attended the opening was Lange's granddaughter, Leslie Dixon. Awed by the crowd and glitter of the gathering, the little girl said in amazement, "I didn't know Grandma was famous!"[1] In a sense, Leslie was right. Lange was not well known, except within a circle of people who knew about photography and photographers. Although her photographs were often used to illustrate historical pieces about the Depression, they were usually published without her credit line. She was not a major photojournalist, and there had been few exhibitions of her work. It was only after her death that she became widely recognized as one who had made a contribution to the development of photography.

Describing Lange as a documentary photographer is an oversimplification, as her retrospective exhibition revealed. The portraits she made at the beginning of her career stood up well beside her later, better-known work. Trained in a well-established tradition of studio portrait photography, she attained a very high level of commercial portraiture. The skin tones and light quality of these photographs carry through into her later work. The contrast between her portraits and her first photographs of San Francisco breadlines was one of subject, not the

quality of her work. From the exhibition, it was obvious that she was one of the first and best government photographers, who was able to define her task as expressing the quality of an era in American history. Lange's attempt to carry this effort through wartime was underrepresented in the exhibition; only one of her photographs from the relocation of Japanese Americans was included. Her nongovernmental work during the war revealed her ability to maintain concern for a changing California, even though she was not always hired to do so. The work from the fifties covered several discrete and more tightly focused subjects than did her government photographs; her photo essays showed how well she was able to give the essence of a subject in a few strong and well-unified photographs. During this period, when the picture magazines were at their peak, Lange used their form of photography but not their style, and her photo essays exhibited a sustained intimacy with each subject that few magazine photojournalists showed. Lange's home and travel photographs showed how she extended this intimacy into areas personally relevant to her own life. This direction was different from that taken by others working in the documentary tradition. They usually used the witness-like power of the camera to speak about their subjects, but Lange consciously used her camera to speak of her relationships with her subjects.

Yet, in many senses of the term, Lange was a documentary photographer. She recognized that every photograph is a document of the time and place and of the relationships and exchanges that make its existence possible. This sensitivity informed her work throughout her career, which spanned the developing years of the documentary form of photography. Because of the juxtaposition of her own use of the camera as a tool to document relationships and the growth of the documentary approach, her work was characterized by "that quest for understanding, that burning desire to help people to know one another's problems, that drive for defining in pictures the truth" which is at the heart of the documentary tradition.[2]

Hanging on the walls of the Museum of Modern Art, Lange's photographs revealed her rootedness in this tradition and some of the ways she transcended the directions documentary photography has taken since the 1930s. However, a museum exhibition remains an abstraction of a photographer's work. Even the most carefully assembled exhibit is a synthesis of how a photographer's work looks when divorced from the context in which it was made and previously seen. The chaste museum walls could not transmit an understanding of Lange's

motivations and attitudes toward her medium or tell which of those attitudes sustained her work throughout her life and which were molded by changes and opportunities.

Throughout her life, Lange saw herself as a vehicle for others. To be personally satisfying, her work had to fulfill a purpose, to serve her subjects in some useful way. Ultimately, this attitude governed her choice of subjects. Hers was never the detached view. She always tried to go in "over her head," she said, to experience her subjects' experience in order to reveal it to a wider audience or to future generations. Because she believed in the value of sharing experience, she did not see her camera as a privacy-invading tool. Her confidence in the validity of her work and in photography as the medium especially suited to expressing the human condition enabled her to enter situations on a personal level without violating her credo of "the contemplation of things as they are." The Bacon quote that hung on her darkroom door for over thirty years demanded "a clear, unfettered, uncompromising, yet compassionate use of the camera."[3] Her personal involvement can be seen in her work on subjects of nationwide importance, such as migrant labor, and on the small things, like her many graceful photographs of feet.

Lange usually referred to "making" a photograph rather than "taking" one. The larger format camera she preferred to use "calls for different and I think more deliberate responses to the subject. . . . You have to wait until certain decisions are made by the subject—what he's going to give to the camera, which is a very important decision; and the photographer—what he's going to choose to take. It is a much longer inner process than putting the camera between you and the subject and, as I say, reeling them off by the yard."[4]

Lange was always critical of those photographers whose zeal for their craft stemmed from a reliance on its technical considerations, for once the techniques were mastered, she felt they had nowhere left to go with their photography.[5] Unlike most people who become serious photographers after using a camera for a while, Lange began to photograph out of intense feelings about the power of visual imagery. Consequently, she often talked about photographs but seldom discussed the techniques of how they were made.[6]

When she did talk about the mechanical aspects of photography, she spoke of them as primarily limitations of the medium: "For better or worse, the destiny of the photographer is bound up with the destinies of a machine. . . . His machine must prove that it can be endowed with the passion and humanity of the photog-

rapher; the photographer must prove that he has the passion and humanity with which to endow the machine."[7] For Lange, it was a constant struggle to match her thoughts with the capabilities of her camera and lenses. Her friend Homer Page said, "She often tried to command her medium to do things it did not care to do. Sometimes she won this struggle; often she lost it." Page credits her greatness to the fact that "she understood that vision comes before the camera."[8]

Lange also understood that vision extends beyond the making of photographs. She had none of the compunctions about cropping her photographs that many documentary photographers have. She would crop to simplify an image or to isolate the subject from environmental factors that she felt added nothing to the photograph. The results of her cropping were usually far more intense than the image on the negative. "Why not do that when the medium permits it?" she asked; "I think it should be explored to the limit." It allowed her "the possibility of exposing to more than normal view something that you would otherwise not see."[9]

Lange never sought the easy out of the photographers who maintain that their images speak for themselves. Not always confident writing about her own photographs, she selected writers to help her communicate her intentions in articles about her work and in texts to accompany her photographs; and she was never reticent in talking about her work or expanding others' understanding of her photographs. For Lange, the combining of words and photographs for a variety of contexts opened many more possibilities for communication than photographs alone ever could.

These were the continuities behind Lange's photography. But many of her ideas changed in the course of her career. In part these changes were due to the different agencies and publications that provided new outlets for her work. More important were changes within herself as she bent with the effort of documenting a changing world. When Lange died, she was on the verge of completing a cycle in her work, from personal portraits to photographs presenting social issues to a more personal perspective again. Her portraits represented her desire to create an intimate image that was expressive of the person's private self. The wider scope of her work in the thirties and forties, though no less concerned with people, emphasized her subjects in their relationship to political, social, and economic issues. Beginning in the fifties, her focus changed to showing people, not in terms of issues, but as they related to specific aspects of their own environment, and to showing the aspects of her own life that were familiar to

others. As her conception of her audience broadened, her ideas of how to communicate with that audience evolved back into the realm of photographing that which subject, photographer, and viewer know in common.

Lange's appreciation of the denotative power of photography—the medium's ability to name a person in time and place—had given way to an exploration of the camera's connotative function. Her concern in the thirties, of fusing information and affect in her photographs, had evolved toward an increasing appreciation of the affective power of photography. She came to see photography's unique ability to arouse in its viewers deep feelings about their commonality with others. She wanted her photographs to be understood as highly condensed expressions about the universality of human experience, which supersedes the rich variety of human life. Consistent with this change of purpose, Lange's ways of cropping and combining photographs became more condensed in her later years. Even the words she selected to go with her photographs were more succinct and more heavily laid over with connotation.

Increasingly, Lange relied on "the secret places of the heart" for her direction. Her camera was no longer making photographs of things which she knew were recognizable and understood, whereby "you have in mind the common denominator as a kind of leveling place, beyond which you can't stray too far or else you will be defying or denying these laws of communication that we hear so much about." This new attitude did not deviate from her purpose of revealing things that others could share, but she said it did obscure the usefulness of her work as it related to the concerns of an editor or an institution.[10] In fact, she said, this conception of her work would require her to cut herself loose from the mundane concerns of daily life: "That frame of mind that you would need to make very fine pictures of a very wonderful thing, is different from the frame of mind of being on the pavements, jostled and pushed and circulating and rubbing up against people with no identity. You cannot do it by not being lost yourself."[11] Lange saw "being lost" as a state of mind that she felt capable of for the first time in her life.

Were it not for obligations of family, she said, she would have lived "a completely visual life." "I would like to photograph constantly, every conscious hour, and assemble a record of everything to which I have a direct response. I would like to accumulate a file of images which would be a complete visual diary. I would like to devote myself to the visual image."[12] Were she "sufficiently ruthless," she said, she would do it. "I could now, I believe, at a time when I

have such feeble energies, I could now do my best work, I know." [13] But she could not let down her responsibilities to her family.

I'm not focusing this entirely on myself. I'm speaking of the difference between the role of the woman as artist and the man. There is a sharp difference, a gulf. The woman's position is immeasurably more complicated. There are not very many first-class woman producers, not many. That is producers of outside things. They produce in other ways. Where they can do both, it's a conflict. . . . I'd like to take one year, almost ask it of myself, "Could I have one year?" Just one, when I would not have to take into account anything but my own inner demands. [14]

Lange's sense of the necessity of foregoing all other responsibilities to do her best work was a sharp departure from her earlier reservations about the artist's life. Although her work had appeared in museums and art exhibits since the early thirties and she was included in collections of art photographers, she had never done anything, Taylor said, "to convey the impression, 'Now I am an artist, now you've got to excuse me and let me go my way.'" [15] She always thought "that what people call 'art' was a by-product . . . a 'plus something' that happens when your work is done, if it's done well enough and intensely enough." Thus, her purpose was never to produce works of art, and she had shrugged off suggestions that she herself was an artist. "I've denied the role of artist," she said; "It embarrassed me and I didn't know what they were talking about." [16]

However, during the last years of her life, she became aware of the importance of satisfying her own needs before those of others. "My illness had something to do with it," she said, "and I now feel that I have a right, that it's more important that I now say how I feel about something than it ever was before." She was aware of the change when it occurred, and "it was sharp"; it meant the difference between being "a conscious and an unconscious artist." She said, "It's the addition of that certain little thing that only you can do. . . . [I]t puts you in the company of those who say that if they didn't do it, nobody would be saying it right now. . . . It's the essential uniqueness that comes out of the insides of your own nature. Now you can't go out and say 'I'm going to express myself.' It's not like that. It's not finding a turn that nobody else had done so far, for the sake of itself. It's not that. It's something that you have earned. In your own sight you have to have earned the right." [17] Lange's belief that she had special things to say in her work which came from her innermost self and which no one else was saying led to her final acceptance of herself as an artist.

She believed that artists "are controlled by the life that beats in them, like the ocean beats on the shore"; and as she came to terms with her approaching death, Lange tried to understand the relationships between the life that beat within her and the external forces that had shaped her existence and direction. She pursued this exploration into her own past in a number of ways. The retrospective exhibition was one channel; another was the interview she granted for the Regional Oral History Project on Bay Area artists. She wanted to discover the roots of her life in photography, why she was always compelled to photograph as a direct response to what was around her.[18] The desire to lead a purely visual life, even for a year, had to be put aside; but a review of her life and work could suggest to her why she was so drawn to that way of life and where it might have taken her.

Lange said during her last year that she was "just beginning to sense what's really in this medium."[19] No one can say where she would have taken it, but her direction certainly would not have been confined to making more photographs. Throughout her life, she had devoted considerable energy toward finding a place for the kind of photography she believed in, and she indicated in various ways that the visual life she envisioned for herself would include expanding these efforts.

Lange had been both stimulated and disappointed by the ways photography had grown in the course of her life. In the hands of amateurs and professionals, she said, "the medium, the instrument has developed many, many uses and people's awareness of the power of the visual image and the visual record in many ways has been kindled."[20] Photographs are everywhere, she said; we see them "unconsciously, in passing, from the corner of our eyes, flashing at us." Because of this exploitation of photography, she believed our eyes had become "calloused": "The habit of many people is not to see—they look at things. The habit of most people is to talk, seeing is not a habit for them. So many fine visual things are buried under torrents of words."[21]

She disapproved of much of photographic criticism because it obscured vision instead of encouraging the use of our eyes to enlarge understanding. "However, if the image has really affected the viewer," she said, "and he in turn tries to express what the consequences of looking at that picture has been for him, then I think those words are apt to be good words. They would serve the communication process. It hinges on the word 'consequences.' When people say there is no use talking or writing about photographs, something is sacrificed that pictures can do." The result of this void "is that photographic standards are not built up

and a photographic tradition is not developed."[22] Consequently, the way is paved for photographs that exploit our emotions without increasing our appreciation of the world around us.

Lange's realization of the power of the FSA's photographic project had contributed to her disappointment in the state of the medium as it had developed after the thirties. "The value of that project is now proven," she said; "it's a repository of cultural history, that only gradually has crept into people's consciousness."[23] Yet, no parallel project had taken root. Lange had taken a hand in contributing to the appreciation of this project and of other photographs which she thought showed a similar concern for a record of cultural history. When Edward Steichen was assembling the "Bitter Years" exhibition for the Museum of Modern At, Lange had put aside her own work and made several trips to New York to contribute her ideas to this major exhibit of FSA photographs.[24] Earlier, in the fifties, when Steichen was drawing together work for the "Family of Man" exhibition, Lange had a hand in collecting and selecting the photographs.[25]

More rewarding than having her own work used in these contexts, was laying the foundation for extending her ideas about photography to others. Besides teaching the seminar at the California School of Fine Art, she personally sponsored a photographer to document the migrant labor situation in California, since she could no longer do it herself; and she frequently tried to find jobs for photographers whose work she respected. Her biggest effort to extend the medium of photography she called Project I, a plan for hiring a team of photographers to document urban America. She had been turning this idea over in her mind since the early fifties, and finally, less than two years before she died, she decided to "give it a shove."[26]

The roots of Project I lay with the FSA's Historical Section. The "Bitter Years" exhibit had renewed public interest in the FSA photography and had raised the question, why had there been no sequel to that landmark of documentary photography? Lange set about gaining support and consulting with people about how Project I might be implemented. As she envisioned it, it could be done for $250,000 a year over a five-year period.

Before going to Egypt, Lange had talked to Henry Allen Moe about the possibility of the Guggenheim Foundation's helping to get support for the project, and in 1963, she made a special trip to New York to discuss her ideas with photographers and others who might take a role in Project I.[27] Among those she consulted with were several former FSA photographers, including Ben Shahn and Arthur Rothstein. She agreed that Phil Greene could make a film for

National Educational Television to present the idea to the American public.[28]

In the prospectus Lange drew up for Project I, she wrote: "It will establish a benchmark, to measure change, progress and decay. It can become an invaluable asset to historians, social scientists, students of environmental design and the humanities, teachers, writers, artists, legislators, judges, administrators, planners. It will become a national resource for all who, in the future, have use for visual images and the contemporary record."[29] Creating a record of the sixties would be much harder than the FSA's assignment during the thirties, she knew, for Project I was not to be photographs of destitute people. "We know by now how to photograph poor people," she said. "What we don't know is how to photograph affluence—whose other face is poverty."[30] Ideally, she saw it as a project that would be repeated every fifteen years, but she cautioned, "It must be done with very sharp purpose, and with great energy, I believe, by *young* people."[31]

Simultaneously, Lange worked on a second project, to establish a photography center that would extend the use of photography within higher education and would encourage the development of a visual language. Project II, as she called it, would house the photographs made for Project I, would support "research and experimentation in visual language," and would teach "not only *how* to make a fine photograph, but also . . . what it *takes* to make great photographs or great sequences of photographs." She hoped the center, besides attracting photographers, would serve as "a training ground for students of the visual" and provide an "opportunity for people to learn to see." The center would invite amateur and professional photographers from all areas, teachers from diverse fields, museum directors, librarians, critics, and researchers interested in using its laboratory, library, and gallery. They could also participate in seminars on photographic techniques, criticism, and cultural history. The center would be a place of "integrated efforts to explore the place of photography in visual communication."[32]

Neither project got off the ground, though the efforts continued after Lange's death. People met and tried to find an appropriate place for the center. The School of Environmental Design on the Berkeley campus seemed to be a likely place for a while. Various people were considered for the position of director. Lange and Taylor asked Paul Vanderbilt to consider the position, but it never materialized.[33] There were problems finding money; the federal government could not be enticed to finance the projects. The problems were many. Perhaps, if Lange had lived longer, her energies would have surmounted them, but it is doubtful.

Although the two projects did not succeed, they revealed the depth of Lange's

commitment to photography. She was never content only to be making photographs. The spirit behind her work was the extension of the photographic medium down new roads of exploration, and her goal was always to establish its integrity as a medium through which all people—those making photographs, those in photographs, and those looking at photographs—learn more about themselves and others.

In May, 1975, the *Village Voice* carried a review criticizing the New York galleries' tendency to omit photographs from their regular exhibitions and to hide their permanent collections of photographs from the public view. In so doing, the reviewers said, the galleries prevent the public from developing sensitivity about looking at photographs and ignore the opportunity photographs offer for reevaluating our own past. In particular, they mentioned Lange's work: "Ten years ago at the Modern's Dorothea Lange retrospective, her pictures from the thirties looked as if they might become period pieces. Now, with hard times upon us again, her work may either have great urgency, or be simpleminded. We need to see."[34]

We need to see these photographs again and again, but we need to see much more of Lange's work. She is classified as a documentary photographer, among the finest to come out of the hard times of the 1930s. Yet this category is too narrow to accommodate her work comfortably. It is too easy to look at her most famous photographs and see only the theme of one decade in our history. By looking more closely at the range of her work—not only her photographs—and by looking at it again and again, we come to see that she helped implement the redefinition of what is important in this world. She wanted to see photographs made, "not to show how great we are, but to show *what it's like*."[35] As Vanderbilt has said, she began to rescale our values by showing us the significance of "the small incident, the anonymous act, the spontaneous expression."[36] Lange showed us that within the scope of time and the momentous events of which history is made, it is small, nearly unnoticed expressions that weave the fabric of our lives. "Look at it!" she said; "look at it!"[37]

Notes

Preface

1. See, for example, Beaumont Newhall, *The History of Photography, 1839 to Present* (New York, 1964), 143–46, 148, 150; Beaumont Newhall and Nancy Newhall, *Masters of Photography* (New York, 1958), 140–49; F. Jack Hurley, *Portrait of a Decade: Roy Stryker and the Development of Documentary Photography in the Thirties* (Baton Rouge, 1972), 174; Helmut Gernsheim and Alison Gernsheim, *A Concise History of Photography* (New York, 1965), 254, 256; Helmut Gernsheim, *Creative Photography: Aesthetic Trends 1839–1960* (New York, 1962), 221, 240; Peter Pollack, *The Picture History of Photography*, (Rev. ed.; New York, 1969), 251, 347–48.

2. The range of these publications is immense, from scholarly books such as Sidney Baldwin, *Poverty and Politics: The Rise and Decline of the Farm Security Administration* (Chapel Hill, 1968), to popular books such as Archibald MacLeish, *Land of the Free* (New York, 1938), and articles in popular and educational magazines, ranging from John Steinbeck, "A Primer on the 30's," *Esquire*, LIII (June, 1960), 85–93, to "Days of Darkness, Days of Despair—The Depression," *Scholastic Search*, IV (April 18, 1974), 3–21 and cover.

3. Lange said this photograph had been used so widely that it was no longer her own. This embarrassed her, for she did not regard herself as a "one-picture photographer" (*Dorothea Lange: The Closer for Me*, produced, edited, and directed by Phillip Greene, Robert Katz, and Richard Moore, for KQED, San Francisco, and National Educational Television; available from Indiana University; released in 1966). See also Lange, "The Assignment I'll Never Forget," *Popular Photography*, XLVI (February, 1960), 42; and Paul S. Taylor, "Migrant Mother: 1936," *American West*, Vol. VII, No. 3, May 1970, pp. 41–47.

4. Maisie Conrat and Richard Conrat, *Executive Order 9066* (Los Angeles, 1972); A. D. Coleman, "A Dark Day in History," New York *Times*, September 24, 1972, Sec. D, p. 19; and *Guilty by Reason of Race*, produced by NBC, first televised in 1972.

5. Susan Sontag, *On Photography* (New York, 1977), 17.

6. For example, "Days of Darkness, Days of Despair"; "What a Depression Is Really Like: Scenes from the 1930s," *U.S. News and World Report*, November 11, 1974, pp. 36–40 and cover; *Documentary Photography* (New York, 1972), 78–81; and *Photojournalism* (New York, 1971), 118–33 *passim*. Lange's husband, Paul S. Taylor, has said that the number of requests for her work increases each year. Interview, Paul S. Taylor, by Karin B. Ohrn, May 29, 1974.

7. Examples include the Environmental Protection Agency's DocuAmerica and recent efforts within the Photographic Department of the Department of Agriculture.

8. Dorothea Lange, *The Making of a Documentary Photographer* (Berkeley, 1968); interview, Dorothea Lange by Richard K. Doud, May 22, 1964 (Transcript in Archives of American Art, Smithsonian Institution).

9. Located in the Roy Stryker Collection, University of Louisville Photographic Archives, Louisville, Ky. (hereinafter cited as UL). These letters are also available on microfilm, in the Roy Stryker Papers, Archives of American Art, Smithsonian Institution, Washington, D.C. (hereinafter cited as SI).

10. Lange's work for the FSA is located in the Farm Security Administration Files, Prints and Photographs Division, Library of Congress, Washington, D.C. The work she did for the Bureau of Agricultural Economics and the War Relocation Authority is located in the Bureau of Agricultural Economics Records, Audio-Visual Division of the National Archives, Washington, D.C.

11. Located in the Dorothea Lange Collection, Oakland Museum, Oakland, California.

12. The articles are listed in the bibliography herein. The films are *Dorothea Lange: Under the Trees* (Produced by Phillip Greene and Robert Katz, directed by Phillip Greene and Richard Moore, for KQED, San Francisco, and National Educational Television; available from Indiana University; released in 1965) and *Dorothea Lange: The Closer for Me*.

Chapter I

1. Lange, *The Making of a Documentary Photographer*, iii.
2. *Ibid.*, 13.
3. *Ibid.*, 17.
4. *Ibid.*, 13.
5. *Ibid.*, 26, 23, 14–15, 22, 21, 26, 19–20.
6. *Ibid.*, 69–70.
7. *Ibid.*, 36.
8. Lange-Doud interview, 1.
9. Lange, *The Making of a Documentary Photographer*, 28, 45.
10. *Ibid.*, 32.
11. *Ibid.*, 49.
12. *Ibid.*, 34.
13. This discussion of the Photo-Secession draws extensively on the thorough analysis of the history of that movement by Robert Doty, *Photo-Secession: Photography as a Fine Art* (New York, 1960).
14. Alfred Stieglitz, "Four Happenings," reprinted in Nathan Lyons (ed.), *Photographers on Photography* (Englewood Cliffs, N.J., 1960), 26.
15. Doty, *Photo-Secession*, 28.
16. Sadakichi Hartmann, *Camera Work*, No. 33 (1910), as cited in Newhall, *History of Photography*, 109. Emphasis in the original.
17. Doty, *Photo-Secession*, 57.
18. New York *Times*, October 13, 1912, Sec. 7, p. 7.
19. Newhall, *History of Photography*, 111.
20. Lange, *The Making of a Documentary Photographer*, 75–76, 38, 39.

21. *Ibid.*, 44.

22. *Ibid.*, 28−29.

23. *Ibid.*, 30−31.

24. Lange-Doud interview, 1; Daniel Dixon, "Dorothea Lange," *Modern Photography*, XVI (December 1952), 71; Lange, *The Making of a Documentary Photographer*, 44.

25. Lange, *The Making of a Documentary Photographer*, 80, 77, 52.

26. *Ibid.*, 55−56.

Chapter II

1. Lange, *The Making of a Documentary Photographer*, 81.

2. *Ibid.*, 84−85; Dorothea Lange, *Dorothea Lange* (New York: Museum of Modern Art, 1966), 105.

3. Lange, *The Making of a Documentary Photographer*, 87.

4. *Ibid.*, 87−90.

5. *Ibid.*, 93−94.

6. Arnold Genthe had been a good friend of Dixon's before moving to New York. In his autobiography, Genthe described the activities of the San Francisco "Bohemian Club"—weekend-long costume parties and camp-outs, attended by people who did not let daily responsibilities inhibit the good times they enjoyed together. A caricature Dixon drew of Genthe is included in Genthe's autobiography, *As I Remember* (New York: Reynal and Hitchcock, 1936).

7. Milton Meltzer, *Dorothea Lange: A Photographer's Life* (New York, 1978), 52.

8. Lange, *The Making of a Documentary Photographer*, 90, 118−19.

9. *Ibid.*, 91−92.

10. *Ibid.*, 90−91.

11. Imogen Cunningham, *Imogen Cunningham: Portraits, Ideas and Design* (Berkeley, 1961), 87−88.

12. *Ibid.*, 196.

13. Lange, *The Making of a Documentary Photographer*, 92.

14. Lange, *Dorothea Lange*, 105.

15. Lange, *The Making of a Documentary Photographer*, 109, 122.

16. *Ibid.*, 138−39.

17. *Ibid.*

18. The albums are now located in the Lange Collection.

19. Joanne Lovett Lathrop to Karin B. Ohrn, December, 1974.

20. The Lovett album is now located in the Lange Collection.

21. Lange, *The Making of a Documentary Photographer*, 148.

22. Dixon, "Dorothea Lange," 73.

23. Lange, *The Making of a Documentary Photographer*, 148.

24. Lange-Doud interview, 3.

25. Lange, *The Making of a Documentary Photographer*, 144.

26. Lange-Doud interview, 5.

27. Dixon, "Dorothea Lange," 73, 75.

28. Nat Herz, "Dorothea Lange in Perspective," *Infinity*, XII (April, 1963), 9.

29. Lange, *The Making of a Documentary Photographer*, 152−53.

30. Newhall, *History of Photography*, 128.

31. Lange, *The Making of a Documentary Photographer*, 91.

32. *Ibid.*, 144.

33. Dixon, "Dorothea Lange," 75.

34. Lange, *The Making of a Documentary Photographer*, 149. Martin Lange had come to San Francisco several years after his sister.

35. Herz, "Dorothea Lange in Perspective," 9.

36. Dixon, Dorothea Lange," 75. The contact prints of these photographs are located in Vol. 6, Lange Collection. The most famous, "White Angel Breadline," has been widely published in collections of Lange's work, in books and articles on documentary photography, and in books and articles about the Depression. As recently as 1974, "White Angel Breadline" was published (not credited to Lange) on the cover of a national magazine as a symbol of the Depression. *U.S. News and World Report*, November 11, 1974. Whenever she was asked to assemble a group of prints to represent her work, Lange always included this image. It remained a favorite of hers and continued to symbolize those first tentative steps into the streets.

37. Lange-Doud interview, 5.

Chapter III

1. Edward Angly collected many of these official statements and predictions in his book *Oh Yeah?* (New York, 1931).

2. Cabell Phillips, *From the Crash to the Blitz, 1929–1939: The New York Times Chronicle of American Life* (New York, 1969), 235. An article in *Fortune* that autumn was a landmark in the press's and the nation's recognition of the Depression. "No One Has Starved," VI (September, 1932), 18–29ff.

3. The variety of forms this movement took is thoroughly treated by William Stott, *Documentary Expression and Thirties America* (New York, 1973), especially Chap. 7, pp. 119–40.

4. Matthew Josephson, *Infidel in the Temple: A Memoir of the Thirties* (New York, 1967), 390–93; Carl Degler, *Out of Our Past* (New York, 1959), 390.

5. "Murals by American Painters and Photographers," reprinted from 1932 catalog, in *American Art of the Twenties and Thirties* (New York, 1969).

6. Berenice Abbott, *Changing New York* (New York, 1939).

7. See Erwin O. Christenson (ed.), *The Index of American Design* (New York, 1950); and "The Index of American Design: A Portfolio," *Fortune*, XV (June, 1937), 103–10.

8. Paul Rotha, *Documentary Film* (3rd ed.; New York, 1952), 38. Significantly, Rotha's study was first published in 1935, and the second edition came out four years later, noting the growth in size and importance of the documentary film movement.

9. Stott, *Documentary Expression*, 77–80.

10. "The Press and the People: A Survey," *Fortune*, XX (August, 1939), 65, 70; Paul Lazarsfeld, *The Press and the Printed Page* (New York, 1940); Archibald MacLeish, *A Time to Act* (Boston, 1943), 160.

11. Paul Hogarth, *The Artist as Reporter* (London, 1967), 67.

12. Stott, *Documentary Expression*, 34.

13. For example, see Federal Writers' Project, *These Are Our Lives* (Chapel Hill, 1939), and *Lay My Burden Down: A Folk History of Slavery*, ed. B. A. Botkin (Chicago, 1945).

14. For example, see Clifford R. Shaw, *The Jack Roller: A Delinquent Boy's Own Story* (Chicago, 1930); Edwin H. Sutherland (ed.), *The Professional Thief* (Chicago, 1937); Clinch Calkins, *Some Folks Won't Work* (New York: Harcourt, Brace and Co., 1930).

15. Selections of such accounts can be found in John L. Spivak, *America Faces the Barricades* (New York, 1935).

16. For a thorough discussion of the forms used in the nonfiction of the 1930s, see Stott, *Documentary Expression*, 141–257.

17. Rosalie Wax, *Doing Fieldwork* (Chicago, 1971), 38–41; Stott, *Documentary Expression*, 152–70.

18. W. Lloyd Warner and Paul S. Lunt, *The Social Life of a Modern Community* (New Haven,

Conn., 1941); Robert Lynd and Helen Lynd, *Middleton in Transition* (New York, 1937); John Dollard, *Caste and Class in a Southern Town* (New Haven, Conn., 1937); William F. Whyte, *Street Corner Society* (Chicago, 1943).

19. Thomas Minehan, *Boy and Girl Tramps of America* (New York, 1934).

20. For example, see Edwin H. Sutherland and Harvey J. Locke, *20,000 Homeless Men* (Chicago, 1936); E. Wright Bakke, *Citizens Without Work* (New Haven, Conn., 1940), and *The Unemployed Worker* (New Haven, Conn., 1940).

21. Alfred Kazin, *On Native Grounds* (Garden City, N.Y., 1956), 381, 385, 386. The first edition of this analysis of the literature of the 1930s was published in 1942.

22. Matthew Brady, as cited by Gernsheim and Gernsheim, *A Concise History of Photography*, 142.

23. Henry Mayhew, *London Labour and London Poor*, photographs by Richard Beard (London, 1851); John Thomson and Adolphe Smith, *Street Life in London* (London, 1877).

24. Arthur Siegel, "Fifty Years of Documentary," *American Photography*, XLV (January, 1951), 23.

25. Jacob Riis, *How the Other Half Lives* (New York, 1890).

26. Newhall, *History of Photography*, 139–42.

27. See Judith M. Gutman, *Lewis Hine and the American Social Conscience* (New York, 1967).

28. Roy Stryker-Lewis Hine correspondence, Stryker Collection, UL.

29. For contemporary discussion of this phenomenon, see "Orbus Pictus," *The Nation*, CXLI (October 16, 1935), 426; and Robert Taft, *Photography and the American Scene: A Social History, 1839–1889* (New York, 1964), 320. The first edition of this book was published in 1938 by MacMillan.

30. Basil L. Walters, "Pictures vs. Type Display in Reporting the News," *Journalism Quarterly*, XXIV (September, 1947), 193.

31. Theodore B. Peterson, *Magazines in the Twentieth Century* (Urbana, Ill., 1956), 15, 313.

32. See Tim N. Gidal, *Modern Photojournalism: Origin and Evolution, 1910–33* (New York, 1972).

33. Examples of Stefan Lorant's picture editing, together with a photo essay by Felix Man, can be found in *Photojournalism*, 58–61.

34. For a more complete account of the work of these men, see Gidal, *Modern Photojournalism*.

35. Daniel D. Mich, "The Rise of Photojournalism in the United States," *Journalism Quarterly*, XXIV (September, 1947), 205.

36. Stott, *Documentary Expression*, 129.

37. Advertisement for *Life*, New York *Times*, August 13, 1937, pp. 10–11. Circulation figures are drawn from James L. McCamy, *Government Publicity: Its Practice in Federal Administration* (Chicago, 1939), 81.

38. *Look*, August 17, 1937, p. 3; McCamy, *Government Publicity*, 81.

39. Mich, "The Rise of Photojournalism," 205.

40. Henry Luce, "Giving the People What They Want," *Public Opinion in a Democracy*, special supplement to *Public Opinion Quarterly*, II (January, 1938), 65.

41. Taft, *Photography and the American Scene*, 448.

42. Beaumont Newhall, foreword to Dorothea Lange, *Dorothea Lange Looks at the American Country Woman* (Forth Worth, Tex., 1967), 5. The following discussion of the characteristics of documentary photographers' techniques and goals is based in large part on Beaumont Newhall, "Documentary Approach to Photography," *Parnassus*, X (March, 1938), 2–6.

43. George P. Elliott, "Photographs and Photographers," in *A Piece of Lettuce* (New York, 1969), 93.

44. Dorothea Lange, "Documentary Photography," in T. J. Maloney, Grace M. Morley, and Ansel Adams (eds.), *A Pageant of Photography* (San Francisco, 1940).

Chapter IV

1. Willard Van Dyke, "The Photographs of Dorothea Lange: A Critical Analysis," *Camera Craft*, XLI (October, 1934), 465.

2. Lange, *The Making of a Documentary Photographer*, 150.

3. Van Dyke, "The Photographs of Dorothea Lange," 461, 464.

4. Lange, *The Making of a Documentary Photographer*, 150–51.

5. See Paul S. Taylor, "Mexicans North of the Rio Grande," *Survey Graphic*, LXVI (May, 1931), 134–40, 197, 200–202, 205.

6. Paul S. Taylor, *Paul Schuster Taylor: California Social Scientist* (Berkeley, 1973) I, 227.

7. Paul S. Taylor and Norman L. Gold, "San Francisco and the General Strike," *Survey Graphic*, LXX (September, 1934), 404–11.

8. Baldwin, *Poverty and Politics*, 59. "The term 'rehabilitation' was borrowed from the work of rehabilitating disabled veterans of World War I and other persons during the 1920s in which the word referred to 'the occupational reestablishment, with a view to complete or partial economic independence, of the physically handicapped, and covers measures of every kind which tend to bring this about, whether they be therapeutic, psychological, educational or socioeconomic.'" Oscar M. Sullivan, cited by Baldwin, *Poverty and Politics*, 63n.

9. Clark Kerr, then a student of Taylor's, wrote his dissertation on the UXA cooperatives. See "Productive Enterprises of the Unemployed" (Ph.D. dissertation, University of California, Berkeley, 1949).

10. Taylor, cited in Lange, *The Making of a Documentary Photographer*, 167n.

11. Lange, *The Making of a Documentary Photographer*, 165–66.

12. Meltzer, *Dorothea Lange*, 88.

13. Lange, *The Making of a Documentary Photographer*, 165–66. Lange's photographs from Oroville were included in an exhibition on the UXA self-help cooperatives at Haviland Hall, at the University of California, Berkeley. The photographs from the exhibit are now located in the Bancroft Library, University of California, Berkeley.

14. Taylor, prologue to Lange, "The Assignment I'll Never Forget," 43, 45.

15. Lange, *The Making of a Documentary Photographer*, 159–62.

16. Taylor, *Paul Schuster Taylor*, I, 130–31.

17. Dixon, "Dorothea Lange," 76.

18. Paul S. Taylor, "Again the Covered Wagon," *Survey Graphic*, LXXI (July, 1935), 348–51, 368.

19. Lange, *The Making of a Documentary Photographer*, 154–55, 146–47.

20. Paul S. Taylor-Ohrn interview.

21. Taylor, *Paul Schuster Taylor*, I, 138; in FSA Files, Prints and Photographs Division, Library of Congress, see Paul S. Taylor and Dorothea Lange, "Establishment of rural rehabilitation camps for migrants in California," March 15, 1935, Lot 898, and Paul S. Taylor and Dorothea Lange, "Migration of Drought Refugees to California," April 17, 1935, Lot 897.

22. Articles and editorial appeared in the San Francisco *News*, August 18, 1935, and March 10, 1936. See Taylor, *Paul Schuster Taylor*, I, 138–39; and Taylor, "Migrant Mother: 1936," 42–43.

23. Sacramento *Bee*, October 12, 1935.

24. Taylor, *Paul Schuster Taylor*, I, 149.

25. Baldwin, *Poverty and Politics*, 92, 62–63. Baldwin refers to the Shakers, the Rappites, the Amana Colonies and the Mormon settlements as examples of the communities which provided patterns used in the construction of the New Deal. See also Lewis Mumford, *The Story of Utopias* (New York, 1922).

26. Baldwin, *Poverty and Politics*, 117.

27. *Ibid.*, 119.

28. For a thorough examination of the agency, including its structure and its changes under political and budgetary constraints, see Baldwin, *Poverty and Politics*.

29. For more complete accounts of the development of the Historical Section and its staff, see Werner J. Severin, "Photographic Documentation by the Farm Security Administration, 1935–41" (M.A. thesis, University of Missouri, 1959); and Hurley, *Portrait of a Decade*. The best early account is Hartley Howe, "You Have Seen Their Pictures," *Survey Graphic*, LXXVI (April, 1940), 236–41.

30. Rexford G. Tugwell, Thomas S. Munro, and Roy E. Stryker, *American Economic Life* (New York, 1925).

31. John Durniak, "Focus on Stryker," *Popular Photography*, LI (September, 1962), 81.

32. The best sources on Stryker include Durniak, "Focus on Stryker"; Edward Stanley, "Roy Stryker: Photographic Historian," *Popular Photography*, IX (July, 1941), 28–29ff; Roy E. Stryker and Nancy Wood, *In This Proud Land: America 1935–1943 As Seen in the Farm Security Administration Photographs* (New York, 1973); and Hurley, *Portrait of a Decade*.

33. Hurley, *Portrait of a Decade*, 37.

34. See Lorentz's comments in Dorothea Lange and Pare Lorentz, "Camera with a Purpose," *U.S. Camera Annual*, I (1941), 97; and Clifton C. Edom, "Documentary Photography," *The P.S.A. Journal*, XII (April, 1946), 142–43.

35. McCamy, *Government Publicity*, 119.

36. Newspapers using Resettlement and FSA photographs include the Des Moines *Register and Tribune* (see the Sunday rotogravure section, January 10, 1937, a syndicated feature published in other Sunday picture magazines); New York *Times Magazine*, June 10, 1937, and April 11, 1937; and the Washington *Daily News*, July 2, 1936.

For examples of how magazines used the photographs, see: "Caravans of Hunger," *Look*, May 25, 1937, pp. 18–19; "Life on the Farm," *Look*, October 12, 1937, pp. 16–21; Lillian P. Davis, "Relief and the Sharecropper," *Survey Graphic*, LXXII (January, 1936), 20–22; Dorothea Lange, "Draggin' Around People," *Survey Graphic*, LXIII (March, 1936), 524–25; Mark Adams and Russell Lee, "Our Town in East Texas," *Travel*, LXXIV (March, 1940), 5–12; and Edward Steichen, "The Farm Security Administration Photographers," *U.S. Camera Annual, 1939*, pp. 44–63. Also *Colliers, Time, Newsweek*, and *McCalls* used FSA photographs (Howe, "You Have Seen Their Pictures," 238).

Government pamphlets in which Resettlement Administration and FSA photographs were published include: U.S. Department of Agriculture, *The Negro in American Agriculture* (Washington, D.C., July 1940); and C. E. Lively and Conrad Taenker, "Rural Migration in the U.S.," Research Monograph 19, WRA Division of Research (Washington, D.C., 1939).

Books that used the photographs include MacLeish, *Land of the Free*; Herman C. Nixon, *Forty Acres and Steel Mules* (Chapel Hill, 1938); Sherwood Anderson, *Home Town* (New York, 1940); and Walker Evans, *American Photographs* (New York, 1938).

"Documents of America," an exhibit of FSA photographs at the First International Photographic Exposition at Grand Central Palace, New York, April 18–19, 1938, was later circulated by the Museum of Modern Art to high schools and colleges from Vermont to Iowa. Lot 997, Prints and Photographs Division, Library of Congress. The largest exhibitions of FSA photographs were at the California Pacific International Exposition (San Diego, 1936), the Texas Centennial (Dallas, 1936) and the Great Lakes Exposition (Cleveland, 1936). FSA photographs accompanied several congressional committee reports on migrant labor and tenancy conditions and were used as evidence in the Tolan committee hearings on civil rights of migrants in 1941.

37. McCamy, *Government Publicity*, 79, 80, 81.

38. Stryker and Wood, *In This Proud Land*, 8.

39. As cited in a draft of an article by Archie Robertson, "They Have Seen Your Faces," in Stryker Papers, SI, microfilm NDA4, frame 0074, n.d.

40. Roy Stryker, "The Human Factor," New York *Times*, May 18, 1949; and Roy Stryker,

"Documentary Photography," *Complete Photographer*, IV (April 10, 1942), 1364–73ff. See also Howe, "You Have Seen Their Pictures," 237–38.

41. Stryker, as cited in Stryker and Wood, *In This Proud Land*, 16.

42. Stryker to Edna Bennett, August 29, 1962. Bennett was preparing a program guide for an educational radio station, WPAT in New Jersey, using FSA photographs. Stryker Papers, SI.

43. Lange-Doud interview, 8.

Chapter V

1. Lange-Doud interview, 7.

2. Taylor, *Paul Schuster Taylor*, I, 150, 227.

3. FSA referral and classification and function forms, in Stryker Papers, Microfilm FSA/WDC1, SI. Lange's first letters to Stryker were always signed "Dorothea Lange, Field Investigator-Photographer," and he addressed her the same way. Lange-Stryker correspondence, in Stryker Collection, UL.

4. Hurley, *Portrait of a Decade*, 27–28, 40.

5. Paul S. Taylor-Ohrn interview. Hurley describes Lee's background prior to working for FSA and his employment by Stryker. *Portrait of a Decade*, 78, 80.

6. Interview, Russell Lee by Karin B. Ohrn, March 22, 1978.

7. The information for this comparison was drawn from the photographers' correspondence with Stryker, from transcripts of interviews in which they discussed their FSA work, and from articles written by and about them. Some of this material refers to specific assignments and photographs; more frequently, their accounts are general interpretations of the work they were doing and how it fit into the goals of the Historical Section.

According to James E. Anderson, photoarchivist at the University of Louisville, occasional gaps in the letters can be accounted for by Stryker's practice of editing out letters or portions of letters that reflected his controversies with certain photographers or with members of the administration. Also, Stryker is known to have conducted much of his business over the phone, for which there is no record. Although the correspondence is not complete, the few deletions Stryker made affect only the reconstruction of an exact account of certain controversies; in each case relevant to this research, the major points of controversy appear to have survived in the letters preceding and following the deleted material. The captioned photographs, when paired with the photographers' verbal accounts, indicate how the similarities and differences among the photographers were translated into the documents each of them made.

8. Lange to Stryker, April 27 and May 3, 1937, and Stryker to Lange, "Suggestions for early part of trip (by state)," in Stryker Collection, UL.

9. Lange to Stryker, April 27, 1937, *ibid.*

10. "Memo for [Ed] Rosskam to Stryker, re: Shooting Script for Dorothea," undated, and Stryker to Lange, April 27, 1937, *ibid.*

11. Interview, Rondal Partridge by Karin B. Ohrn, May 29, 1974.

12. Stryker and Wood, *In This Proud Land*, 13.

13. Interview, Roy Stryker by Thomas Garver, July 1, 1968, in *Just Before the War* (Balboa, Calif.: Newport Art Museum, 1968). Others familiar with the FSA Files have noted this quality in Lange's work. Paul Vanderbilt, who oversaw the cataloging of the photographs when they were transferred to the Library of Congress, said that, although all the photographers could relate to their subjects naturally, "certainly Dorothea did it better than the other people" Interview, Paul Vanderbilt by Karin B. Ohrn, August 31, 1974.

14. "American Exodus," *U.S. Camera*, I (May, 1940), 71.

15. Lange-Doud interview, 9.

16. Lange, *The Making of a Documentary Photographer*, 17–18, 19.

17. Partridge-Ohrn interview.

18. Taylor, *Paul Schuster Taylor*, I, 133.

19. *Ibid.*, 134.

20. Paul S. Taylor-Ohrn interview; and Lange, notes accompanying Photograph 381120, Vol. 17, Lange Collection.

21. Arthur Rothstein, "Direction in the Picture Story," *The Complete Photographer*, IV (April 10, 1942), 1357.

22. Vanderbilt-Ohrn interview.

23. Partridge-Ohrn interview.

24. Rothstein, "Direction in the Picture Story," 1360.

25. Arthur Rothstein, "Setting the Record Straight," *Camera 35*, XXII (April, 1978), 50–51.

26. Lee-Ohrn interview.

27. F. Jack Hurley, "Russell Lee," *Image*, XVI (September, 1973), 4.

28. Russell Lee to Stryker, undated, in Stryker Collection, UL. Internal evidence suggests the letter was written in September, 1939. Another example of Lee's interest in complete documentation can be found in his photographs of wheat farms in Walla Walla County, Washington, which include the entire process from harvest to sale to storage. Photographs in FSA Files, Lot 300, Library of Congress.

29. Stryker to Arthur Rothstein, April 29, 1936, in Stryker Collection, UL.

30. Stryker to Rothstein, May 29, 1936, *ibid.*

31. Stryker to Lee, January 19, 1937, *ibid.*

32. Stryker to Lee, January 29, 1940, *ibid.*

33. Stryker to Lee, June 24, 1937, *ibid.*

34. Newhall, in foreword to Lange, *American Country Woman*, 7.

35. Lange, *The Making of a Documentary Photographer*, 167.

36. Paul S. Taylor-Ohrn interview.

37. Partridge-Ohrn interview.

38. Paul S. Taylor-Ohrn interview.

39. *Ibid.*

40. Hurley, "Russell Lee," 4.

41. Stryker to Lee, February 13, 1939, Stryker Collection, UL.

42. Stryker to Lange, September 25, 1939, *ibid.*

43. Hurley, "Russell Lee," 4.

44. Stryker to Lee, October 19, 1940, in Stryker Collection, UL.

45. Stryker-Garver interview, in *Just Before the War*.

46. Lange to Stryker, September 5 and September 7, 1936, and September 7, 1939; Stryker to Lange, October 7, 1936; Stryker to Rothstein, March 4, 1942 (includes reference to Lee's photographs); Stryker to Rothstein, May 12, 1936, and March 28, 1940; Rothstein to Stryker, April 1, 1940, and an undated letter which internal evidence suggests was written in March, 1940, all in Stryker Collection, UL.

47. Stryker to Lange, April 16, 1937, *ibid.*

48. Lange to Stryker, June 3, 1937, *ibid.*

49. Paul Taylor to Tom Blaisdell, Jr., June 3, 1937, *ibid.*

50. Paul S. Taylor-Ohrn interview.

51. Lange, "Notes from the Field," June 8, 1937, in Stryker Collection, UL; also caption for Negative RA 17983C, FSA Files, Lot 1644, Library of Congress.

52. Taylor to Blaisdell, June 8, 1937, in Stryker Collection, UL.

53. Taylor to Blaisdell, June 23, 1937, *ibid.*

54. Lee to Stryker, January 4, 1962, *ibid.*

55. Lee to Stryker, February 14, February 16, February 28, and March 17, 1939, *ibid.*

56. Stryker described "Migrant Mother" as *"the* picture of Farm Security,"* in Stryker and Wood, *In This Proud Land,* 19. Somewhat ironically, other photographs Lange made of this family were published first. San Francisco *News,* March 10, 1936. With the passage of time, "Migrant Mother" (the closest photograph Lange made of the woman) has received recognition as one of the most memorable pictures of the last fifty years. During the last decade, the photograph has entered the stream of folklore, as people have redrawn and adapted it without acknowledging its source. In 1964, the Latin American periodical *Bohemia* had "Migrant Mother" on its cover, redrawn in color, with one of the children's heads turned around and a face drawn in. In December, 1972, the Black Panther paper in Oakland used "Migrant Mother" on its back page, redrawing the group as a black family. Paul S. Taylor-Ohrn interview.

57. Lange, "The Assignment I'll Never Forget," 42.

58. *Ibid.*

59. Roy Stryker, "The Lean Thirties," *Harvester World,* LI (February–March, 1960), 11.

60. Lange to Stryker, June 3, 1937, in Stryker Collection, UL.

61. Rothstein to Stryker, April 23, 1936, *ibid.*

62. Ed Locke to Rothstein, August 7, 1936, and Stryker to Lange, August 25, 1936, *ibid.*

63. References to this series appear in the Lee-Stryker correspondence, June 14 to July 7, 1939, *ibid.* The photographs are included in the FSA Files, Prints and Photographs Division, Lot 525, Library of Congress.

64. Lee to Stryker, February 8, 1939, in Stryker Collection, UL.

65. Stryker to Lange, September 30, 1937, *ibid.*

66. Rothstein to Stryker, January 27, 1937, Stryker to Lee, January 30, 1937, Lange to Stryker, February 18, 1937, *ibid.*

67. Lange, General Caption, No. 27—Pacific Northwest, November, 1939, in Stryker Papers, Microfilm FSA/WDCL, SI; also in FSA Files, Lot 302, Library of Congress.

68. Lange, *The Making of a Documentary Photographer,* 172–73. See also Lange to Stryker, February 12, 1936, in Stryker Collection, UL.

69. One of the most helpful officials was Tom Collins, manager of the federal camp for migratory workers at Arvin, California. In the film *The Closer for Me,* Lange described his leadership in the camp and the mass of information he had stored in his head. When John Steinbeck inquired at FSA about a good source to work with while researching *Grapes of Wrath,* he was put in touch with Collins. Steinbeck worked with him for several weeks, and Collins figured as the camp manager in the novel.

70. Lange to M. E. Gilfond, October 19, 1936, in Stryker Collection, UL.

71. Stryker to Lange, February 2, 1939, Stryker to Lange, April 11, 1939, and Stryker to Rothstein, March 19, 1940, *ibid.*

Chapter VI

1. Stryker to Lange, October 30, 1935, and Lange to Stryker, December 31, 1935, in Stryker Collection, UL.

2. Lange to Stryker, December, 1935, *ibid.*

3. Stryker to Lange, January 3 and January 14, 1936, *ibid.*; Partridge-Ohrn interview.

4. Partridge-Ohrn interview; Lange to Stryker, May 23 and November 6, 1938, in Stryker Collection, UL.

5. Stryker to Lange, undated, in Stryker Collection, UL; internal evidence suggests the letter was written in late February or early March, 1936.

6. Stryker to Lange, January 3, 1936, *ibid.*

7. Stryker to Lange, January 14, 1936, *ibid.*

8. Lange, *The Making of a Documentary Photographer,* 53, 56–57, 178–79; Jacob Deschin,

"Dorothea Lange and her Printer," *Popular Photography*, LIX (July, 1966), 28, 30, 68, 70; Partridge-Ohrn interview.

9. Stryker to Lange, March 17, 1937, in Stryker Collection, UL.

10. Stryker to Lange, November 21, 1936, Lange to Stryker, March 19, 1937, *ibid.*

11. Lange to Stryker, March 19, 1937, in Stryker Collection, UL.

12. Stryker-Garver interview, in *Just Before the War.*

13. Lange to Stryker, November 18, 1937, Lange to Stryker, October 20, 1937, and Lange to Stryker, January 18, 1939, *ibid.*

14. Partridge-Ohrn interview. For example, in the Lange Collection there are negatives from summer trips Lange took across the country in 1937 and 1938 while working for FSA, for which there are no duplicates in the FSA Files, Prints and Photographs Division, Library of Congress. In the catalog for Lange's retrospective exhibition, photographs selected from the Resettlement and FSA collections are so credited; others made during the same period are credited to the Oakland Museum and selected from Lange's personal collection there. See Lange, *Dorothea Lange.*

15. Stryker to Lange, February 2, 1939, *ibid.*

16. Paul S. Taylor-Ohrn interview.

17. Interview, Beaumont Newhall by Karin B. Ohrn, May 16, 1974.

18. Lange to Stryker, May 16, 1939, in Stryker Collection, UL. In this letter, Lange refers to two letters from Stryker (May 11 and May 13) which are not included in the papers he donated to the University of Louisville Photographic Archives—an indication that he probably edited them out. One of the negatives in question Lange refers to as the "Oklahoman," which appears in unretouched form in MacLeish, *Land of the Free.* Others have noted the retouching of "Migrant Mother," pointing to the "ghostly thumb" holding back the tent flap in the retouched version (see Van Deren Coke, "Dorothea Lange: Compassionate Recorder," *Modern Photography*, XXXVII (May, 1973), 90–95; interview, Robert Doherty by Karin B. Ohrn, May 10, 1974). In general, this relatively minor incident in Lange's career has been overrated as evidence of a lack of commitment on her part to documentary accuracy. I consider it significant only as one indication of Lange's sense of autonomy from the constraints that most other FSA photographers adhered to and as an episode which further aggravated the strain in Lange and Stryker's relationship about her attitudes toward her work. For those interested in this esoteric, if not trivial, argument, prints made from the unretouched negative can be found in McCamy, *Government Publicity*, facing p. 238, and in MacLeish, *Land of the Free.*

19. Lange, *The Making of a Documentary Photographer*, 173–74.

20. Lange to Stryker, February 24, 1936, Lange to Stryker, October 6, 1937, and Stryker to Lange, February 2, 1939, *ibid.*

21. Stryker to Rothstein, June 10 and June 30, 1936, Stryker to Lee, April 4, 1940, *ibid.*

22. Lange, *The Making of a Documentary Photographer*, 206.

23. Captions on Photographs 4803D and 20353E, FSA Files, Prints and Photographs Division, Library of Congress.

24. Lee to Stryker, March 24, 1939, and Stryker to Lee, April 4, 1940, in Stryker Collection, UL.

25. Lange to Stryker, September 3, 1936, and May 3, 1937, respectively, and Lange to Stryker, January 12, 1938, *ibid.* She was referring to Photograph 29, page 80, herein.

26. Lange to Stryker, October 20, 1937, in Stryker Collection, UL.

27. Stryker to Lange, December 21, 1936 and March 23, 1937, Stryker to Rothstein, January 23, 1937; Lange to Stryker, February 18, March 23, April 2, 1937, *ibid.* See "The U.S. Dust Bowl," *Life*, June 21, 1937, pp. 61–65.

28. Lange to Stryker, March 23, 1937, Lange to Stryker, March 23 and February 16, 1937, and see also Lange to Stryker, February 8, 1937, all in Stryker Collection, UL.

29. Lange to Stryker, December 13, 1936, *ibid.*

30. Lange-Doud interview, 7.

31. Stryker to Rothstein, June 6, 1936, Stryker to Lee, September 9, 1939, Rothstein to Stryker,

September 10, 1939, and Stryker to Lange, October 6, 1939, all in Stryker Collection, UL. In the last letter, Stryker refers to a phone call the night before that had "stirred up" Lange over the situation.

32. Lange and Lorentz, "Camera with a Purpose," 94.

33. See "First International Photographic Exposition," April 18–20, 1938, FSA Files, Lot 997, Library of Congress.

34. Lange to Stryker, October 13, 1938, Stryker Collection, UL.

35. See "Visual Work Done for Government and Non-Government Agencies," from Official Records for Budget and Personnel, Farm Security Administration, undated. This is a list of the agencies the FSA photographers worked for and the types of work they did, in Stryker Papers, Microfilm NDA8, 0023–25, SI.

36. Stryker to Lange, May 11, 1937, and October 14, 1938, respectively, Stryker Collection, UL.

37. Stryker to Lee, June 13, 1939, and Lee to Stryker, June 14, 1939, *ibid.*

38. Jonathan Garst to Stryker, November 21, 1939, *ibid.*

39. Stryker to Garst, November 30, 1939, *ibid.*

40. Stryker to Lee, January 11, 1940, *ibid.* None of the Stryker-Lange correspondence on her termination was in the files Stryker donated to the University of Louisville Photographic Archives.

41. Dorothea Lange and Paul S. Taylor, *An American Exodus: A Record of Human Erosion* (New York, 1939).

42. Stryker to Lange, December 22, 1938, and Lange to Stryker, December 7, 1938, in Stryker Collection, UL.

43. Lange and Taylor, *American Exodus*, 6.

44. Erskine Caldwell and Margaret Bourke-White, *You Have Seen Their Faces* (New York, 1937). Caldwell had conceived of the idea for such a book, and his agent put him in touch with Bourke-White, who was working half-time for advertisers, half-time for the Luce publications, especially *Fortune* and *Life* magazines. They were married in 1939, divorced in 1942. Stott, *Documentary Expression*, 216, 219.

45. Dorothea Lange to George P. Elliott, August 5, 1965, in George P. Elliott Papers, Washington University Libraries, St. Louis, Mo. Elliott was preparing the introductory essay for the catalog for Lange's retrospective exhibition—"On Dorothea Lange," in Lange, *Dorothea Lange*, 6–14. The study she refers to in her letter to Elliott is Gregory Bateson and Margaret Mead, *Balinese Character* (New York, 1942).

46. Lange and Taylor, *American Exodus*, 5.

47. Taylor, *Paul Schuster Taylor*, I, 218.

48. *Ibid.*, 219.

49. *An American Exodus* was published in a revised edition (New Haven, Conn., Yale University Press, 1969) with an additional section entitled "The End of the Road: The City" that included photographs Lange had made after 1939. They documented the changes in America brought about by the urbanization process during the postwar years. A reprint of the 1939 edition was published in 1975 (New York: Arno Press).

50. Paul Vanderbilt, "Memorandum on the Photography of America," Madison, Wisconsin, February 7, 1963, p. 2, in Stryker Papers, Microfilm NDA4, 100–109, SI. Vanderbilt had been in charge of transferring the FSA files to the Library of Congress, and when it was suggested in the mid-sixties that new efforts to document America in photographs be established at the federal level, Vanderbilt was asked to write this proposal.

51. Lange, *The Making of a Documentary Photographer*, 170; and Lange, in the film, *The Closer for Me.*

52. Taylor's notations, made on July 28, 1973, to Lange-Doud interview indicate that over one-third of the photographs in MacLeish, *Land of the Free*, are by Lange; more than 8 percent of the photographs in "The Bitter Years" exhibition were by Lange (Museum of Modern Art, 1962); and in

an exhibition of FSA photographs in London, 30 percent were by Lange ("The Compassionate Camera," Victoria and Albert Museum, London, 1973).

53. See Edward Steichen (ed.), *The Bitter Years, 1935–41*, (New York, 1962), viii. Vanderbilt has said that he was deeply influenced by Lange's verbatim captions and that they contributed to his evaluation of her work as forming the strongest portion of the FSA file. Vanderbilt-Ohrn interview.

Chapter VII

1. Rothstein had worked for the magazine for several weeks in 1937, and when the opportunity came along to work for *Look* full time in 1940, he took it. During the war, he returned to the FSA briefly and served in the Signal Corps. He returned to *Look* after the war and soon rose to the position of editor. The man who hired Rothstein was Ed Locke, former picture editor for FSA.

2. Lange to Stryker, March 31, 1940, Stryker Collection, UL.

3. For example, "A Pageant of Photography," which was held in 1940 in the Palace of Fine Arts on Treasure Island in San Francisco, included examples of documentary photography. Lange's description of documentary photography (see page 37, herein) was included in the catalog, Thomas J. Maloney, Grace McCann Morley, and Ansel Adams (eds.), *A Pageant of Photography* (San Francisco, 1940).

4. Meltzer, *Dorothea Lange*, 230.

5. These photographs and captions are located in Record Group 83, Audio-Visual Division, National Archives. Some photographs which Lange labeled "BAE rejects" are located in Vol. 21, Lange Collection.

6. Caption for Negative 44035, Vol. 21, Lange Collection. See also others of the same scene in RG 83, Audio-Visual Division, National Archives.

7. The first photographer to receive a John Simon Guggenheim Memorial Fellowship was Edward Weston in 1937. He used the two-thousand-dollar award to travel 35,000 miles photographing the American West. Henry Allen Moe, a member of the board of selection, had wanted to make the award to a photographer in order to set a precedent for others. Weston was considered a likely candidate because his realistic photographs showed high craftsmanship and artistic significance, and they avoided social controversy. Taylor said that Lange helped Weston prepare his application because she respected his work and shared Moe's wish that photographers be considered for these fellowships. It was consistent with Lange's concern, not only to find a place for her own work, but to extend the opportunities for good photography in this country. Taylor-Ohrn interview.

8. Lange, *The Making of a Documentary Photographer*, 184–85.

9. Lange, notes in Vol. 23, Lange Collection.

10. Meltzer, *Dorothea Lange*, 234–36.

11. Lange, notes in Vol. 21, Lange Collection.

12. Lange, *The Making of a Documentary Photographer*, 183; Taylor-Ohrn interview.

13. Lange, *The Making of a Documentary Photographer*, 184.

14. Stryker to Rothstein, March 4, 1942; also Stryker to Rothstein, February 11, 1942, and Rothstein to Stryker, February 18, 1942, all in Stryker Collection, UL. Rothstein was on leave from *Look* at the time.

15. Lee to Stryker, June 14, 1940; see also Rothstein to Stryker, January 17, 23, and 30, 1942, *ibid.*

16. For a thorough description of the budgetary and political problems that brought the FSA to an end, see Baldwin, *Poverty and Politics*. In October, 1943, Stryker was hired by Standard Oil of New Jersey to head up a photographic team formed to document the history of oil. The photographs from this project are located in the Standard Oil of New Jersey Collection, University of Louisville Photographic Archives.

17. Baldwin, *Poverty and Politics*, 226–28.

18. Eugene V. Rostow, "The Japanese American Case: A Disaster," in Richard M. Abrams and Lawrence W. Levine (eds.), *The Shaping of Twentieth Century America* (2d ed.; Boston, 1971), 459. Numerous studies and accounts have been published concerning the Japanese American experience during World War II. Among the most valuable are Martin Grodzins, *Americans Betrayed* (Chicago, 1949), and Michi Weglyn, *Years of Infamy: The Untold Story of America's Concentration Camps* (New York, 1976). See also the three-volume study published as Dorothy S. Thomas and Richard S. Nishimoto, *The Spoilage* (Berkeley, 1946); Dorothy Thomas *et al.*, *The Salvage* (Berkeley, 1952); and Jacobus ten Broek *et al.*, *Prejudice, War and the Constitution* (Berkeley, 1954).

19. The Nisei were not drafted, but many enlisted in military service. The 442nd Regional Combat Team, the Japanese American unit, received more citations than any other of its size under their motto Go for Broke.

20. The camps were located near Sacaton and Parker in Arizona; at Tule Lake and Manzanar in California; near Eden, Idaho; Amache, Colorado; Cody, Wyoming; and Delta, Utah. Two additional camps were located in Arkansas, near McGehee and Jerome.

21. Report of Special Meeting of Federal Regional Advisory Council, San Francisco, March 16, 1942, in Record Group 210, National Archives.

22. U.S. Army, Western Defense Command and Fourth Army, *Final Report: Japanese Evacuation from the West Coast, 1942* (Washington, D.C., 1943), 34. This report was authorized by Colonel Karl R. Bendetsen, administrator of the evacuation program, and signed by General John L. Dewitt, commander of the Western Defense Command and the Fourth U.S. Army.

23. Grodzins, *Americans Betrayed*, 164–65.

24. These examples are cited in Conrat and Conrat, *Executive Order 9066*, 42, 44. Other examples of the racist statements in the press and by public officials appear throughout the book.

25. The photographers, in addition to Lange, included Hikaru Iwasaki, Tom Parker, Frank Stewart, Charles Mace, Fred Clark, and Clem Albers.

26. Lange, *The Making of a Documentary Photographer*, 191; Taylor, *Paul Schuster Taylor*, I, 228. Lange's photographs and captions from her WRA work are located in Record Group 210, Audio-Visual Division, National Archives.

27. Interview, Ruth Teiser by Karin B. Ohrn, June 4, 1974. Teiser interviewed Adams for the Regional Oral History Office, University of California.

28. Ansel Adams to Karin B. Ohrn, April 2, 1975.

29. Ansel Adams to Nancy Newhall, Fall, 1963.

30. Ansel Adams, *Born Free and Equal* (New York, 1944). This comparative analysis can also be found in Karin B. Ohrn, "What You See Is What You Get: Dorothea Lange and Ansel Adams at Manzanar," *Journalism History*, IV (1977), 14–22, 32.

31. Adams *Born Free and Equal*, 112, 36, 25.

32. Caption and Photographs G-C460, C461, RG/210, Audio-Visual Division, National Archives. One of these photographs can be seen in Bill Hosokawa, *Nisei* (New York, 1969), 354.

33. Dixon, "Dorothea Lange," 139.

34. Paul S. Taylor-Ohrn interview; interview, Phillip Greene by Karin B. Ohrn, June 3, 1974.

35. Ansel Adams, *Making a Photograph* (New York, 1935), 88. With the exception of Lange's "White Angel Breadline," all photographs in the volume are by Adams. In a statement on Group f.64, written around 1934, Adams described Lange's work: "She is both a humanitarian and an artist. Her pictures of people show an uncanny perception, psychological and emotional, which is transmitted with immense impact on the spectator. To my mind, she presents the almost perfect balance between artist and human being. I am frankly critical of her technique in reference to the standards of purist photography, but I have nothing but admiration for the more important things—perception and intention. Her pictures are both records of actuality and exquisitely sensitive emotional documents." As cited in Nancy Newhall, *The Eloquent Light* (San Francisco, 1964), 82, Vol. I of Newhall, *Ansel Adams: A Biography*.

36. John Collier, Jr., and Ansel Adams, "Two Approaches to Portraiture," *Camera 35*, IV (October–November, 1960), 30.

37. Lange, *The Making of a Documentary Photographer*, 186–87, 193–94.

38. *Ibid.*, 188–89.

39. Captions for Photographs G-A63, A537, R6210, Audio-Visual Division, National Archives.

40. Adams, *Born Free and Equal*, 112.

41. Nancy Newhall, *Eloquent Light*, 106.

42. See Ansel Adams, "Personal Credo," in Lyons (ed.), *Photographers on Photography*, 25–31.

43. Adams, *Born Free and Equal*, 9.

44. Greene-Ohrn interview; Partridge-Ohrn interview.

45. Partridge attributed this description of Adams' work to Lange's son, Dan Dixon. Partridge-Ohrn interview.

46. Nancy Newhall, *Eloquent Light*, 106.

47. Ansel Adams, "Personal Credo," in Lyons (ed.), *Photographers on Photography*, 25–31; in Ira Latour, "West Coast Photography: Does It Really Exist?" *Photography* (London), III (June, 1957), 36.

48. Adams, *Born Free and Equal*, 112.

49. Lange, *The Making of a Documentary Photographer*, 191, 182–83. One young Japanese American, Charles Kikuchi, kept a diary of his experiences and expressed resentment at the presence of a photographer during the evacuation: "There goes a 'thing' in slacks and she is taking pictures of that old Issei lady with a baby. She says she is the official photographer, but I think she ought to leave these people alone." Modell (ed.) *The Kikuchi Diary*, 52. The diary entry was made April 30, 1942, at the Berkeley Central Station, as people were being evacuated to the assembly center at Tanforan Race Track in San Bruno. Lange did photograph this phase of the operation, and she was the only woman who was an "official" photographer for the WRA.

50. Adams to Ohrn, April 2, 1975.

51. Taylor, *Paul Schuster Taylor*, I, 229–30, 235.

52. Adams to Nancy Newhall, December 24, 1944.

53. Adams to Ohrn, April 2, 1975.

54. Taylor, *Paul Schuster Taylor*, I, 230.

55. Tolan had been a long-standing supporter of the FSA and its Historical Section, and he had used FSA photographs in hearings he held on migratory labor.

56. Taylor, *Paul Schuster Taylor*, I, 229–31.

57. Interview, Richard Conrat by Karin B. Ohrn, June 15, 1975.

58. Lange, *The Making of a Documentary Photographer*, 200–201, 190–91.

59. Adams to Ohrn, April 2, 1975.

60. Carey McWilliams, *California: The Great Exception* (New York: 1949), 233–34.

61. Lange, in the film *The Closer for Me*.

62. Dorothea Lange and Ansel Adams, "Richmond Took A Beating," *Fortune*, XXI (February, 1945), 262–69; Adams to Ohrn, April 2, 1975.

63. Lange, in the film *The Closer for Me*. The photographs Lange made are located in Vol. 24, Lange Collection, together with a few notes by her.

64. Notes to accompany Negative 42004, Vol. 24, Lange Collection.

65. Lange, in the film *The Closer for Me*. The photographs Lange made during this period formed a core of an additional section to the revised edition of Lange and Taylor, *American Exodus*, published in 1969.

66. Beaumont Newhall, in foreword to Lange, *American Country Woman*, 7.

67. Lange, *The Making of a Documentary Photographer*, 181–82.

68. [Dorothea Lange and Ansel Adams], "American-Italians" *Victory*, Vol. I, No. 4, pp. 27–35; [Lange], "Americans of Spanish Descent," *Victory*, Vol. I, No. 5, pp. 26–30.

69. Lange, *The Making of a Documentary Photographer*, 181.

70. Lange to Stryker, undated, in Stryker Collection, UL. Internal evidence suggests she wrote the letter in 1944.

71. Lange, *The Making of a Documentary Photographer*, 182.

72. Newhall, in foreword to Lange, *American Country Woman*, 7–8; "American-Italians," 32–35.

73. Located in Vol. 25, Lange Collection.

74. Dixon, "Dorothea Lange," 139. See also Lange's discussion of this assignment in the film *Under the Trees*.

75. Meltzer, *Dorothea Lange*, 250–51.

76. Lange, notes in Vol. 27, Lange Collection.

77. See Hosokawa, *Nisei*; Modell (ed.), *The Kikuchi Diary*; Alexander Leighton, *Governing of Men* (Princeton, N.J., 1945).

78. "WRA Photographer Who Aided Relocation Dies," in San Francisco *Nichi-Bei Times*, October 14, 1965.

79. Taylor, *Paul Schuster Taylor*, I, 233. Taylor was a member of the American Committee on Friendship and Fair Play, which tried to insure good treatment of the evacuees and made provisions for their return. See Paul S. Taylor, "Our Stakes in the Japanese Exodus," *Survey Graphic*, LXXVII (September, 1942), 373–75, 378, 396–97.

80. Houston and Houston, *Farewell to Manzanar*, 163.

81. Conrat and Conrat, *Executive Order 9066*.

82. Coleman, "Dark Day in History," 19.

83. Lange, *The Making of a Documentary Photographer*, 192. On December 18, 1944, the Supreme Court ruled that loyal citizens could not legally be detained (*Ex parte Mitsuye Endo*) 323, U.S. 283), but it has never clearly ruled on the constitutionality of the executive order establishing military areas for incarcerating people. On February 19, 1976, the thirty-fourth anniversary of Executive Order 9066, President Gerald R. Ford issued Proclamation 4417, the first presidential statement admitting the error of the internment. Ford closed the proclamation with the promise that "this kind of action shall never again be repeated."

Chapter VIII

1. Wilson Hicks, *Words and Pictures* (New York, 1952), 86, 58.

2. Arthur Rothstein, *Photojournalism*, (Philadelphia, 1965), 128.

3. Henri Cartier-Bresson, *The Decisive Moment* (New York, 1952).

4. "Photography," *Newsweek*, October 21, 1974, p. 66. See Robert Frank, *The Americans* (Paris, 1958). In the introduction to *The Americans*, Jack Kerouac challenged, "Anybody doesn't like these pitchers don't like potry see? Anybody don't like potry go home see Television shots of big hatted cowboys being tolerated by kind horses" (vi).

5. Hicks, *Words and Pictures*, 88.

6. See Werner Severin, "Cameras with a Purpose: The Photojournalists of the FSA," *Journalism Quarterly*, XLI (Spring, 1964), 199; Paul Vanderbilt, "Memorandum on the Photography of America," Stryker Papers, Microfilm NDA4, 100, SI; Hicks, *Words and Pictures*, 105.

7. Stryker and Wood, *In This Proud Land*, 8. See also Stryker's comments on *Life*, as cited in Durniak, "Focus on Stryker," 81.

8. For example, Stryker to Lee, June 24, 1937, in Stryker Collection, UL.

9. See Edom, "Documentary Photography," 140–41.

10. Hicks, *Words and Pictures*, 88.

11. *Ibid.*, 89, 107.

12. Erskine Caldwell and Margaret Bourke-White, "The South of Erskine Caldwell As Photographed by Margaret Bourke-White," *Life*, November 22, 1937, pp. 48–52; Bourke-White, "Hogs,"

Fortune, I (February, 1930), 54–61, and Bourke-White, "Franklin Roosevelt's Wild West," *Life*, November 3, 1936, cover and pp. 9–17. Hicks discusses these photographers and their qualifications in *Words and Pictures*, 80–84.

13. Newhall-Ohrn interview.

14. Lists of Bourke-White's photo essays can be found in Theodore M. Brown, *Margaret Bourke-White, Photojournalist* (Ithaca, N.Y., 1972), 113–15, and in Margaret Bourke-White, *The Photographs of Margaret Bourke-White* (New York, 1972), 205–206.

15. W. Eugene Smith, *W. Eugene Smith: His Photographs and Notes* (New York, 1969). See Smith, "Country Doctor," *Life*, September 20, 1948, pp. 115–26, and Smith, "Spanish Village," *Life*, August 9, 1951, pp. 120–29.

16. Dorothea Lange and Ansel Adams, "Three Mormon Towns," *Life*, September 6, 1954, pp. 91–100; Dorothea Lange, "Irish Country People," *Life*, March 21, 1955, pp. 135–43; Dorothea Lange, "The American Farm Woman," *Harvester World*, LI, (November, 1960), 2–9; a different version of this was published as Dorothea Lange, "Women of the American Farm," *America Illustrated* (USIA), Russian ed., November 1962, pp. 56–61; Polish ed., December 1962, pp. 2–7; Arabic ed., April 1962, pp. 18–23.

17. Lange, *The Making of a Documentary Photographer*, 153.

18. Meltzer, *Dorothea Lange*, 284.

19. Lange, in the film *Under the Trees*.

20. Taylor, *Paul Schuster Taylor*, I, 245.

21. Dixon, "Dorothea Lange," 140.

22. "Miss Lange's Counsel: Photographer Advises Use of Picture Themes," New York *Times*, December 7, 1952, Sec. II, p. 23.

23. Beaumont Newhall, in foreword to Lange, *American Country Woman*, 9.

24. Lange, "The American Farm Woman"; Lange, "Women of the American Farm"; and Lange, *American Country Woman*.

25. Lange, *American Country Woman*, 70.

26. Although Lange's work was later recataloged according to date and subject by Lange and her assistant, Richard Conrat, some of the "themes" can still be found in her files in Berkeley. These were made available to me through the courtesy of Paul Taylor.

27. Newhall, in foreword to Lange, *American Country Woman*, 9.

28. Dixon, "Dorothea Lange," 141.

29. Dorothea Lange and Daniel Dixon, "Photographing the Familiar," *Aperture*, Vol. I, No. 2 (1952), 9.

30. *Ibid.*, 13, 9.

31. Notes to accompany Contact Sheet 57201, Vol. 36, Lange Collection.

32. Lange, *The Making of a Documentary Photographer*, 74.

33. See Margaret Bourke-White, *Eyes on Russia* (New York, 1931); Bourke-White, "Moscow Fights Off Nazi Bombers," *Life*, September 1, 1941, cover and pp. 15–21; and Bourke-White, "Russia Mud and Blood Stall the German Army," *Life*, November 17, 1941, pp. 33–39.

34. W. Eugene Smith, "My Daughter Juanita," *Life*, September 21, 1953, cover and pp. 165–71.

35. Newhall-Ohrn interview.

36. Meltzer, *Dorothea Lange*, 301.

37. Taylor-Ohrn interview.

38. Vols. 32–35, 41, Lange Collection.

39. Dixon, "Dorothea Lange," 77.

40. Lange, *The Making of a Documentary Photographer*, 197.

41. Herz, "Dorothea Lange in Perspective," 10. She expressed similar ideas in Lange, *The Making of a Documentary Photographer*, 198.

42. Dixon, "Dorothea Lange," 77.

43. Notes accompanying Contact Sheet 54161–62, Vol. 34, Lange Collection.

44. Partridge-Ohrn interview.

45. Adams to Ohrn, April 2, 1975.

46. Taylor, *Paul Schuster Taylor*, I, 244–45.

47. *Ibid.*, 242–44.

48. Adams to Lange, October 25, 1954, in Lange's personal files.

49. Lange, *The Making of a Documentary Photographer*, 208–209, 183.

50. Greene-Ohrn interview.

51. Lange and Taylor, *American Exodus*; Caldwell and Bourke-White, *You Have Seen Their Faces*.

52. Bourke-White, *Photographs of Margaret Bourke-White*, 139.

53. Margaret Bourke-White, "The Vultures of Calcutta Eat the Indian Dead," *Life*, September 9, 1946, pp. 38–39; Taylor, *Paul Schuster Taylor*, I, 262–63.

54. Dorothea Lange and Pirkle Jones, "Death of a Valley," *Aperture*, VIII, No. 3 (1960), 128.

55. Greene-Ohrn interview.

56. Lange and Jones, "Death of a Valley," 127.

57. Lange, in a conversation with George Leonard, September 4, 1964 (Transcript in possession of Margaretta Mitchell).

58. Dorothea Lange and Margaretta K. Mitchell, *To A Cabin* (New York, 1973).

59. Chester Morrison, "Dorothea Lange, Friend of Vision," *Look*, March 22, 1966, pp. 34–38.

60. Irwin Welcher to Jacob Deschin, February 26, 1966, Lange Collection; Lange, *The Making of a Documentary Photographer*, 208, 209.

61. Adams to Ohrn, April 2, 1975.

62. Greene-Ohrn interview.

63. *Ibid.*

64. Lange and Jones, "Death of a Valley," 127–65. "Death of a Valley" was exhibited at the San Francisco Museum of Art, November 2–December 4, 1960, and at the Art Institute of Chicago, January 26–March 3, 1963. Pirkle Jones has possession of all the negatives they made on this assignment.

65. *Ibid.*, 127.

66. Meltzer, *Dorothea Lange*, 299–300.

67. Lange, in a letter to Magnum, 1958, as cited in W. Eugene Smith, "One Whom I Admire, Dorothea Lange (1895–1965)," *Popular Photography*, LVIII, (February, 1966), 8.

68. A description of this seminar is located in Lange's personal files in Berkeley. The California School of Fine Arts is now the San Francisco Art Institute.

69. Smith, "One Whom I Admire," 88.

Chapter IX

1. Lange-Doud interview, 2.

2. These albums are now located in the Lange Collection.

3. Lathrop to Ohrn, December, 1974.

4. This photograph appears in Lange, *Dorothea Lange*, 74. "First Born" also appeared in the "Family of Man" exhibition at the Museum of Modern Art in 1955.

5. "Words Spoken by Daniel Dixon on October 30, 1965, at Memorial Services for Dorothea Lange," in Lange, *The Making of a Documentary Photographer*, 241, 240.

6. *Ibid.*

7. Lange, in a conversation with George Leonard.

8. *Ibid.*

9. *Ibid.*

10. *Ibid.* Leonard had suggested John Vachon, formerly a photographer for the FSA, as one who might help Lange complete her photographs at Steep Ravine.

11. Karin B. Ohrn, "Prodigal Photography: Professional Returning to the Home Mode," a paper presented to the Conference on Culture and Communication, Temple University, Philadelphia, Pa., March, 1975.

12. Harry Callahan, *The Multiple Image* (Chicago, 1961).

13. Ralph Eugene Meatyard, *Ralph Eugene Meatyard* (Lexington, Ky., 1970).

14. Emmet Gowin, *Photographs* (New York, 1976).

15. Elliot Erwitt, *The Private Experience: Elliott Erwitt* (Los Angeles, 1974), 4–5, 18–25.

16. See Jacques Henri Lartigue, *Boyhood Photos of J.-H. Lartigue: The Family Album of a Gilded Age* (Lausanne [?] : 1966); also Jacques Henri Lartigue, *Diary of a Century*, ed. Richard Avedon (New York, 1970).

17. Smith, "My Daughter Juanita."

18. W. Eugene Smith, "Man of Mercy," *Life*, November 15, 1954, pp. 161–72; Smith, "Spanish Village"; and Cartier-Bresson, *The Decisive Moment.*

19. Taylor, *Paul Schuster Taylor*, I, 247, 266, 277, 282.

20. *Ibid.*, 248, 277. Lange wrote to the Newhalls, "I go because Paul's work takes him there. For my own work I would choose to stay in my own country." As cited by Beaumont Newhall, in foreword to Lange, *American Country Woman*, 8. The only time Lange's work took her overseas was in 1955, when she went to Ireland on assignment for *Life*. Lange, "Irish Country People".

21. Taylor, *Paul Schuster Taylor*, I, 247.

22. Lange, in a conversation with John Szarkowski, director of photography, Museum of Modern Art, recorded in the film *Under the Trees.*

23. Newhall, in foreword to Lange, *American Country Woman*, 5.

24. Taylor, *Paul Schuster Taylor*, I, 259, 252.

25. This photograph appears, tightly cropped, in Lange, *Dorothea Lange*, front cover and p. 94.

26. Taylor, *Paul Schuster Taylor*, I, 252.

27. Dorothea Lange to Suzanne Riess, June 8, 1963.

28. Dorothea Lange to Imogen Cunningham, undated. The letter was probably written in late spring, 1963.

29. Taylor, *Paul Schuster Taylor*, I, 244–45.

30. George Elliott, in foreword to Lange, *Dorothea Lange*, 13. Upon reading a draft of Elliott's introduction, Lange wrote him, "What you said about the Egyptian is *perfectly* the way it was and is." Lange to Elliott, August 14, 1965, in Elliott Papers.

31. Ralph Gibson, in a talk at the Refocus Festival, University of Iowa, Iowa City, April 16, 1976.

32. Taylor, *Paul Schuster Taylor*, I, 254, 258–59.

33. One of the photographs from this series appears in Lange and Mitchell, *To A Cabin*, 125.

34. Interview, Dyanna Taylor by Karin B. Ohrn, May 29, 1974. One of these photographs appears in Lange and Mitchell, *To A Cabin*, 76.

35. Interview, Margaretta Mitchell by Karin B. Ohrn, June 3, 1974.

36. Taylor, *Paul Schuster Taylor*, I, 260–61. One of the photographs from this series was used on the poster advertising Lange's retrospective at the Museum of Modern Art and appears in the catalog. Lange, *Dorothea Lange*, back cover and p. 95.

37. Dyanna Taylor-Ohrn interview. One of these photographs appears in Lange and Mitchell, *To A Cabin*, 87.

38. Taylor, *Paul Schuster Taylor*, I, 260.

39. Lange, *The Making of a Documentary Photographer*, 216.

40. Dyanna Taylor-Ohrn interview.

41. Partridge-Ohrn interview.

42. Paul S. Taylor-Ohrn interview.

43. Interview, Therese Heyman by Karin B. Ohrn, June 6, 1974; Mitchell-Ohrn interview.

44. Lange, in the film *The Closer for Me*.

45. Conrat-Ohrn interview.

46. Partridge-Ohrn interview.

47. Arthur Goldsmith, "A Harvest of Truth: The Dorothea Lange Retrospective Exhibition," *Infinity*, XV (March, 1966), 23–30.

48. Lange-Doud interview, 22.

49. Lange, "Miss Lange's Counsel," in New York *Times*, December 7, 1952, II, p. 23.

50. As reproduced in Lange and Mitchell, *To A Cabin*, 11.

51. Lange and Mitchell, *To A Cabin*, was assembled after Lange's death by Mitchell, in consultation with Lange's family. Mitchell and her family had also spent time at a cabin at Steep Ravine, and the Mitchells and the Taylors were friends. The book combines Mitchell's and Lange's photographs and presents Lange's photographs differently than in any work Lange edited and assembled herself, grouping them according to themes which grew in part out of Mitchell's experience at Steep Ravine. As Mitchell readily admits, *To A Cabin* cannot be taken as Lange's final statement about "freedom, of which the cabin would be the device." Mitchell-Ohrn interview.

52. Conrat-Ohrn interview.

53. Lange, in "A Born Photographer Talks of Her Craft," in Berkeley *Review*, January 28, 1960; reproduced in Lange, *The Making of a Documentary Photographer*, 255–56.

54. Lange, *The Making of a Documentary Photographer*, 206–207, 203–204, 207–208.

55. *Ibid.*, 202.

56. The photograph appears cropped in this way in Lange, *Dorothea Lange*, 90.

57. Dorothea Lange, "Remembrance of Asia," in *Photography Annual, 1964*, comp. editors of *Popular Photography* (New York: Ziff-Davis, 1963), 50–59, 191, 193; Lange, *Dorothea Lange*, 107.

58. Meltzer, *Dorothea Lange*, 344–45.

59. Dorothea Lange to Richard Grossman, reproduced in Lange and Mitchell, *To A Cabin*, 3.

60. Lange, in the film *Under the Trees*.

61. See "Photography"; Jonathan Green (ed.), *Snapshot*, published as *Aperture*, XIX, No. 1 (1974).

Chapter X

1. "The New California" panel of Dorothea Lange retrospective exhibition, Museum of Modern Art, New York, March, 1966.

2. "Miss Lange's Counsel," in New York *Times*, December 7, 1952, II, p. 23.

3. Lange to Stryker, May 13, 1960, in Stryker Collection, UL.

4. Taylor, *Paul Schuster Taylor*, I, 289.

5. Meltzer, *Dorothea Lange*, 341.

6. Lange, in the film *Under the Trees*.

7. Conrat-Ohrn interview.

8. Van Dyke, "The Photographs of Dorothea Lange," 461.

9. Lange, in the film *Under the Trees*.

10. Conrat-Ohrn interview.

11. Some of this process can be seen in the film *The Closer for Me*.

12. Lange, in the film *Under the Trees*.

13. Lange, *The Making of a Documentary Photography*, 215.

14. Lange, in the film *Under the Trees*.

15. Lange, *The Making of a Documentary Photographer*, 148–49; Lange, in the film *Under the Trees*.

16. Newhall, in foreword to Lange, *American Country Woman*, 9; Lange, in the film *Under the Trees*.

17. Goldsmith, "Harvest of Truth," 25.

18. Lange, in the film *The Closer for Me*. At the risk of sounding pedantic, I should point out that Lange's perspective on cross-cultural communication is not informed by research. Gross misunderstandings often result from reliance on cues from one's own culture for interpreting expressions made by a member of a different culture. See, for example, Edward T. Hall, *The Silent Language* (Garden City, N.Y., 1959).

19. This photograph was actually made by Dan Dixon, as part of a story he and Lange were doing together on the city's cable cars. Dixon told Milton Meltzer that she had set the camera for the correct exposure and handed it to him. Meltzer, *Dorothea Lange*, 307–308. The photograph was incorrectly captioned in Lange's retrospective as "Man Stepping off Curb."

20. Lange, in the film *Under the Trees*.

21. Conrat-Ohrn, Heyman-Ohrn, and Taylor-Ohrn interviews.

22. Lange, in the film *Under the Trees*; "The Last Ditch" panel, Lange retrospective, Museum of Modern Art.

23. Goldsmith, "Harvest of Truth," 25.

24. Lange to Elliott, August 5, 1965, in Elliott Papers.

25. Irwin Welcher to Jacob Deschin, February 26, 1966, in Lange Collection. Welcher wrote the letter for the article by Deschin, "Dorothea Lange and Her Printer."

26. *Ibid.*

27. *Ibid.*

28. *Ibid.*

29. *Ibid.*

30. Goldsmith, "Harvest of Truth"; and Deschin, "Dorothea Lange and Her Printer."

31. Lange, *The Making of a Documentary Photographer*, 204.

32. Lange to Elliott, August 14, 1965, in Elliott Papers.

33. Newhall, in foreword to Lange, *American Country Woman*, 10.

34. "Some notations of the last days and hours," in Lange, *The Making of a Documentary Photographer*, 252.

Chapter XI

1. Taylor, *Paul Schuster Taylor*, I, 221.

2. Newhall, in foreword to Lange, *American Country Woman*, 5.

3. Wayne Miller, "Dorothea Lange, October 1965," a memorial letter from Magnum, reproduced in Lange, *The Making of a Documentary Photographer*, 245.

4. Lange, *The Making of a Documentary Photographer*, 54.

5. See Lange and Dixon, "Photographing the Familiar," 6.

6. Newhall-Ohrn interview.

7. Lange and Dixon, "Photographing the Familiar," 6.

8. Homer Page, "A Remembrance of Dorrie," *Infinity*, XIV (November 1965), 26.

9. Lange, *The Making of a Documentary Photographer*, 202–203.

10. *Ibid.*, 216–17.

11. Lange, in the film *The Closer for Me*.

12. Herz, "Dorothea Lange in Perspective," 11.

13. Lange, *The Making of a Documentary Photographer*, 218.

14. *Ibid.*, 219–20.

15. Taylor, *Paul Schuster Taylor*, I, 221. See also Lange, *The Making of a Documentary Photographer*, 75.

16. Lange, *The Making of a Documentary Photographer*, 214.

17. *Ibid.*, 213–14, 218.

18. *Ibid.*, 145–46.

19. Walter Blum, "Looking Back at a Great Woman Photographer," in San Francisco *Examiner and Chronicle*, January 23, 1966, "California Living" sec., p. 16.

20. Lange, *The Making of a Documentary Photographer*, 154.

21. Lange, as cited in Herz, "Dorothea Lange in Perspective," 11.

22. *Ibid.*

23. Lange, in the film *The Closer for Me*.

24. Lange to Stryker, June 21, 1962, in Stryker Collection, UL.

25. Lange, *The Making of a Documentary Photographer*, 209–10. See Edward Steichen (ed.), *The Family of Man* (New York, 1955).

26. Partridge-Ohrn interview; Lange, in the film *The Closer for Me*; also Jacob Deschin, "This is the Way it is—Look at it! Look at it!" *Popular Photography*, LIX (May, 1966), 58.

27. Meltzer, *Dorothea Lange*, 342–43.

28. The film *The Closer for Me* was shot in one afternoon in 1965 and was edited over two months and released in 1966. Phillip Greene did the photography. When the severity of her illness became apparent to her, Lange agreed to another film, to be focused more directly on her life and work. According to Greene, this second film, *Under the Trees*, was shot over a year-and-a-half period, and the editing was completed shortly before she died. Her reaction on seeing it was "You did it, Phil; you did it!" Greene-Ohrn interview.

29. Meltzer, *Dorothea Lange*, 343.

30. Lange, "Project I," April, 1964, reproduced in Lange, *The Making of a Documentary Photographer*, 250.

31. Lange, in the film *The Closer for Me*.

32. Lange, "A Photography Center," July 17, 1964, reproduced in Lange, *The Making of a Documentary Photographer*, 247–49.

33. Vanderbilt-Ohrn interview.

34. Roberta Hellman and Marvin Hoshino, "An Eye Test with Glasses," *Village Voice*, May 19, 1975, p. 110.

35. Lange, in the film *The Closer for Me*.

36. Vanderbilt-Ohrn interview.

37. Lange, in the film *The Closer for Me*.

Bibliography

Collections

Bureau of Agricultural Economics Records. Record Group 83. Audio-visual Division, National Archives, Washington, D.C.

George P. Elliott Papers. Washington University Libraries, St. Louis, Mo.

Farm Security Administration Files, Prints and Photographs Division, Library of Congress, Washington, D.C.

Dorothea Lange Collection. Oakland Museum, Oakland, Calif.

Roy Stryker Collection. University of Louisville Photographic Archives, Louisville, Ky.

Roy Stryker Papers. Archives of American Art, Smithsonian Institution, Washington, D.C.

Interviews

Collier, John, Jr., by Karin B. Ohrn, June 7, 1974.

Conrat, Richard C., by Karin B. Ohrn, June 15, 1975.

Doherty, Robert, by Karin B. Ohrn, May 10, 1974.

Greene, Phillip, by Karin B. Ohrn, June 3, 1974.

Heyman, Therese, by Karin B. Ohrn, June 6, 1974.

Lange, Dorothea, by Richard K. Doud, May 22, 1964. Transcript in Archives of American Art, Smithsonian Institution, Washington, D.C., 1964.

Lange, Dorothea, conversation with George Leonard, September 4, 1964. Transcript in possession of Margaretta Mitchell.

Lee, Russell, by Karin B. Ohrn, March 22, 1978.

Mitchell, Margaretta, by Karin B. Ohrn, June 3, 1974.

Newhall, Beaumont, by Karin B. Ohrn, May 16, 1974.

Partridge, Rondal, by Karin B. Ohrn, May 29, 1974.

Stryker, Roy, by Thomas Garver, July 1, 1968. Appears in *Just Before the War*. Balboa, Calif.: Newport Art Museum, 1968.

Taylor, Dyanna, by Karin B. Ohrn, May 29, 1974.

Taylor, Paul S., by Karin B. Ohrn, May 29 and 30, 1974.

Teiser, Ruth, by Karin B. Ohrn, June 4, 1974.

Vanderbilt, Paul, by Karin B. Ohrn, August 31, 1974.

Works by Dorothea Lange (Arranged chronologically)

Taylor, Paul S., and Dorothea Lange. "Establishment of rural rehabilitation camps for migrants in California," March 15, 1935. Lot 898, Farm Security Administration Files, Prints and Photographs Division, Library of Congress, Washington, D.C.

Taylor, Paul S., and Dorothea Lange. "Migration of Drought Refugees to California," April 17, 1935. Lot 897, Farm Security Administration Files, Prints and Photographs Division, Library of Congress, Washington, D.C.

Lange, Dorothea. "Draggin' Around People." *Survey Graphic*, LXIII (March, 1936), 524–25.

Lange, Dorothea, and Paul S. Taylor. *An American Exodus: A Record of Human Erosion.* New York: Reynal and Hitchcock, 1939; Rev. ed., New Haven, Conn.: Yale University Press, 1969; Reprint ed., New York: Arno Press, 1975.

Lange, Dorothea. "Documentary Photography," in T. J. Maloney, G. M. Morley, and Ansel Adams, eds., *A Pageant of Photography*. San Francisco: Crocker Union, 1940.

Lange, Dorothea, and Pare Lorentz. "Camera with a Purpose." *U.S. Camera Annual*, I (1941), 94–116.

[Lange, Dorothea, and Ansel Adams]. "American-Italians." *Victory*, Vol. I, No. 4, pp. 27–35.

[Lange, Dorothea]. "Americans of Spanish Descent." *Victory*, Vol. I, No. 5, pp. 26–30.

Lange, Dorothea, and Ansel Adams. "Richmond Took a Beating." *Fortune*, XXXI (February, 1945), 262–69.

Lange, Dorothea, and Daniel Dixon. "Photographing the Familiar." *Aperture*, I, No. 2 (1952), 5–15.

Lange, Dorothea, and Ansel Adams. "Three Mormon Towns." *Life*, September 6, 1954, pp. 91–100.

——. "Irish Country People." *Life*, March 21, 1955, pp. 135–43.

——. "A Born Photographer Talks of Her Craft." Berkeley *Review*, January 28, 1960.

——. "The Assignment I'll Never Forget." *Popular Photography*, XLVI (February, 1960), 42–43, 128.

Lange, Dorothea, and Pirkle Jones. "Death of a Valley." *Aperture*, VIII, No. 3 (1960), 127–65.

Lange, Dorothea. "The American Farm Woman." *Harvester World*, LI (November, 1960), 2–9.

——. "Women of the American Farm." *America Illustrated* (USIA), Russian ed.,

November, 1962, pp. 56–61; Polish ed., December, 1962, pp. 2–7; Arabic ed., April, 1962, pp. 18–23.

————. "Remembrance of Asia." *Photography Annual, 1964*, pp. 50–59, 191, 193. Compiled by editors of *Popular Photography*. New York: Ziff-Davis, 1963.

————. *Dorothea Lange*. New York: Museum of Modern Art, 1966.

————. *Dorothea Lange Looks at the American Country Woman*. Foreword by Beaumont Newhall. Fort Worth, Tex.: Amon Carter Museum, 1967.

————. *The Making of a Documentary Photographer*. An interview by Suzanne Reiss. Berkeley: Regional Oral History Office, Bancroft Library, University of California, 1968.

Lange, Dorothea, and Margaretta K. Mitchell. *To A Cabin*. New York: Grossman, 1973.

Works About Lange

Ballen, Carmen. "The Art of Dorothea Lange." *Overland Monthly*, LXXIV (November, 1919), 396–408.

Blum, Walter. "Looking Back at a Great Woman Photographer." San Francisco *Examiner and Chronicle*, January 23, 1966, "California Living" sec., pp. 16–17.

Coke, Van Deren. "Dorothea Lange: Compassionate Recorder." *Modern Photography*, XXXVII (May, 1973), 90–95.

[Deschin, Jacob]. "Miss Lange's Counsel: Photographer Advises Use of Picture Themes." New York *Times*, December 7, 1952, II, p. 23.

Deschin, Jacob. "This Is the Way It Is—Look at It! Look at It!" *Popular Photography*, LVIII (May, 1966), 58–60.

————. "Dorothea Lange and Her Printer." *Popular Photography*, LIX (July, 1966), 28, 30, 68, 70.

Dixon, Daniel. "Dorothea Lange." *Modern Photography*, XVI (December, 1952), 68–77, 138–41.

"Dorothea Lange." *Great Photographers*. New York: Time-Life Books, 1971, pp. 184–87.

Frankel, Ronni Ann. "Photography and the Farm Security Administration: The Visual Politics of Dorothea Lange and Ben Shahn." Senior honors thesis, Cornell University, 1969.

Goldsmith, Arthur. "A Harvest of Truth: The Dorothea Lange Retrospective Exhibition." *Infinity*, XV (March, 1966), 23–30.

Herz, Nat. "Dorothea Lange in Perspective." *Infinity*, XII (April, 1963), 5–11.

Heyman, Therese Thau. *Celebrating a Collection: The Work of Dorothea Lange*. Oakland, Calif.: Oakland Museum, 1978.

Meltzer, Milton. *Dorothea Lange: A Photographer's Life*. New York: Farrar, Straus & Giroux, 1978.

Morrison, Chester. "Dorothea Lange, Friend of Vision." *Look*, March 22, 1966, pp. 34–38.

Newhall, Beaumont, and Nancy Newhall. "Dorothea Lange." *Masters of Photography*. New York: Braziller, 1958, pp. 140–49.

Ohrn, Karin B. "Dorothea Lange," in Barbara Sicherman, ed., *Notable American Women*, Vol. IV. Cambridge, Mass.: Harvard University Press, forthcoming.

————. "A Life in Photography." *Matrix: The Magazine for Women in Communication*, LXII (Winter, 1976–77), 20–24.

———. "A Nobler Thing:Dorothea Lange's Life in Photography." Ph.D. dissertation, Indiana University, 1977.

———. "What You See Is What You Get: Dorothea Lange and Ansel Adams at Manzanar." *Journalism History*, IV (1977), 14–22, 32.

Page, Homer. "A Remembrance of Dorrie." *Infinity*, XIV (November, 1965), 26–27.

Smith, W. Eugene. "One Whom I Admire, Dorothea Lange (1895–1965)." *Popular Photography*, LVIII (February, 1966), 86–88.

Stoddard, Hope. "Dorothea Lange." *Famous American Women*. New York: T. Y. Crowell, 1970, pp. 245–54.

Taylor, Paul S. "Migrant Mother: 1936." *American West*, VII (May, 1970), 41–47.

Van Dyke, Willard. "The Photographs of Dorothea Lange: A Critical Analysis." *Camera Craft*, XLI (October, 1934), 461–67.

Films

Dorothea Lange: The Closer for Me. Produced, edited, and directed by Phillip Greene, Robert Katz, and Richard Moore, for KQED, San Francisco, and National Educational Television. Available from Indiana University. Released in 1966.

Dorothea Lange: Under the Trees. Produced by Phillip Greene and Robert Katz, directed by Phillip Greene and Richard Moore, for KQED, San Francisco, and National Educational Television. Available from Indiana University. Released in 1965.

Guilty by Reason of Race. Produced by NBC. First televised in 1972.

Other Sources

Abbott, Berenice. *Changing New York*. New York: E. P. Dutton, 1939.

Adams, Ansel. *Born Free and Equal*. New York: U.S. Camera, 1944.

———. *Making a Photograph*. New York: Studio Publications, 1935.

———. "Personal Credo." *American Annual of Photography*, LVIII (1944), 7–16.

———. "Portraiture." *Camera Craft*, XLI (April, 1934).

Adams, Mark, and Russell Lee. "Our Town in East Texas." *Travel*, LXXIV (March, 1940), 5–12.

"American Exodus." *U.S. Camera*, I (May, 1940), 62–63, 71.

Andersen, Sherwood. *Home Town*. New York: Alliance Book Corp., 1940.

Angly, Edward. *Oh Yeah!* New York: Viking Press, 1931.

Bakke, E. Wright. *Citizens Without Work*. New Haven, Conn.: Yale University Press, 1940.

———. *The Unemployed Worker*. New Haven, Conn.: Yale University Press, 1940.

Baldwin, Sidney. *Poverty and Politics: The Rise and Decline of the Farm Security Administration*. Chapel Hill: University of North Carolina Press, 1968.

Bateson, Gregory, and Margaret Mead. *Balinese Character*. New York: New York Academy of Sciences, 1942.

Bourke-White, Margaret. *Eyes on Russia*. New York: Simon and Schuster, 1931.

———. "Franklin Roosevelt's Wild West." *Life*, November 3, 1936, cover and pp. 9–17.

———. "Hogs." *Fortune*, I (February, 1930), 54–61.

———. "Moscow Fights Off Nazi Bombers." *Life*, September 1, 1941, cover and pp. 15–21.

———. *The Photographs of Margaret Bourke-White*. Edited by Sean Callahan. New York: New York Graphic Society, 1972.

————. "Russian Mud and Blood Stall the German Army." *Life*, November 17, 1941, pp. 33–39.

————. "The Vultures of Calcutta Eat the Indian Dead." *Life*, September 9, 1946, pp. 38–39.

ten Broek, Jacobus, *et al. Prejudice, War and the Constitution*. Berkeley: University of California Press, 1954.

Brown, Theodore, M. *Margaret Bourke-White, Photojournalist*. Ithaca, N.Y.: Cornell University Press, 1972.

Caldwell, Erskine, and Margaret Bourke-White. "The South of Erskine Caldwell Is Photographed by Margaret Bourke-White." *Life*, November 22, 1937, pp. 48–52.

Caldwell, Erskine, and Margaret Bourke-White. *You Have Seen Their Faces*. New York: Modern Age Books, 1937.

Calkins, Clinch. *Some Folks Won't Work*. New York: Harcourt, Brace, 1930.

Callahan, Harry. *The Multiple Image*. Chicago: Press of the Institute of Design, 1961.

"Caravans of Hunger." *Look*, May 25, 1937, pp. 18–19.

Cartier-Bresson, Henri. *The Decisive Moment*. New York: Simon and Schuster, 1952.

Christenson, Erwin O., ed. *The Index of American Design*. New York: MacMillan, 1950.

Coleman, A. D. "A Dark Day in History." New York *Times*, September 24, 1972, Sec. D, p. 19.

Collier, John, Jr., and Ansel Adams. "Two Approaches to Portraiture." *Camera 35*, IV (October–November, 1960), 24–31, 88, 90ff.

Conrat, Maisie, and Richard Conrat. *Executive Order 9066*. Los Angeles: California State Historical Society, 1972.

Cunningham, Imogen. *Imogen!* Seattle: University of Washington Press, 1974.

————. *Imogen Cunningham: Photographs*. Edited by Margery Mann. Seattle: University of Washington Press, 1970.

————. *Imogen Cunningham: Portraits, Ideas and Design*. An interview by Edna Tartaul Daniel. Berkeley: Regional Cultural History Project, University of California, 1961.

Davis, Lillian P. "Relief and the Sharecropper." *Survey Graphic*, LXXII (January, 1936), 20–22.

"Days of Darkness, Days of Despair—The Depression." *Scholastic Search*, IV (April 18, 1974), 3–21 and cover.

Degler, Carl. *Out of Our Past*. New York: Harper and Row, 1959.

Documentary Photography. Life Library of Photography. New York: Time-Life Books, 1972.

Dollard, John. *Caste and Class in a Southern Town*. New Haven, Conn.: Yale University Press, 1937.

Doty, Robert. *Photo-Secession: Photography as a Fine Art*. New York: George Eastman House, 1960.

Durniak, John. "Focus on Stryker." *Popular Photography*, LI (September, 1962), 60–65, 80–83.

Edom, Clifton C. "Documentary Photography." *The P.S.A. Journal*, XII (April, 1946), 142–43.

Elliott, George P. "Photographs and Photographers." *A Piece of Lettuce*. New York: Random House, 1969, pp. 90–103.

Embree, Edwin W. "Southern Farm Tenancy: A Way Out of Its Evils." *Survey Graphic*, LXXII (March, 1936), 149–53.

Erwitt, Elliott. *The Private Experience: Elliott Erwitt*. Los Angeles: Alskog, with Thomas Y. Crowell, 1974.

Evans, Walker. *American Photographs*. New York: Museum of Modern Art, 1938.

Federal Writers' Project. *Lay My Burden Down: A Folk History of Slavery*. Edited by B. A. Botkin. Chicago: University of Chicago Press, 1945.

———. *These Are Our Lives*. Chapel Hill: University of North Carolina Press, 1939.

Frank, Robert. *The Americans*. Paris: Robert Delpire, 1958.

Genthe, Arnold. *As I Remember*. New York: Reynal and Hitchcock, 1936.

Gernsheim, Helmut, and Alison Gernsheim. *A Concise History of Photography*. New York: Grosset and Dunlap, 1965.

Gernsheim, Helmut. *Creative Photography: Aesthetic Trends, 1839–1960*. New York: Bonanza Books, 1962.

Gidal, Tim N. *Modern Photojournalism: Origin and Evolution 1910–33*. New York: MacMillan, 1972.

Gowin, Emmet. *Photographs*. New York: A. A. Knopf, 1976.

Green, Jonathan, ed. *Snapshot*. Published as *Aperture*, XIX, No. 1 (1974).

Grodzins, Martin. *Americans Betrayed*. Chicago: University of Chicago Press, 1949.

Gutman, Judith M. *Lewis Hine and the American Social Conscience*. New York: Walker, 1967.

Hall, Edward T. *The Silent Language*. Garden City, N.Y.: Doubleday, 1959.

Hellman, Roberta, and Marvin Hoshino. "An Eye Test with Glasses." *Village Voice*, May 19, 1975, p. 110.

Hicks, Wilson. *Words and Pictures*. New York: Harper and Brothers, 1952.

Hogarth, Paul. *The Artist as Reporter*. London: Van Nostrand, 1967.

Hosokawa, Bill. *Nisei*. New York: William Morrow, 1969.

Houston, Jeanne Wakatsuki, and James D. Houston. *Farewell to Manzanar*. Boston: Houghton Mifflin, 1973.

Howe, Hartley. "You Have Seen Their Pictures." *Survey Graphic*, LXXVI (April, 1940), 236–41.

Hurley, F. Jack. *Portrait of a Decade: Roy Stryker and the Development of Documentary Photography in the Thirties*. Baton Rouge: Louisiana State University Press, 1972.

———. "Russell Lee." *Image*, XVI (September, 1973), 1–8.

"The Index of American Design: A Portfolio." *Fortune*, XV (June, 1937), 103–10.

Josephson, Matthew. *Infidel in the Temple: A Memoir of the Thirties*. New York: A. A. Knopf, 1967.

Just Before the War. Balboa, Calif.: Newport Art Museum, 1968.

Kazin, Alfred. *On Native Grounds*. Garden City, N.Y.: Doubleday, 1956.

Kerr, Clark. "Productive Enterprises of the Unemployed." Ph.D. dissertation, University of California, 1949.

Lartigue, Jacques Henri. *Boyhood Photos of J.-H. Lartigue: The Family Album of a Gilded Age*. Lausanne [?], Switzerland: A. Guichard, 1966.

———. *Diary of a Century*. Edited by Richard Avedon. New York: Viking Press, 1970.

Latour, Ira. "West Coast Photography: Does It Really Exist?" *Photography* (London), III (June, 1957), 26–45.

Lazarsfeld, Paul. *The Press and the Printed Page.* New York: Duell, Sloan and Pearce, 1940.

Lee, Russell. "Pie Town, New Mexico." *U.S. Camera,* (October, 1941), 39–54ff.

Leighton, Alexander. *Governing of Men.* Princeton, N.J.: Princeton University Press, 1945.

"Life on the Farm." *Look,* October 12, 1937, pp. 16–21.

Lively, C. E., and Conrad Taenker. "Rural Migration in the U.S." Research Monograph 19, War Relocation Authority Division of Research. Washington, D.C.: U.S. Government Printing Office, 1939.

Luce, Henry. "Giving the People What They Want." *Public Opinion in a Democracy.* Special supplement to *Public Opinion Quarterly,* II (January, 1938), 62–66.

Lynd, Robert, and Helen Lynd. *Middletown in Transition.* New York: Harcourt, Brace, 1937.

Lyons, Nathan, ed. *Photographers on Photography.* Englewood Cliffs, N.J.: Prentice-Hall, in collaboration with the George Eastman House, 1960.

McCamy, James L. *Government Publicity: Its Practice in Federal Administration.* Chicago: University of Chicago Press, 1939.

MacLeish, Archibald. *Land of the Free.* New York: Harcourt, Brace, 1938.

———. *A Time to Act.* Boston: Houghton Mifflin, 1943.

McWilliams, Carey. *California: The Great Exception.* New York: Current Books, 1949.

Maloney, Thomas J., Grace McCann Morley, and Ansel Adams, eds. *A Pageant of Photography.* San Francisco: Crocker-Union, 1940.

Mann, Margery. "Imogen Cunningham." *Infinity,* XV (November, 1966), 25–28.

Mayhew, Henry. *London Labour and London Poor.* Photographs by Richard Beard. London: G. Woodfall, 1851.

Meatyard, Ralph Eugene. *Ralph Eugene Meatyard.* Lexington, Ky.: Gnomon Press, 1970.

Mich, Daniel D. "The Rise of Photojournalism in the United States." *Journalism Quarterly,* XXIV (September, 1947), 202–206, 238.

Minehan, Thomas. *Boy and Girl Tramps of America.* New York: Farrar and Rinehart, 1934.

Modell, John, ed. *The Kikuchi Diary.* Urbana: University of Illinois Press, 1973.

Mumford, Lewis. *The Story of Utopias.* New York: Boni and Liveright, 1922.

"Murals by American Painters and Photographers." *American Art of the Twenties and Thirties.* Reprinted from 1932 catalog. New York: Museum of Modern Art, 1969.

Newhall, Beaumont. "Documentary Approach to Photography." *Parnassus,* X (March, 1938), 2–6.

———. *The History of Photography, 1839 to Present.* New York: Museum of Modern Art, 1964.

Newhall, Nancy. *Ansel Adams: A Biography.* Vol. I, *The Eloquent Light.* San Francisco: Sierra Club, 1964.

Nixon, Herman C. *Forty Acres and Steel Mules.* Chapel Hill: University of North Carolina Press, 1938.

"No One Has Starved." *Fortune,* VI (September, 1932), pp. 18–29, 80, 82, 84, 86, 88.

Ohrn, Karin B. "Prodigal Photography: Professionals Returning to the Home Mode." Paper presented at the Conference on Culture and Communication, Temple University, Philadelphia, Pa., March, 1975.

"Orbus Pictus." *Nation*, CXLI (October 16, 1935), 426.

Peterson, Theodore, B. *Magazines in the Twentieth Century*. Urbana: University of Illinois Press, 1956.

Phillips, Cabell. *From the Crash to the Blitz, 1929–39: The New York Times Chronicle of American Life*. New York: MacMillan, 1969.

"Photography." *Newsweek*, October 21, 1974, pp. 64–69 and cover.

Photojournalism. Life Library of Photography. New York: Time-Life Books, 1971.

Pollack, Peter. *The Picture History of Photography*. Rev. ed.; New York: Harry N. Abrams, 1969.

"The Press and the People: A Survey." *Fortune*, XX (August, 1939), 65, 70.

Riis, Jacob. *How the Other Half Lives*. New York: C. Scribner's Sons, 1890. Reprint ed., New York: Dover, 1971.

Rostow, Eugene V. "The Japanese American Case: A Disaster." *The Shaping of Twentieth Century America*. 2nd ed. Edited by Richard M. Abrams and Lawrence W. Levine. Boston: Little, Brown, 1971, pp. 459–94.

Rotha, Paul. *Documentary Film*. 3rd ed. New York: Hastings House, 1952.

Rothstein, Arthur. "Direction in the Picture Story." *Complete Photographer*. Edited by Willard Morgan. IV (April 10, 1942), 1356–63.

———. *Photojournalism*. 2nd ed. Philadelphia: Chilton Books, 1965.

———. "Setting the Record Straight." *Camera 35*, XXII (April, 1978), 50–51.

Rothstein, Arthur, *et al*. *A Vision Shared: The Words and Pictures of the F.S.A. Photographers, 1935–43*. New York: St. Martins, 1976.

Severin, Werner J. "Cameras with a Purpose: The Photojournalists of the F.S.A." *Journalism Quarterly*, XLI (Spring, 1964), 191–200.

———. "Photographic Documentation by the Farm Security Administration, 1935–41." M.A. thesis, University of Missouri, 1959.

Shaw, Clifford R. *The Jack Roller: A Delinquent Boy's Own Story*. Chicago: University of Chicago Press, 1930.

Siegel, Arthur. "Fifty Years of Documentary." *American Photography*, XLV (January, 1951), 20–25ff.

Smith, W. Eugene. "Country Doctor." *Life*, September 20, 1948, pp. 115–26.

———. "Man of Mercy." *Life*, November 15, 1954, pp. 161–72.

———. "My Daughter Juanita." *Life*, September 21, 1953, cover and pp. 165–71.

———. "Spanish Village." *Life*, August 9, 1951, pp. 120–29.

———. *W. Eugene Smith: His Photographs and Notes*. New York: Aperture, 1969.

Sontag, Susan. *On Photography*. New York: Farrar, Straus and Giroux, 1977.

Spivak, John L. *America Faces the Barricades*. New York: Covici, Friede, 1935.

Stanley, Edward. "Roy Stryker: Photographic Historian." *Popular Photography*, IX (July, 1941), 28–29ff.

Steichen, Edward, ed. *The Bitter Years, 1935–41*. New York: Museum of Modern Art, 1962.

———, ed. *The Family of Man*. New York: Museum of Modern Art, 1955.

———. "The Farm Security Administration Photographers." *U.S. Camera Annual, 1939*, pp. 44–63.

Steinbeck, John. *The Grapes of Wrath*. New York: Viking Press, 1939.

———. "A Primer on the 30's." *Esquire*, LIII (June, 1960), 85–93.

Stott, William. *Documentary Expression and Thirties America*. New York: Oxford University Press, 1973.

Strand, Paul. Portfolio. *Camera Work*, No. 50 (1917).

Stryker, Roy E. "Documentary Photography." *Complete Photographer*, IV (April 10, 1942), 1364–73ff.

———. "The Human Factor." New York *Times*, May 18, 1949.

———. "The Lean Thirties." *Harvester World*, LI (February–March, 1960), 6–15.

Stryker, Roy E. "Documentary Photography." *Complete Photographer*. Edited by Willard Morgan. IV (April 10, 1942), 1364–73ff. 1973.

Sutherland, Edwin H., ed. *The Professional Thief*. Chicago: University of Chicago Press, 1937.

Sutherland, Edwin H., and Harvey J. Locke. *20,000 Homeless Men*. Chicago: J. B. Lippincott, 1936.

Taft, Robert. *Photography and the American Scene: A Social History, 1839–1889*. New York: MacMillan, 1938; Reprint ed., New York: Dover Publication, 1964.

Taylor, Paul S. "Again the Covered Wagon." *Survey Graphic*, LXXI (July, 1935), 348–51, 368.

———. "Mexicans North of the Rio Grande." *Survey Graphic*, LXVI (May, 1931), 134–40, 197, 200–202, 205.

———. "Our Stakes in the Japanese Exodus." *Survey Graphic*, LXXVIII (September, 1942), 373–75, 378, 396–97.

———. *Paul Schuster Taylor: California Social Scientist*. Vol. I. An interview by Suzanne Reiss. Berkeley: Regional Oral History Office, Bancroft Library, University of California, 1973.

Taylor, Paul S., and Norman L. Gold. "San Francisco and the General Strike." *Survey Graphic*, LXX (September, 1934), 404–11.

Thomas, Dorothy S., *et al. The Salvage*. Berkeley: University of California Press, 1952.

Thomas, Dorothy S., and Richard S. Nishimoto. *The Spoilage*. Berkeley: University of California Press, 1946.

Thomson, John, and Adolphe Smith. *Street Life in London*. London: n.p., 1877. Reprint ed., London: Banjamin Blom, 1969.

Tugwell, Rexford G., Thomas S. Munro, and Roy E. Stryker. *American Economic Life*. New York: Harcourt, Brace, 1925.

U.S. Army, Western Defense Command and Fourth Army. *Final Report: Japanese Evacuation from the West Coast, 1942*. Washington, D.C.: U.S. Government Printing Office, 1943.

U.S. Department of Agriculture. *The Negro in American Agriculture*. Washington, D.C.: U.S. Government Printing Office, July 1940.

U.S. Department of Commerce. *Small Town Manual for Community Action*. Washington, D.C.: U.S. Government Printing Office, 1942.

"The U.S Dust Bowl." *Life*, June 21, 1937, pp. 61–65.

Walters, Basil L. "Pictures vs. Type Display in Reporting the News." *Journalism Quarterly*, XXIV (September, 1947), 193–96.

Warner, W. Lloyd, and Paul S. Lunt. *The Social Life of a Modern Community*. New Haven, Conn.: Yale University Press, 1941.

Wax, Rosalie. *Doing Fieldwork*. Chicago: University of Chicago Press, 1971.

Weglyn, Michi. *Years of Infamy: The Untold Story of America's Concentration Camps*. New York: William Morrow, 1976.

"What a Depression is Really Like: Scenes from the 1930's." *U.S. News and World Report*, November 11, 1974, pp. 36–40 and cover.

Whyte, William F. *Street Corner Society*. Chicago: University of Chicago Press, 1943.

Index